DARWIN WIGGETT PHOTOGRAPHS

CANADA

DARWIN WIGGETT PHOTOGRAPHS

CANADA

WHITECAP BOOKS

VANCOUVER/TORONTO

Third Printing 2001

Edited by Elaine Jones
Proofread by Lisa Collins
Cover and interior design by Carbon Media
Printed and bound in China (Hong Kong)

Canadian Cataloguing in Publication Data
Wiggett, Darwin R. (Darwin Reginald), 1961-
 Darwin Wiggett photographs Canada

 ISBN 1-55110-621-3
 1. Wiggett, Darwin R. (Darwin Reginald), 1961- 2. Canada –
Pictorial works. 3. Landscape photography. I. Title.
FC59.W54 1997 779'.3671'092 C97-910661-3
F1017.W54 1997

We acknowledge the support of the Canada Council
for the Arts for our publishing program and the Cultural
Services Branch of the Government of British Columbia
in making this publication possible.

This book is for my parents, Reg and Clara, and my grandparents, Buster and Grace, for their continued love and guidance.

I never quite got the hang of photography. As a practitioner, I mean. I could thrill to the work of Cartier-Bresson, Ansel Adams, Diane Arbus, Richard Avedon or Yousuf Karsh as much as the next spectator, but the arcane world of f-stops and backlighting, lens apertures and film speeds has always been pretty much Greek to me. Which is fitting, I guess. The very term derives from a pair of Greek words: *phos*, meaning "light," and *graphein*, "to draw." "Drawing and light" then. The "light drawer" whose work you're holding right now is a young up-and-comer from Alberta named Darwin Wiggett. Wiggett calls this book a panoramic view of Canada–which is also a Hellenic hand-me-down. "Panoramic" is the fruit of a union between *pan*, meaning "all," and *orama*, "view or sight."

Odd words, photography and panorama, when you think about them. But this is an odd book when you look at it closely. Darwin Wiggett has travelled and photographed the length and breadth of Canada. The path he followed was wide and deep with the footprints and tripod pockmarks of the many photographers who went before him trying to capture the essence of the land.

But unlike his predecessors, Wiggett wasn't on a quest for the extraordinary. He didn't slog to Ellesmere Island or plumb the depths of the boreal forest to bring us landscapes the average Canadian will never see first-hand. Wiggett chose to photograph the Canada that lies right under our noses. Here you find a shot of (My God!) Peggy's Cove in Nova Scotia. And Victoria's harbour. Apple trees in the Okanagan. A Saskatchewan ghost town. These are photographs that you or I or any run-of-the-photo-lab freelance shutterbug might have snapped!

Except they're not. We're not good enough and Darwin Wiggett is. Every page in this book is infused with the photographer's sensibility and gilded by his craft. Which is the difference between a professional and an amateur.

Prepare to see Canada through the viewfinder of Darwin Wiggett. Prepare to see a Canada you've never seen before.

Arthur Black

The images for this book were created over an eight-month period of intense travel. I logged about 10,000 kilometres a month criss-crossing Canada in search of these photos. Logistically, that meant I could only spend two or three weeks in each province trying to capture the diverse character of the land. As such, this book is not meant as a treatise of the Canadian landscape but rather as a sampler — an appetizer, if you will, to whet your palate for a more personal exploration of this great country.

Every place illustrated in this book was easily accessible by vehicle, with the majority of images shot from the edges of major highways. Only a few of the photos required short hikes and even these were along well-marked and maintained trails. I didn't want to photograph remote landscapes that few Canadians could visit; I chose to illustrate the great beauty of everyday places in Canada.

Before this project I had never been east of Manitoba and had little desire to visit eastern Canada. After all, how can anything compare with the Rockies? I spent my boyhood exploring the mountains, and nine years as a research biologist studying the social behaviour of Columbian ground squirrels in southwestern Alberta. For me, the east simply wasn't a place to go for wild and scenic beauty. I was wrong! In Ontario, the province I predicted to be visually the most boring, I was continually stunned by the overwhelming diversity and depth of its beauty. My first stop in the province, Rushing River, rewarded me with ethereal photos of silky waters scrambling over tiered layers of Canadian Shield. This was only the beginning; everywhere I stopped wild beauty engulfed me. As I got closer to southern Ontario, visions of wall-to-wall strip malls filled me with dread, but wonderful places like Killarney, the Bruce Peninsula and Algonquin convinced me that southern Ontario is more than sprawling suburbs. Even the rural countryside around Toronto had an inviting, picturesque charm.

Ontario broke down my provincial barriers, but in Quebec I had an experience that changed me profoundly. I was photographing a small waterfall in Mont-Tremblant Park — the air caressed by a light mist, the colours saturated like wet paint, and the silence hypnotic. Suddenly, the forest was filled with fragments of song, like feathers cradled on the wind. The low mist, with an acoustical sleight of hand, twirled the sounds round and round. A family of four, walking a trail and singing a Quebec folk song in the mists of Mont-Tremblant gave me the greatest gift of my journey. In that magical moment, a deep connection was forged — right there I became a Canadian first and an Albertan second.

After visiting every province and territory, I realize I could be at home anywhere in Canada. And it has ignited in me an insatiable hunger to explore the places I missed. Now, when asked which province offers the best scenery for photography, the answer is, "Wherever you live."

Darwin Wiggett

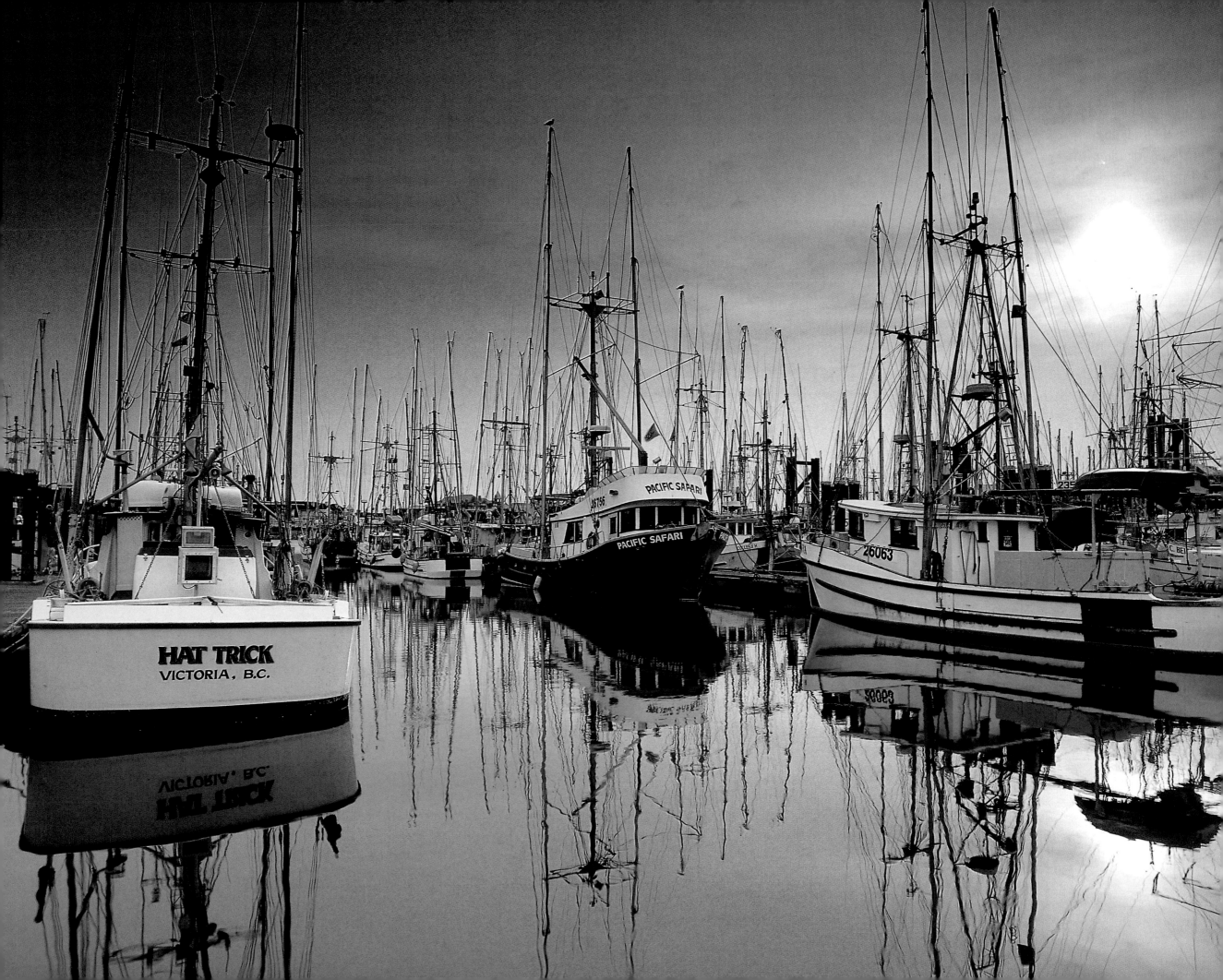

BRITISH COLUMBIA

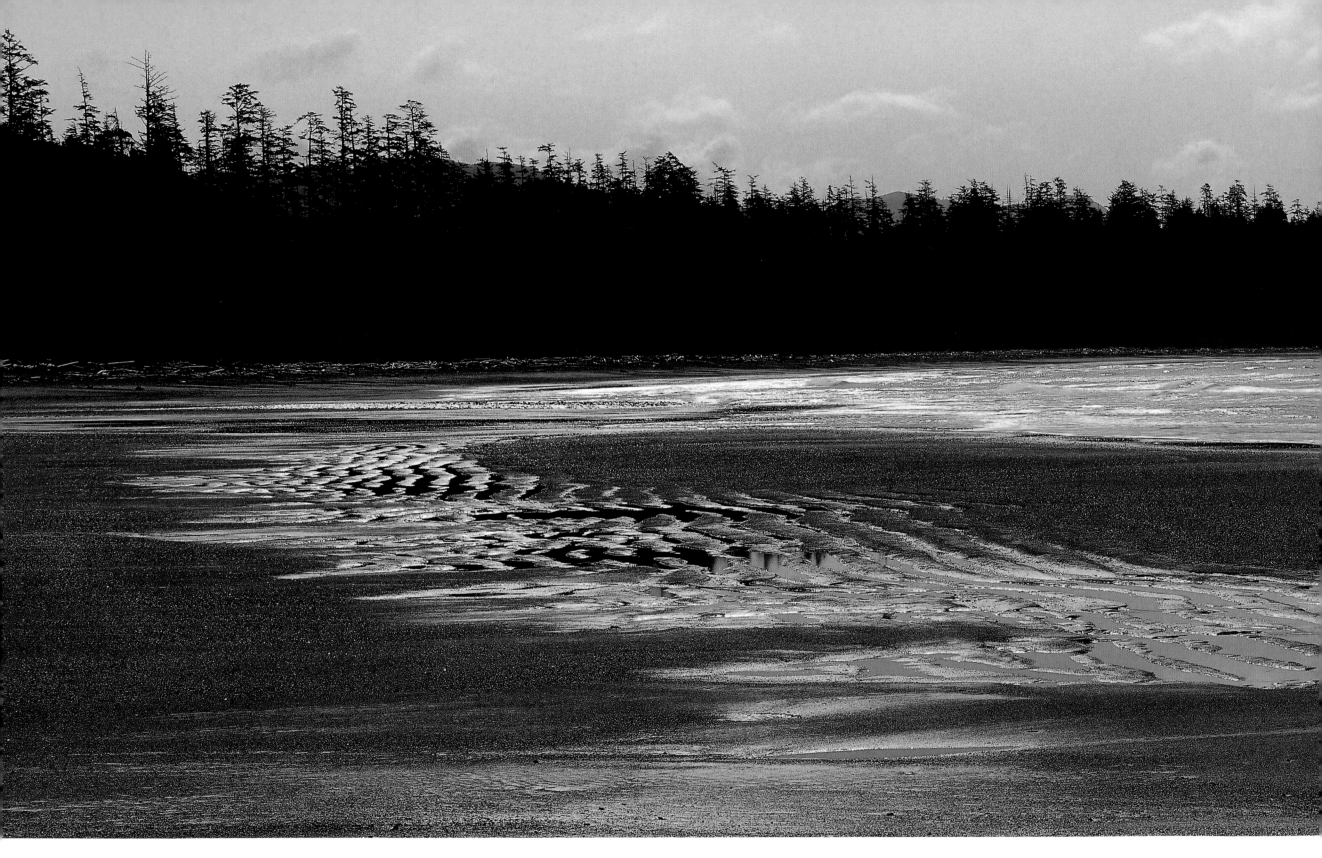

Previous page: **Victoria, British Columbia**

Early one Sunday I wandered among the fishing vessels and houseboats docked in Victoria's harbour. Everything was calm and quiet, and as I walked along the docks I could hear the rhythmic snoring of sleeping residents. A cat wove snake-like between my legs, purring contentedly. The boats in the harbour rocked slowly back and forth, occasionally creaking here and there. I stood and listened to the music of morning: purr, snore, creak; purr, snore, creak. Some things I just can't capture on film, but this image always brings back that cat and those hypnotically soothing sounds.

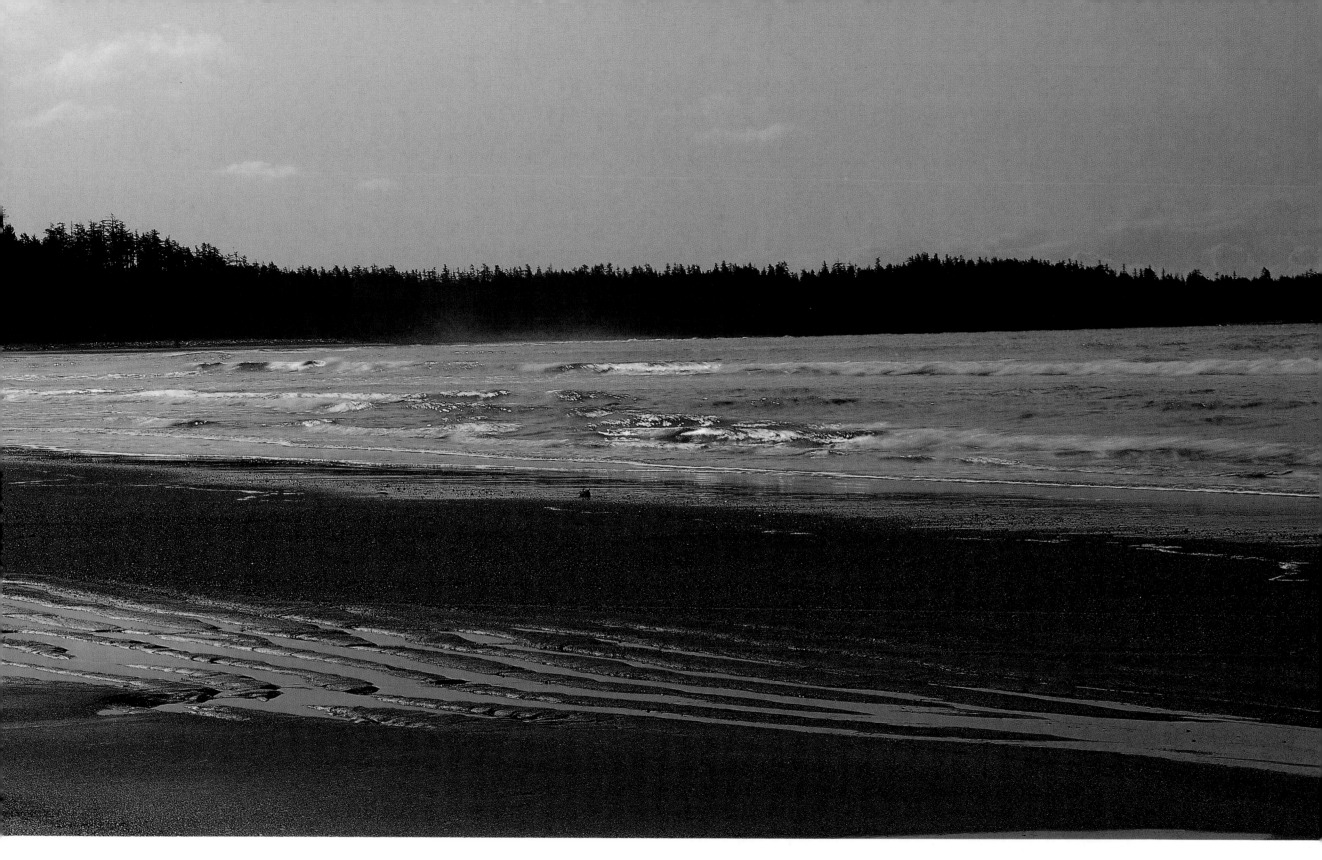

Florencia Bay, British Columbia

Pacific Rim National Park clings to Vancouver Island's rugged west coast in a stunning 105-kilometre stretch of surf-swept sandy beaches, rocky headlands, plunging cliffs, and craggy islands. The most visited area of the park is the Long Beach unit between the towns of Tofino and Ucluelet. Here my favourite spot for sunrise is the five-kilometre sweep of Wreck Beach in Florencia Bay.

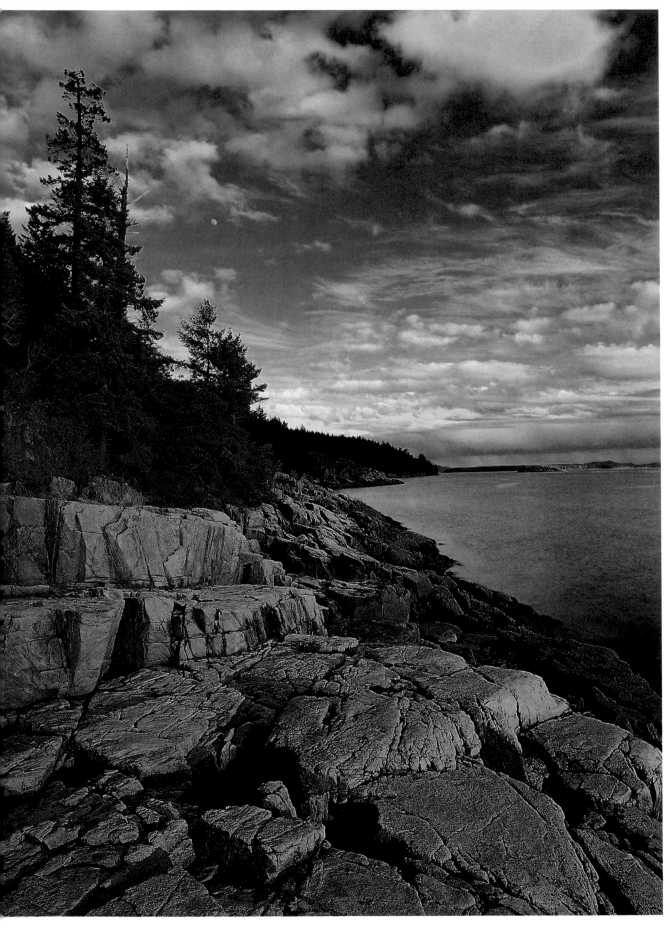

Left: **Dinner Rock, British Columbia**

The Sunshine Coast, although part of the B.C. mainland, is island-like because it depends heavily on car-carrying ferries to keep it connected to the outside world. Amid the maze of inlets, straits, and channels on this sunny section of the west coast, it's still easy to find a quiet stretch of coastline to explore. Dinner Rock north of Powell River is one such place. When I was there I had the place to myself and cooked dinner on my campstove while enjoying the tranquil and rugged view.

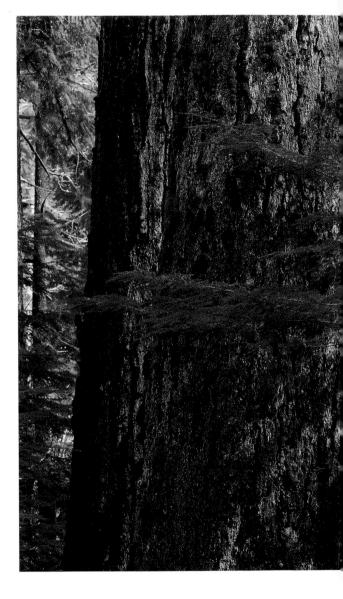

Right: **Cathedral Grove, British Columbia**

Some of the world's biggest trees grow in the ancient rain forests of the Pacific coast. Extensive logging has all but wiped out these great forests, but one of the most accessible sites is Cathedral Grove in MacMillan Provincial Park on Vancouver Island. Here towering Douglas fir, some eight hundred years old and up to seventy metres tall, grow on a thick carpet of moss. The canopy is so dense that at midday, camera exposures may run as long as a few seconds even with fast film. For this photograph, I had to expose the scene for a total of one minute!

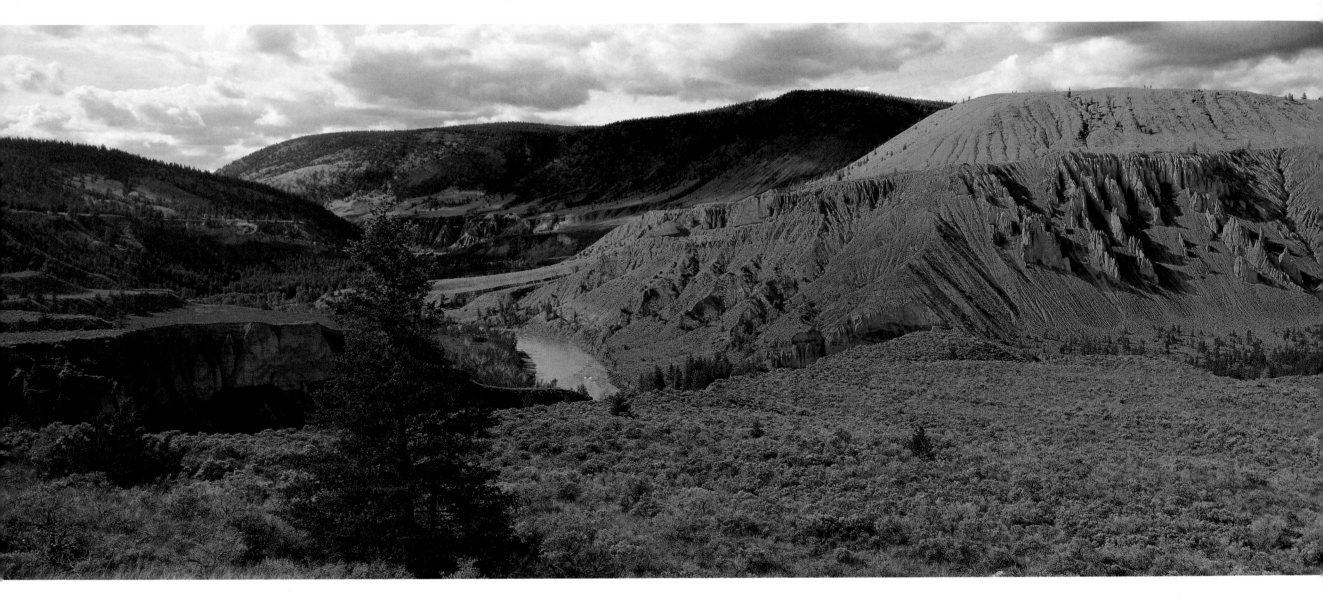

Farwell Canyon, British Columbia
The Chilcotin River cuts deeply through soft golden clay and limestone cliffs, forming bizarrely shaped hoodoos on the canyon's steep wall. On windy days, an active sand dune on the canyon lip above the hoodoos forms a plume of dust reminiscent of a smoking chimney. The gravel road that switchbacks through the canyon is a wonderful adventure, especially after a vicious rain.

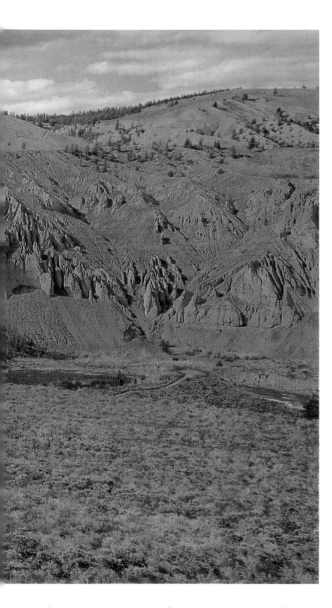

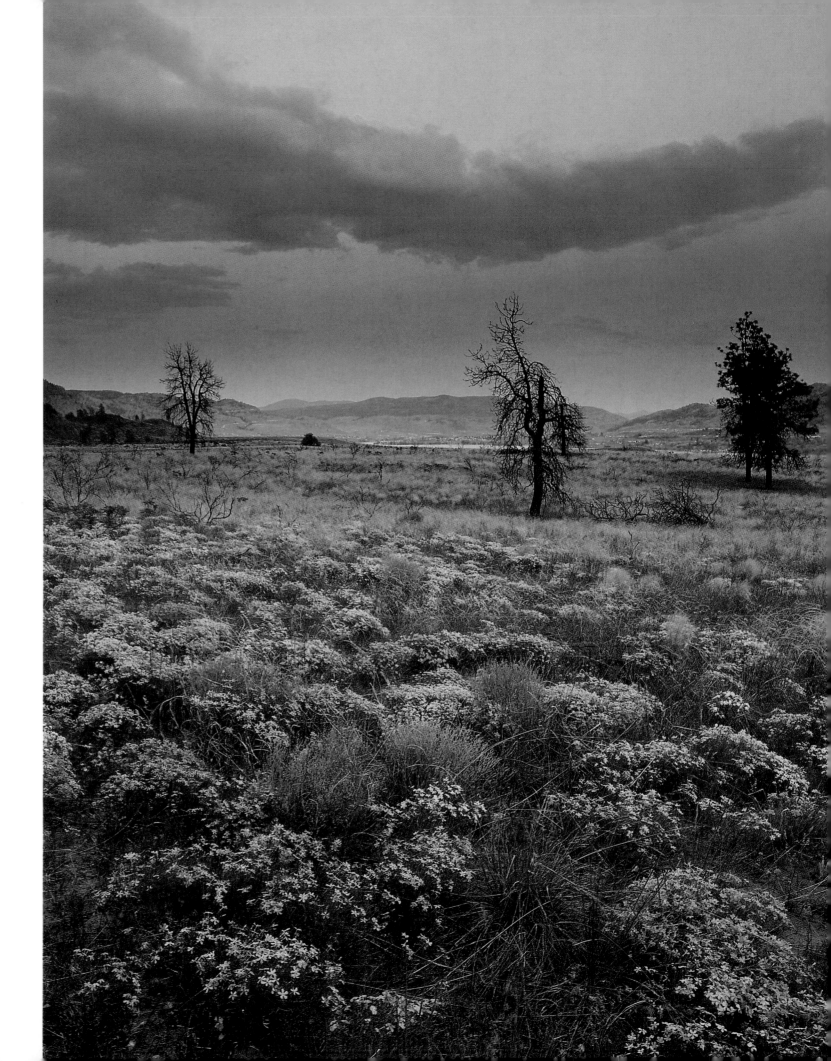

Right: **Osoyoos Ecological Reserve, British Columbia**
Before the Okanagan was transformed through irrigation into a sea of orchards and vineyards, it was a semi-arid region of antelope bush, rabbitbush, sage, and prickly pear cactus. An extension of the American Great Basin Desert, it has now almost been completely replaced by agriculture. The only remnant is this "pocket desert," a 100-hectare protected ecological reserve just outside Osoyoos. In this scene the desert bursts to life following the nourishing spring rains.

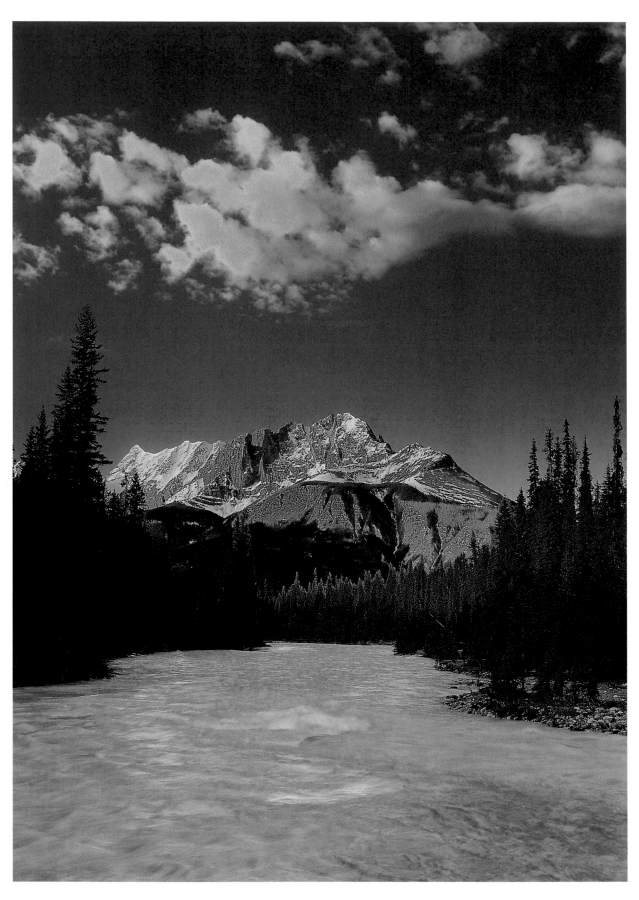

Left: **Yoho National Park, British Columbia**
Scenes like this of the Kicking Horse River and the Ottertail Range in Yoho National Park make it easy to understand how this park was named. *Yoho* is an exclamation of awe and astonishment in the Kootenai language. The Kicking Horse River got its name from an accident that occurred in 1868, when Sir James Hector of the Palliser Expedition was kicked in the chest by a horse he was trying to rescue from the river.

Right: **Manning Provincial Park, British Columbia**
Tall mountains and low valleys create extremes in weather over relatively short distances in British Columbia. One minute you're basking in sunshine and the next you're battling a blizzard. I once photographed the entire transition from winter to summer in only a few hours; at Allison Pass in Manning Provincial Park I captured this wintry wall of trees and later that same afternoon was busy shooting water-skiing in Osoyoos.

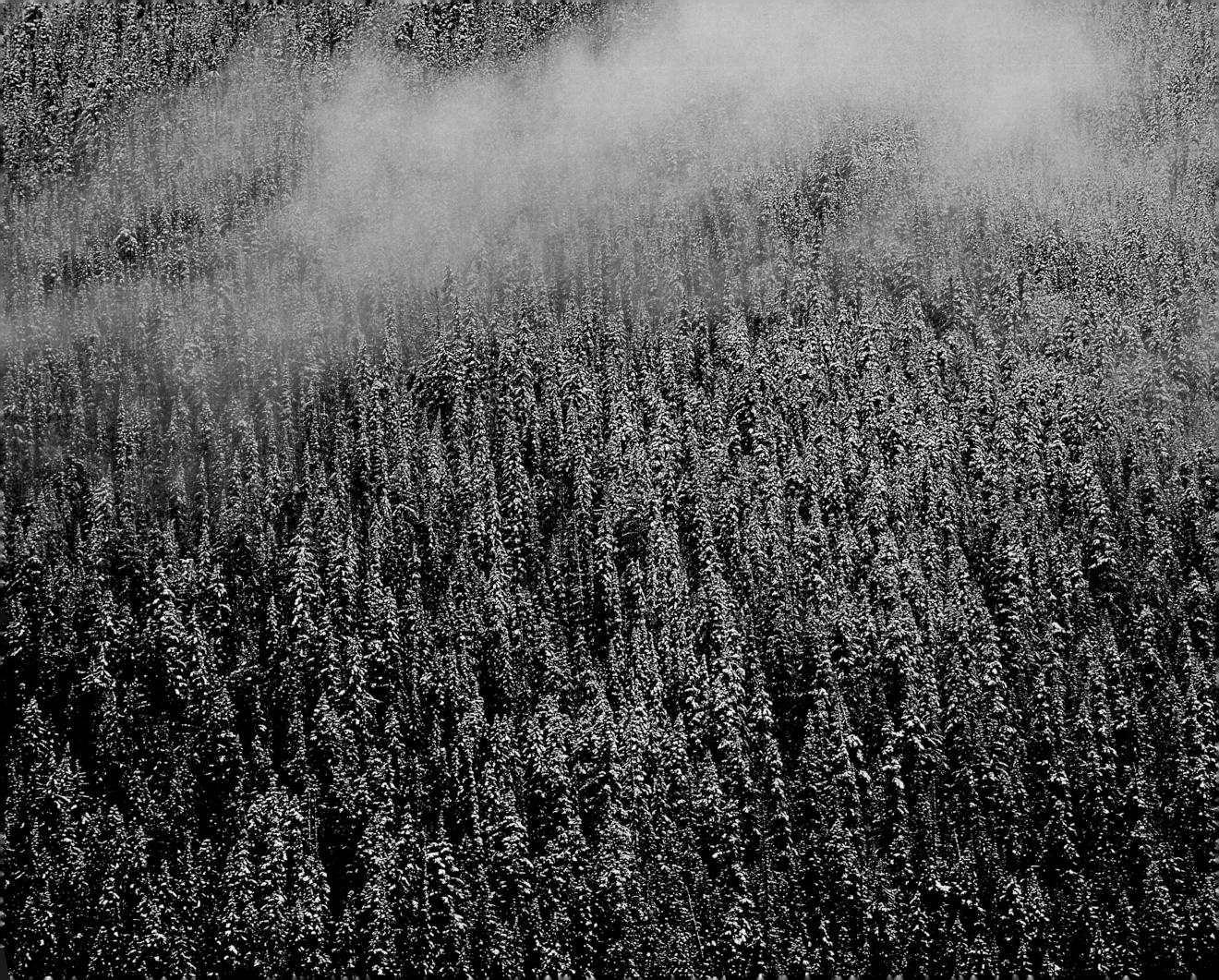

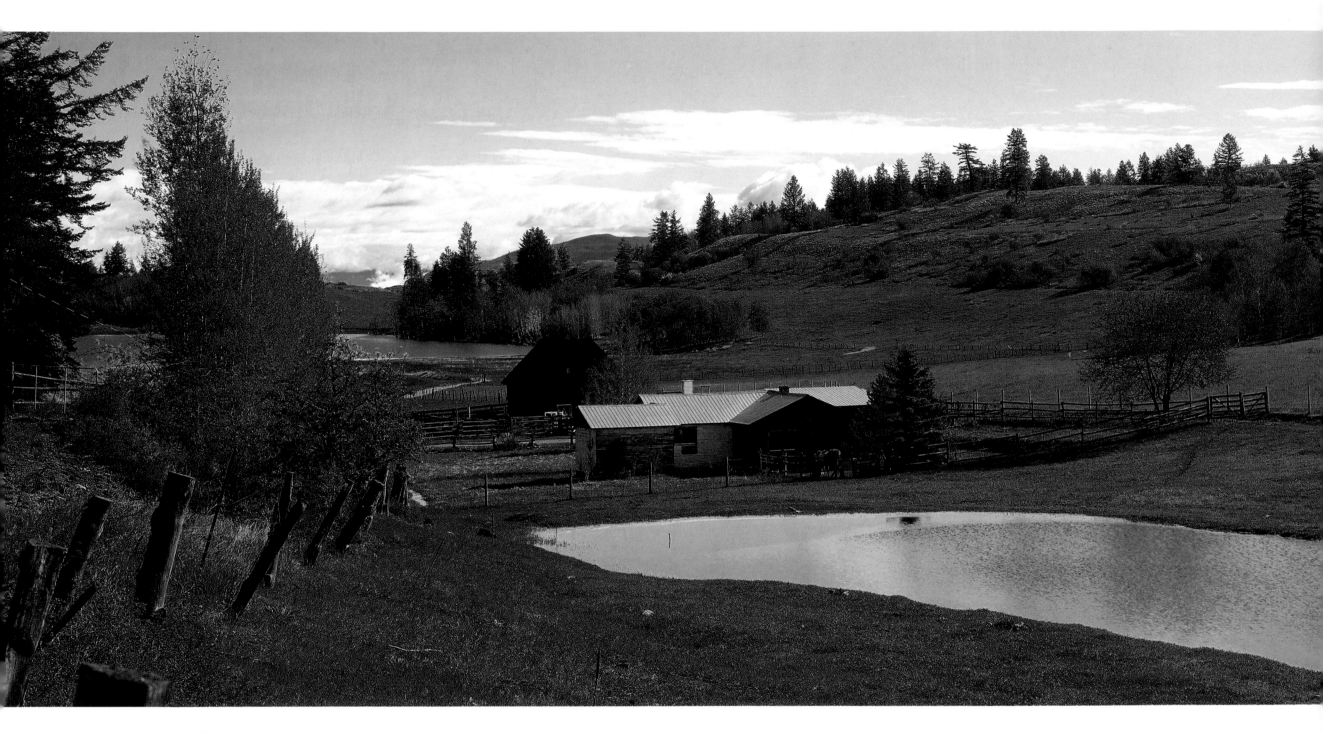

Vernon Area, British Columbia

Almost every April I leave my home in Alberta to head west to catch the first greens of spring. The B.C. spring is about a month ahead of Alberta so I travel west to bask in the glory of fresh colour while Alberta is covered in late winter brown. This pasture, just minutes from the town of Vernon, spoke to me of the hope and renewal of this season.

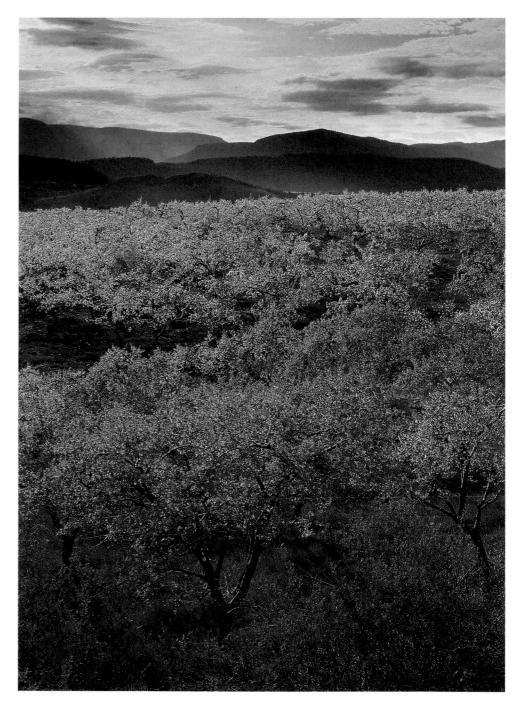

Kelowna, British Columbia

In April and May the Okanagan Valley bursts into brilliant bloom. First come the flowers of apricot and cherry, followed by peaches, pears, plums, and finally apples. Kelowna is one of Canada's fastest-growing cities and views like this one may soon vanish as subdivisions displace orchards and as old mature trees are replaced by newer, shorter, more productive varieties.

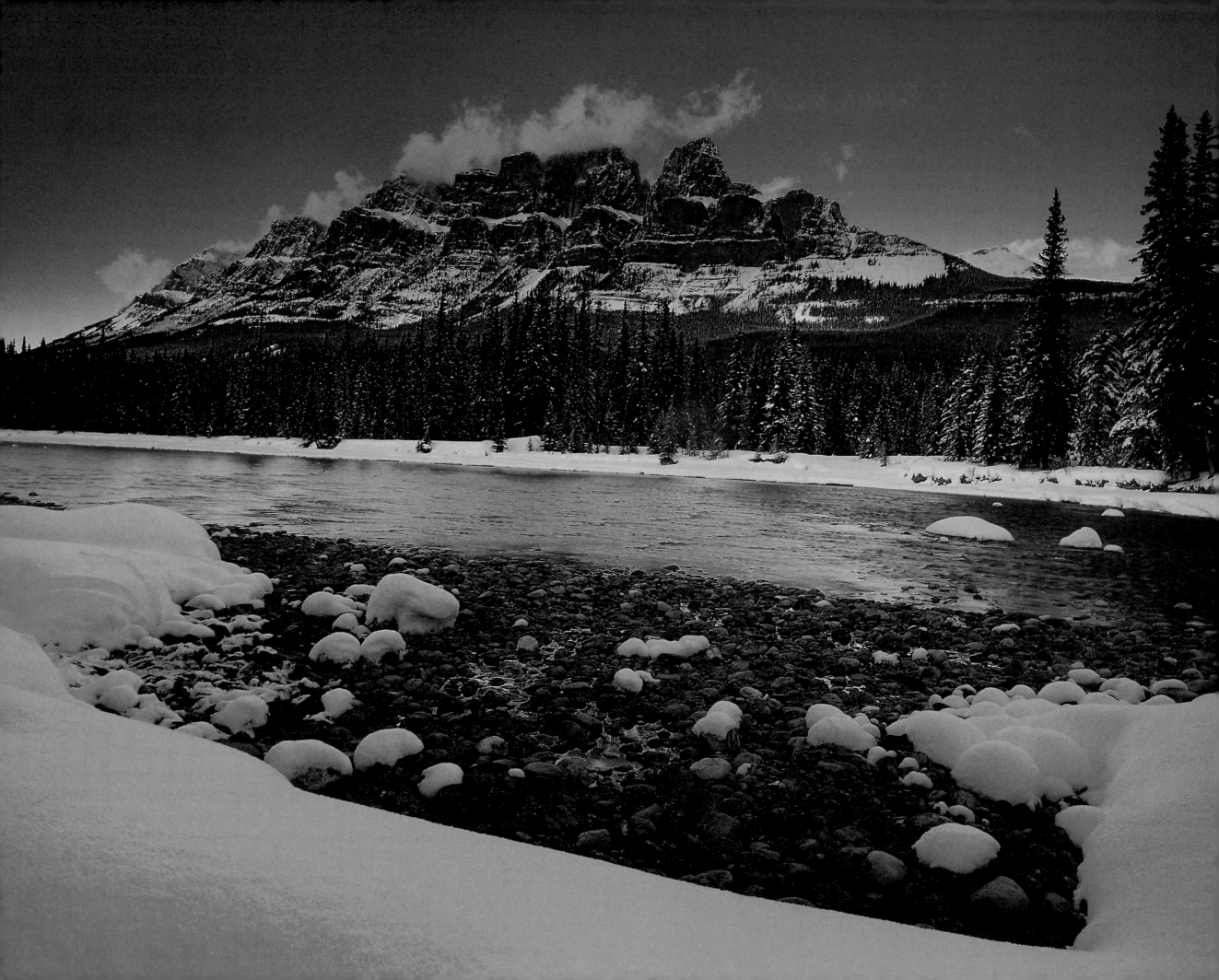

ALBERTA

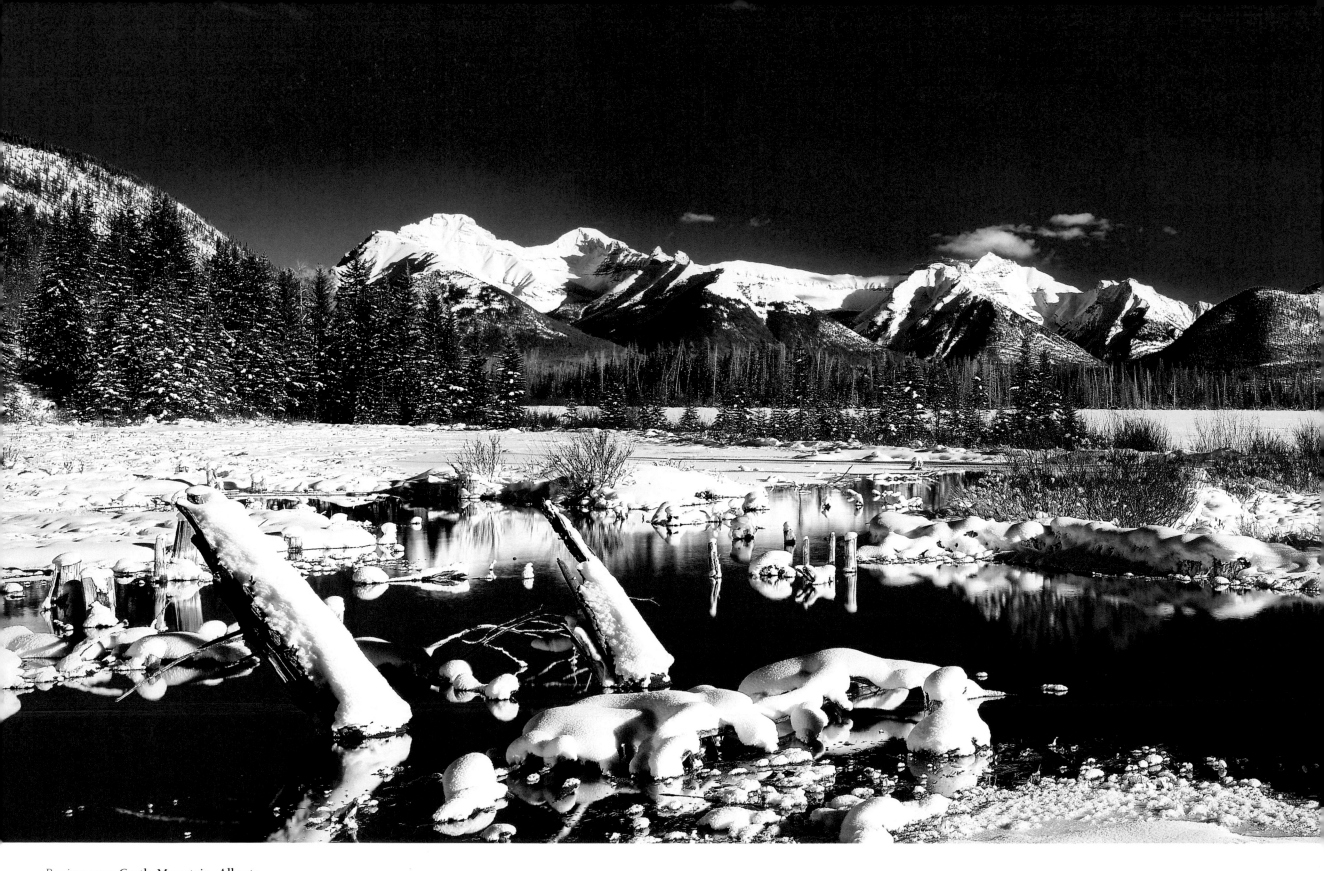

Previous page: **Castle Mountain, Alberta**
One of my favourite places to spend Christmas is in
Banff National Park. Winter transforms the Rockies into
a pristine wonderland of frosted trees, icy fog, and
snowy blue shadows that contrast vividly with the low
warm light of December. This is a view of Castle
Mountain and the Bow River.

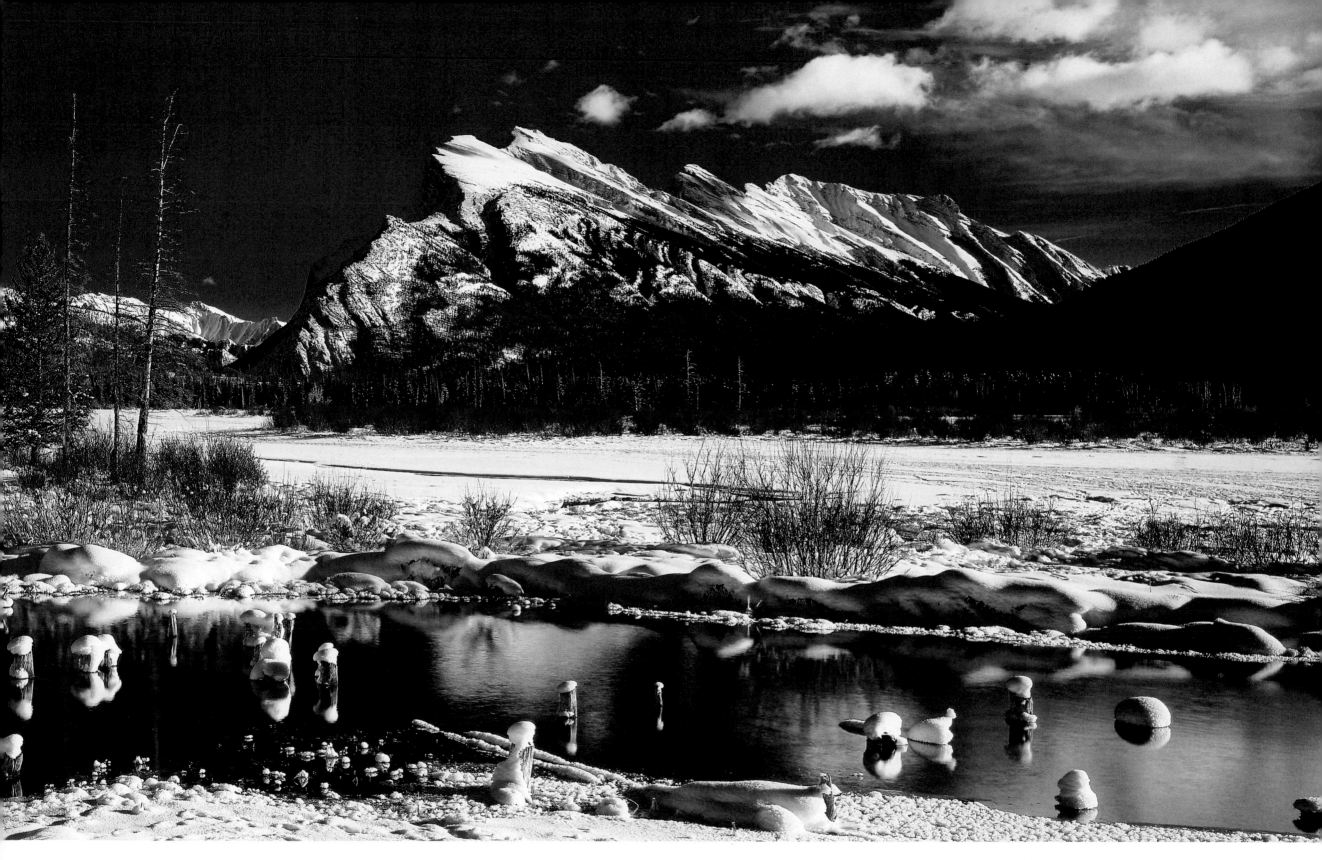

Vermilion Lake, Alberta
Picture-perfect scenery lures more than four million
visitors annually to Banff National Park. Even with such
intense tourist pressure the park remains remarkably
unspoiled as this scene from the second Vermilion Lake
near the Banff townsite attests.

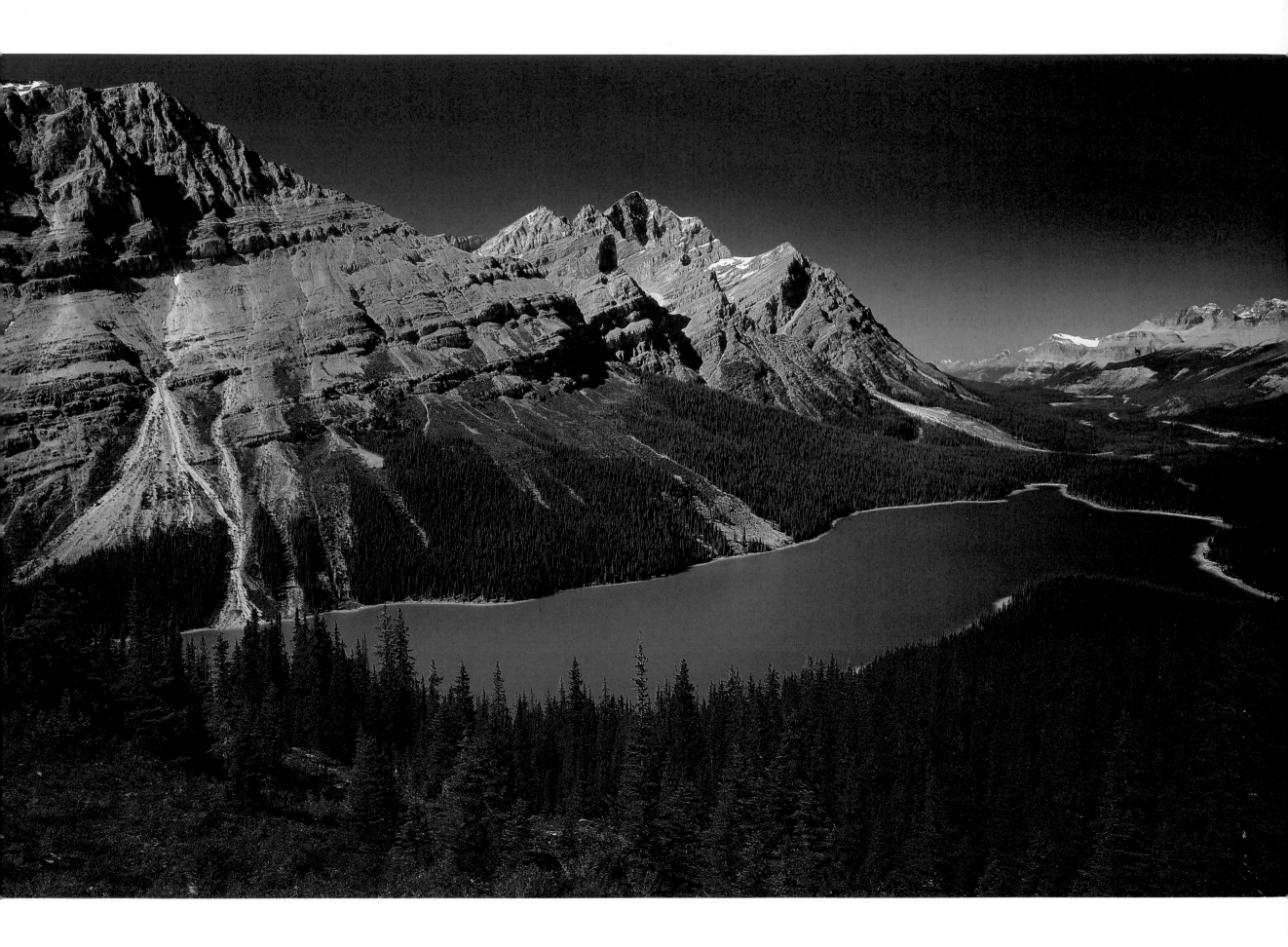

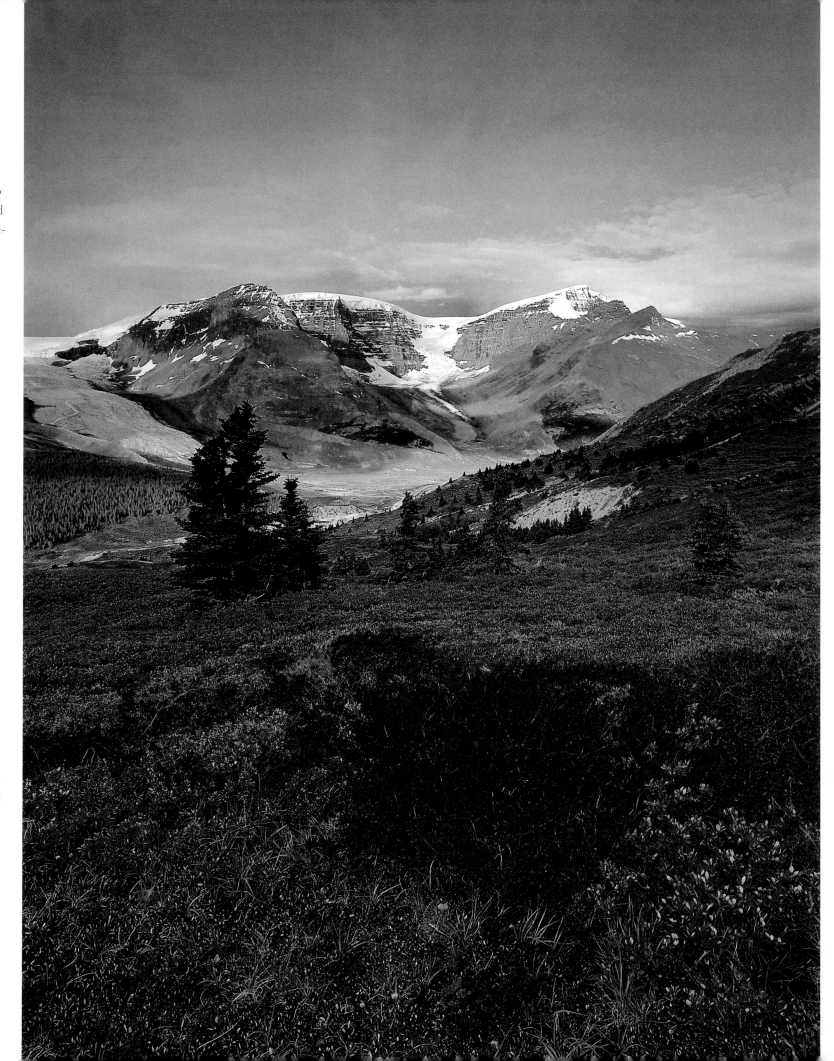

Left: **Peyto Lake, Alberta**

The three most-photographed scenes in Alberta are Lake Louise, Moraine Lake, and Peyto Lake. Almost every visitor to Banff shoots one or all of them. In an attempt to get a different perspective, I hiked down the steep two-kilometre trail to the shoreline of Peyto Lake. Although it was pleasantly tranquil, I discovered that the vista from above was far more pleasing. Sometimes the familiar view remains the best.

Right: **Wilcox Pass, Alberta**

One of the most scenic drives in North America is from Lake Louise to Jasper along the Icefields Parkway. A highlight is the Columbia Icefields where the Athabasca Glacier plunges down to meet the highway. Most visitors spend time down near the glacier, but a short hike up the Wilcox Pass trail leads to stunning aerial panoramas of the Athabasca Glacier, the Snow Dome, and Mount Kitchener. Along the way you are sure to see bighorn sheep grazing the alpine meadows, colourful wildflowers in late July, and fall colours by the end of August.

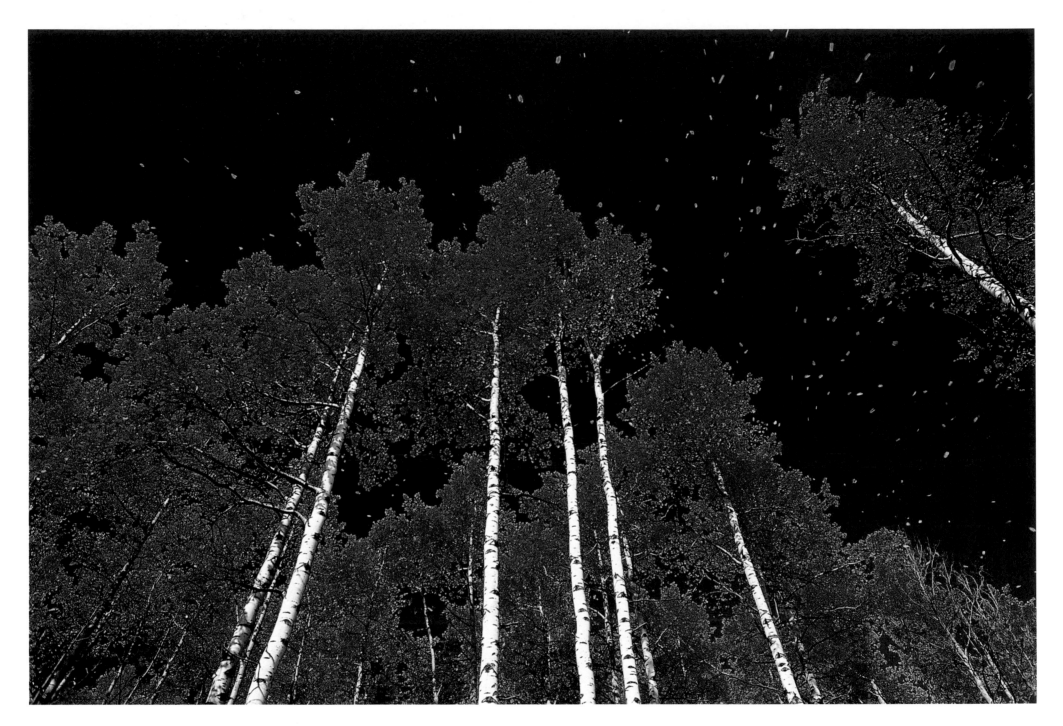

Turner Valley Area, Alberta

In the west, fall is about blue and gold: the brilliant golden yellow of trembling aspen shimmering jewel-like against a rich blue September sky. For me, this photograph of falling leaves on a sunny day near Turner Valley captures the true glory of the western fall. I can almost feel the crisp bite of the air and hear the distant honking of migrating geese.

Right: **Leduc Area, Alberta**

Some of my best photographs are of the pastoral countryside around Leduc, not because the landscape is extraordinary, but because I live here and can go out and shoot whenever the light paints the landscape with an artist's palette. Here new spring growth contrasts with the golden browns of last season. An early morning fog and the glow of dawn work in concert to transform an otherwise ordinary landscape into a painterly scene.

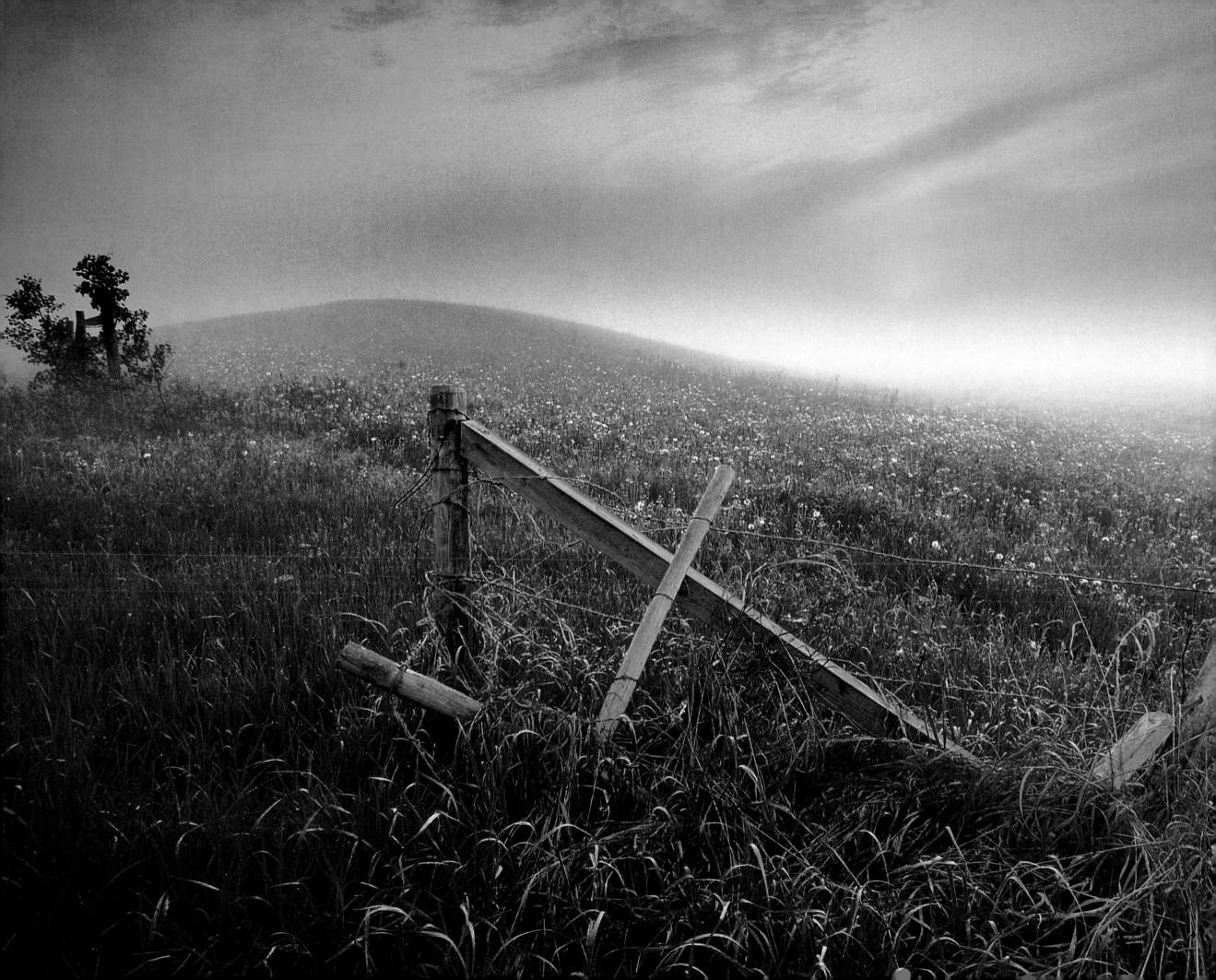

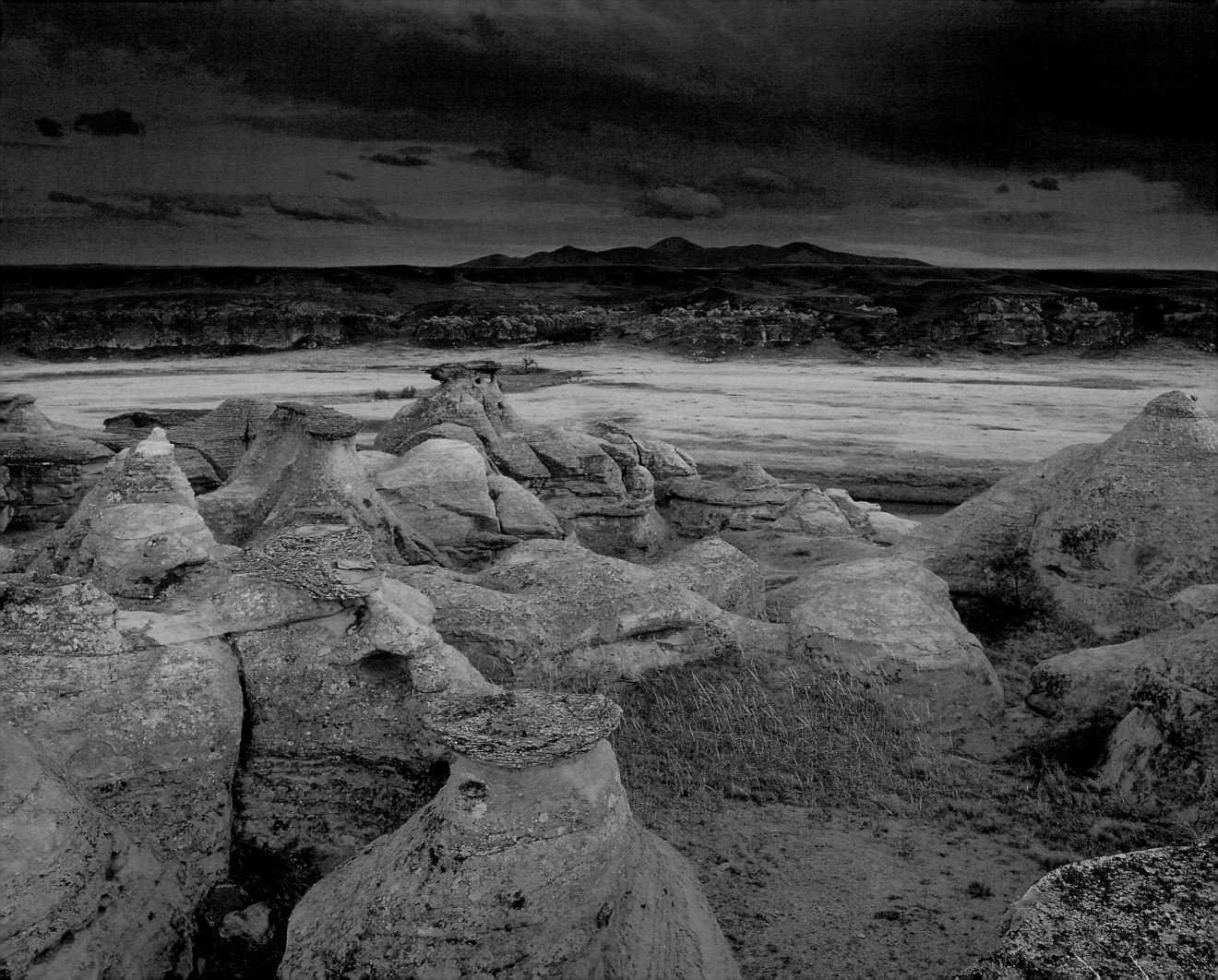

Left: **Writing-on-Stone Provincial Park, Alberta**

Writing-on-Stone Provincial Park in southern Alberta is home to some of the most strange and eerie landforms in Canada. Sandstone-capped pillars called hoodoos, deep crevices, baked earth, and bulbous mounds give this landscape a distinctly alien look. Within the park are twenty-two rock carving and painting sites, the largest concentration of native "writings" on the North American plains. Whenever I visit this park I sense a strong spirituality. Maybe it's just the strange landscape, but something about this place is powerfully attractive. How else can you explain all that rock art?

Right: **Dry Island Buffalo Jump, Alberta**

Few areas can rival the diversity of landforms and habitat of this small park. Dry Island Buffalo Jump Provincial Park has aspen forests, prairie bluffs, eroded badlands, a rich riparian habitat, and drop-dead vistas from the high cliffs bordering the park. In the past, buffalo, herded here by native hunters, plunged to their deaths over these same cliffs. Today the park is a quiet retreat for the few visitors who manage to discover its beauty.

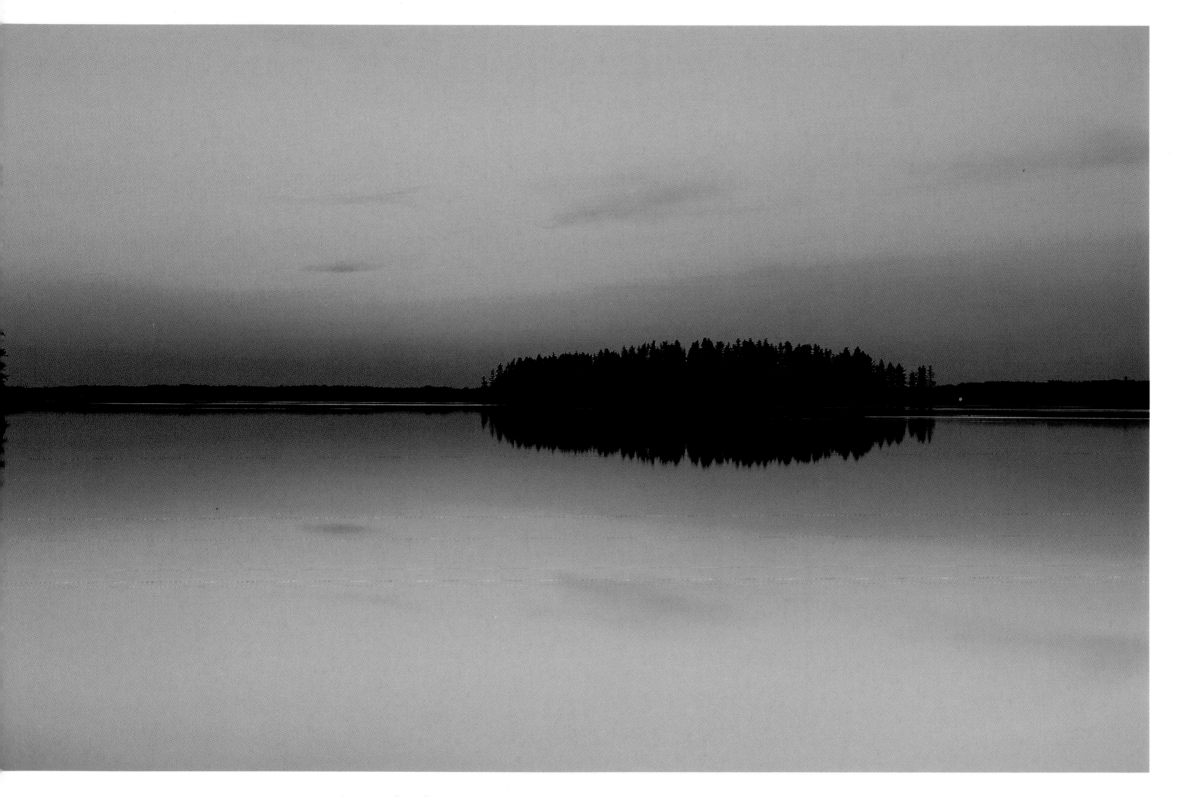

Astotin Lake, Alberta

Thirty minutes from Edmonton, surrounded by a patch-work of agricultural land, is a wilderness oasis called Elk Island National Park. The park is famous for its high concentration of elk, moose, and bison. I've seen as many moose and elk here in a single morning as I'd expect to see over a whole season driving around the rest of the province. Just as common as the big game are the colourful sunsets over the park's many lakes and sloughs. My favourite spot is at Astotin Lake along the boardwalk near the interpretive centre.

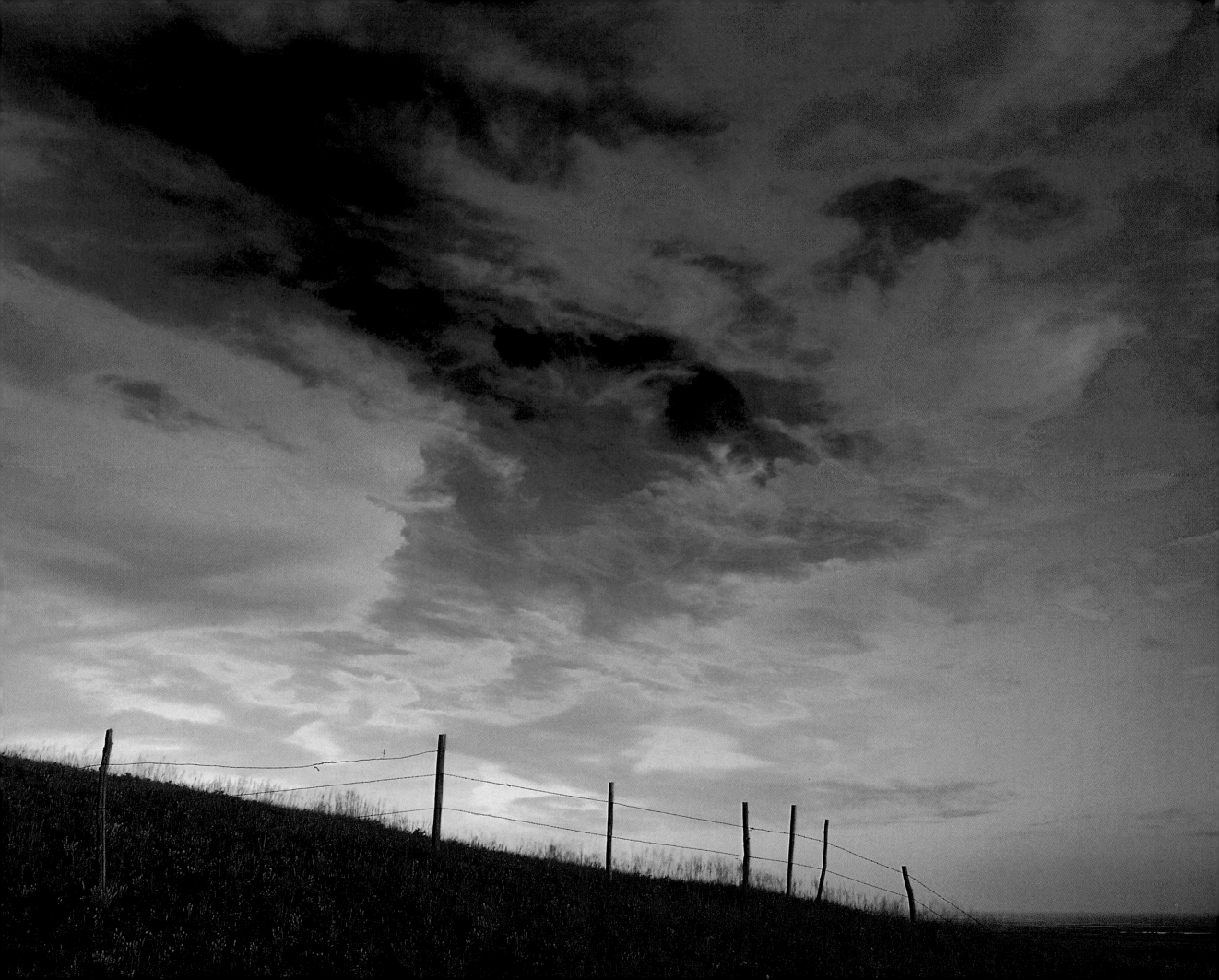

SASKATCHEWAN

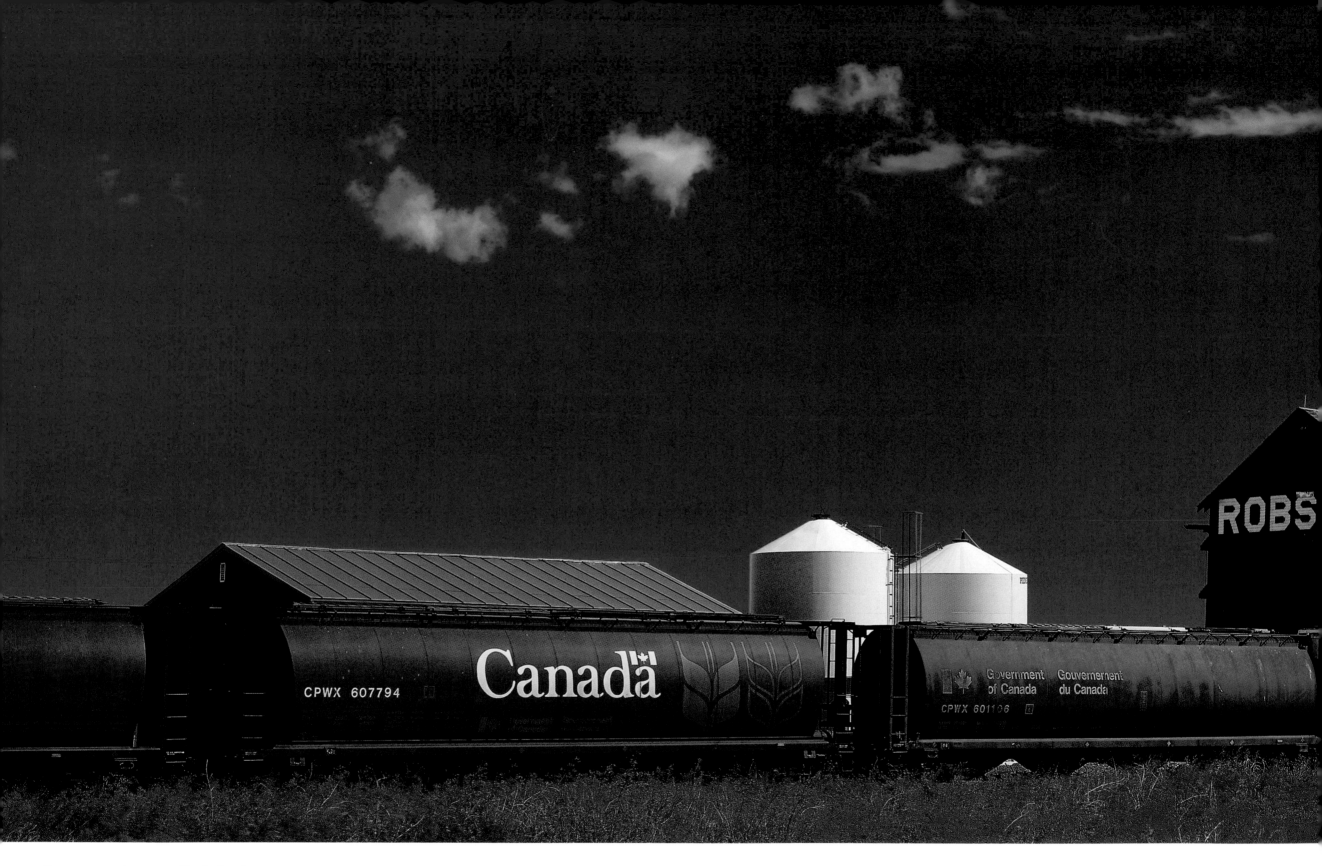

Previous page: **Cypress Hills, Saskatchewan**

The Cypress Hills of southwest Saskatchewan reach a height of 1392 metres — the highest point of land between the Rockies and Labrador (higher than Banff). Among these rolling hills and high plateaus lie forested highlands, grassy meadows, and spectacular views. This photo of a meadow fenceline reaching up to the sunset sky is symbolic of the soaring sense of space I feel whenever I visit this area.

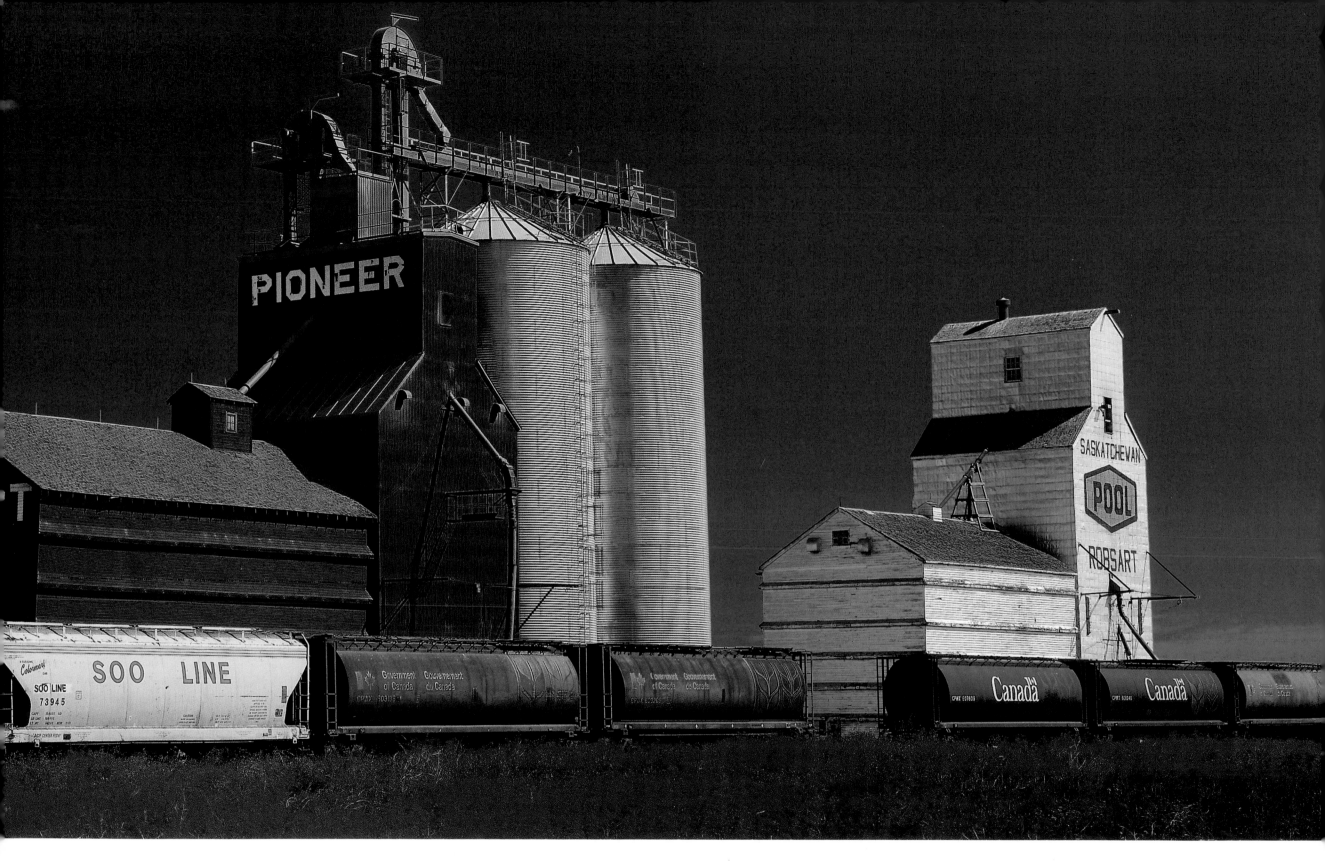

Robsart, Saskatchewan

In the southwest corner of Saskatchewan sits the quiet little town of Robsart. Pictured here is the busy grain terminal, but the town itself is full of vacant houses; many are still filled with furniture, the curtains open, the table set, and the calendars on the wall all reading "June 1955." It's as if some alien force abducted entire families from this sleepy little town. When I asked a local where everyone went, he just shrugged and pointed to the sky.

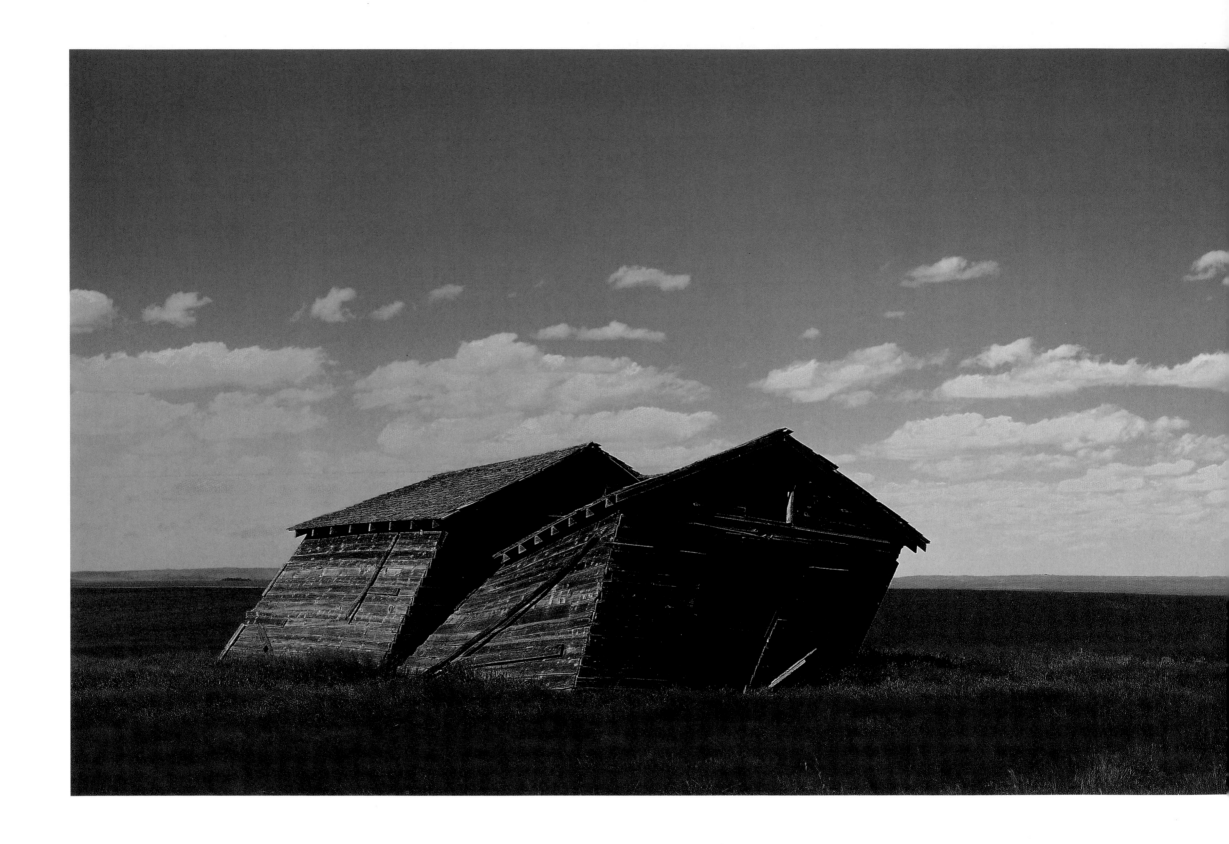

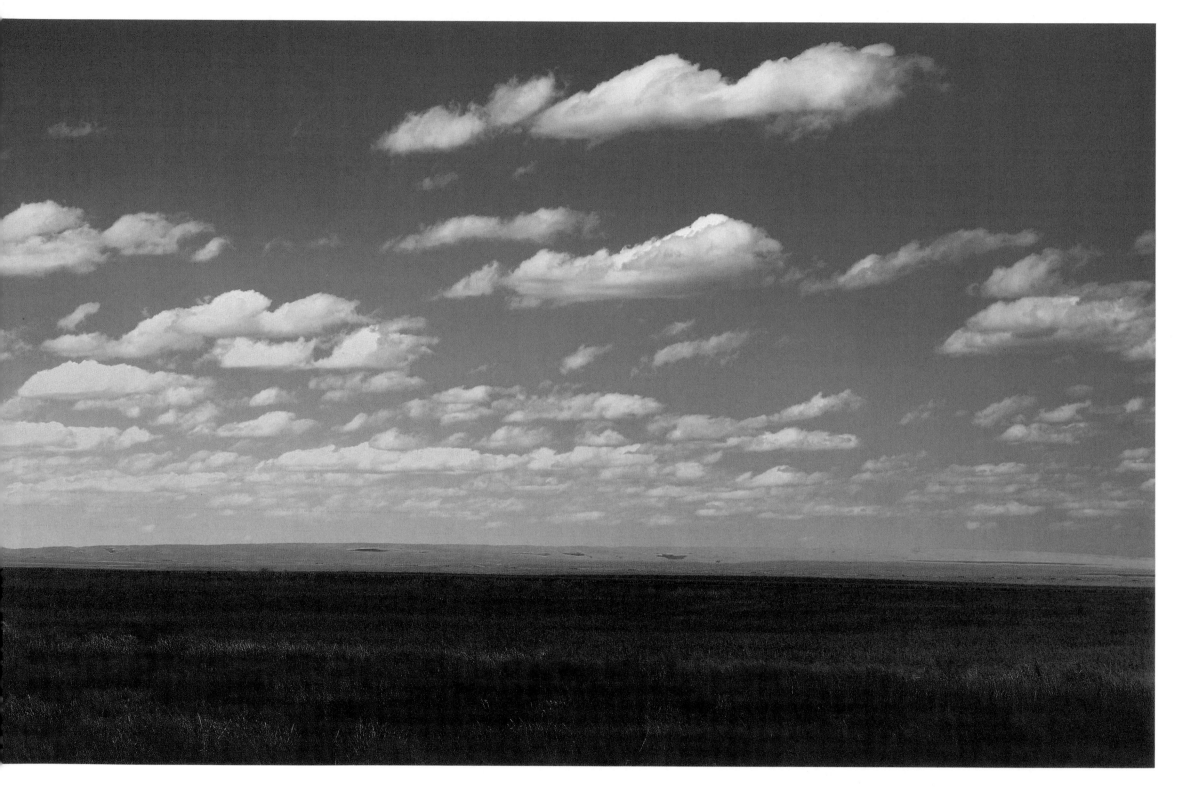

Val Marie Area, Saskatchewan
In southern Saskatchewan the wind is a constant companion. The instant I saw these leaning buildings near Val Marie, I knew I could finally visually represent, in a still image, the unrelenting power of the prairie wind.

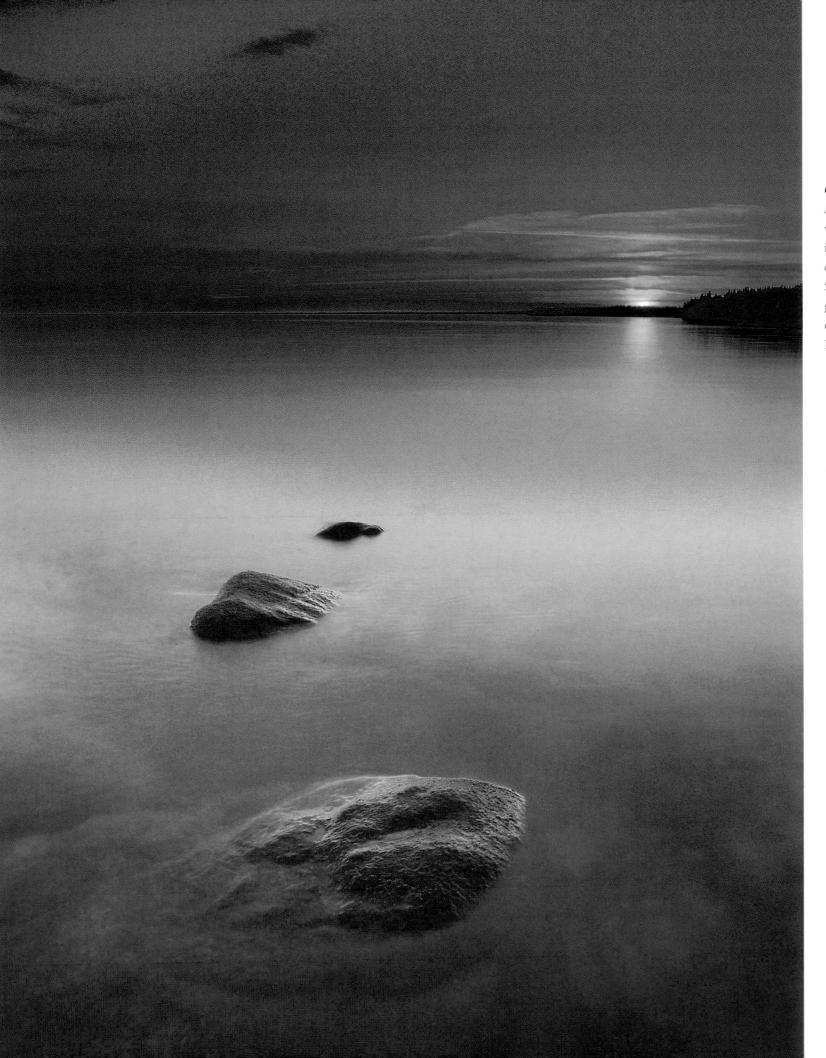

Cold Lake, Saskatchewan

Although most Canadians think of Saskatchewan as wide open prairie, nearly two-thirds of the province is covered by forest. With over 33 million hectares of forest and thousands of clear blue lakes, northern Saskatchewan is truly one of North America's last great escapes. This photo of Cold Lake is taken in one of the province's more accessible northern parks, Meadow Lake Provincial Park.

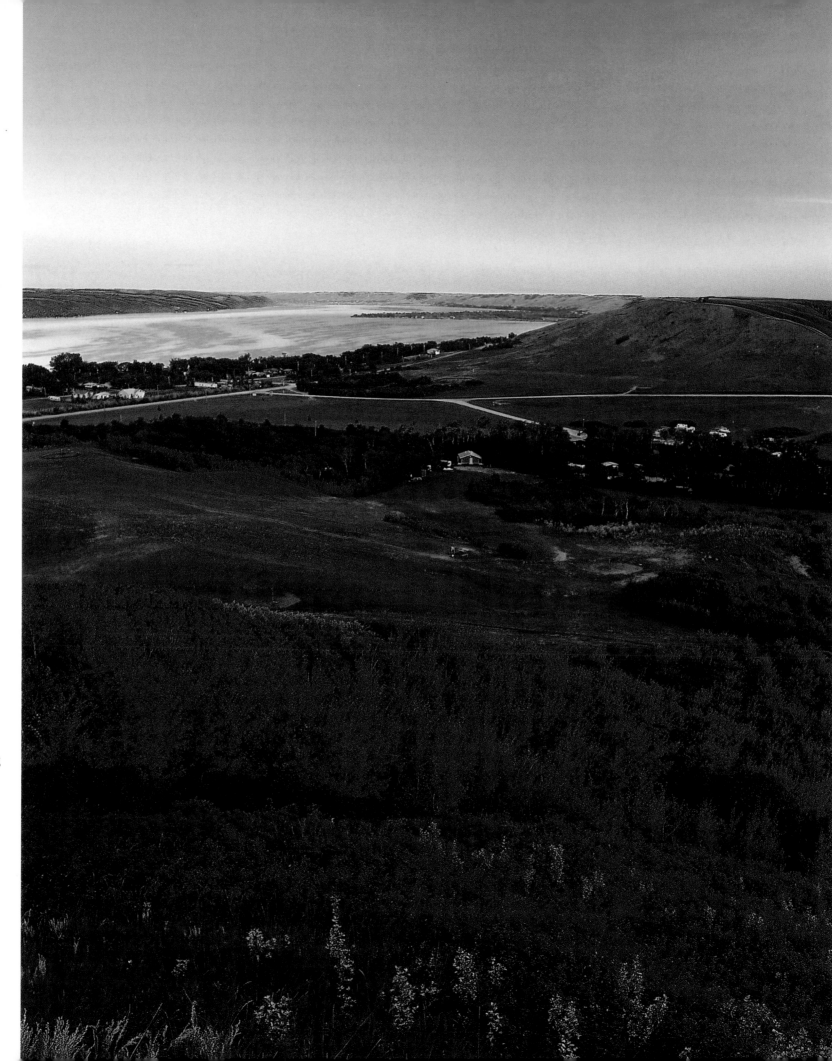

Qu'Appelle Valley, Saskatchewan
The Qu'Appelle Valley is a sunken oasis carved out of the prairie by torrents of glacier-born water. Stretching two-thirds of the way across Saskatchewan, the valley is now a giant playground with resort villages, campgrounds, marinas, golf courses, and provincial parks. This overview shows part of the village of Katepwa Beach, a popular vacation spot on the Fishing Lakes.

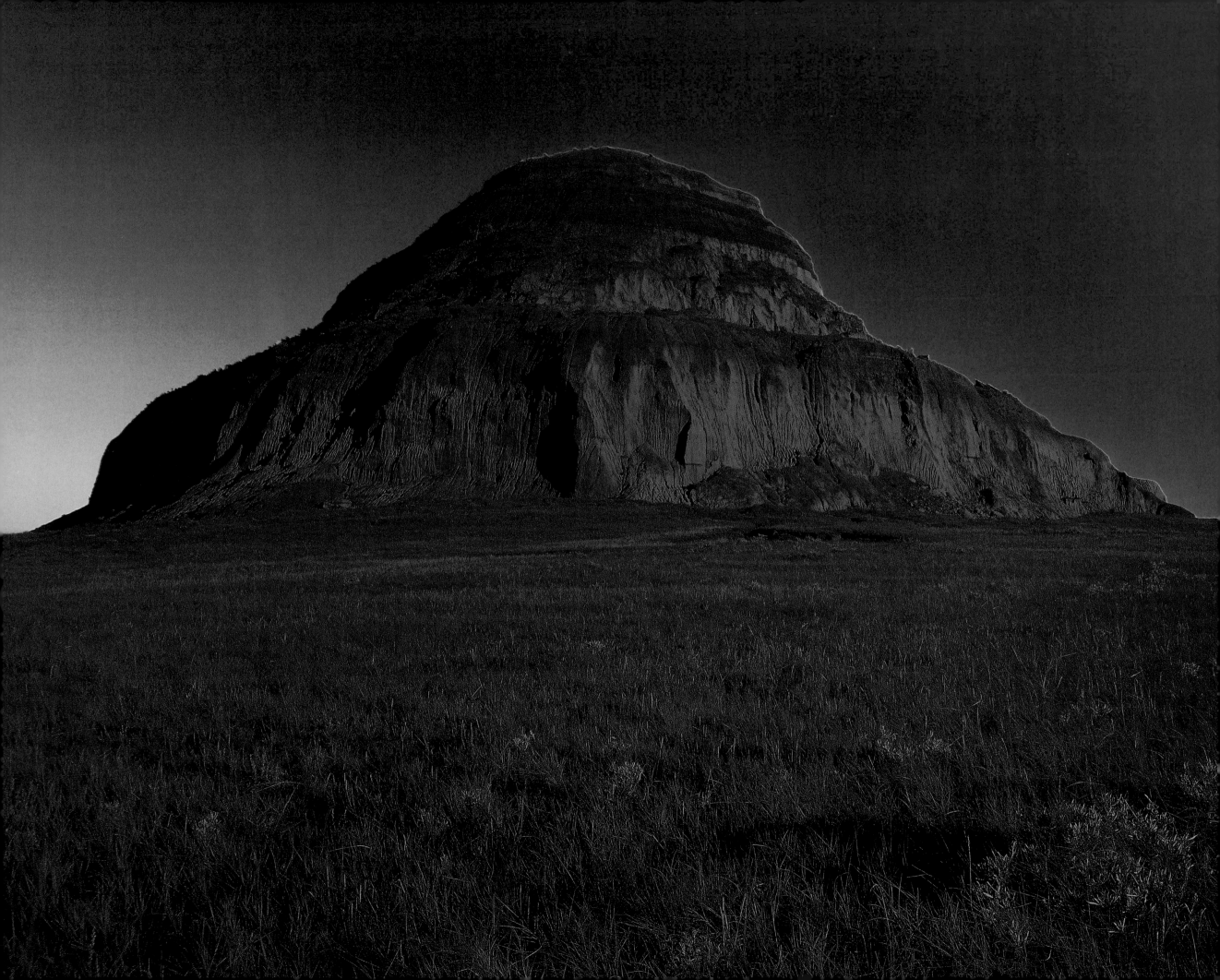

Left: **Big Muddy Badlands, Saskatchewan**

At the turn of the century the badlands along the Big Muddy River made a perfect hideout for road agents, horse thieves, and stagecoach robbers. The most infamous of these outlaws was Butch Cassidy. You can drive through the badlands and tour the caves and hideouts of Dutch Henry, the Jones-Nelson gang, and Sam Kelly and the Wild Bunch, but the only outlaws left slithering around these parts now have a rattle for a tail and a nasty venomous bite.

Right: **The Great Sandhills, Saskatchewan**

Although it is not well known, areas covered by active sand dunes do exist in Canada. Two of the largest sites are in Saskatchewan. A remote 2000-square-kilometre area in the northwest corner of the province, on the south shore of Lake Athabasca, has some of the largest dunes in North America. A smaller but more accessible site lies just south of the town of Sceptre in southwest Saskatchewan. To visit these dunes, just ask for directions at the town visitor centre and within minutes you'll see scenes like this.

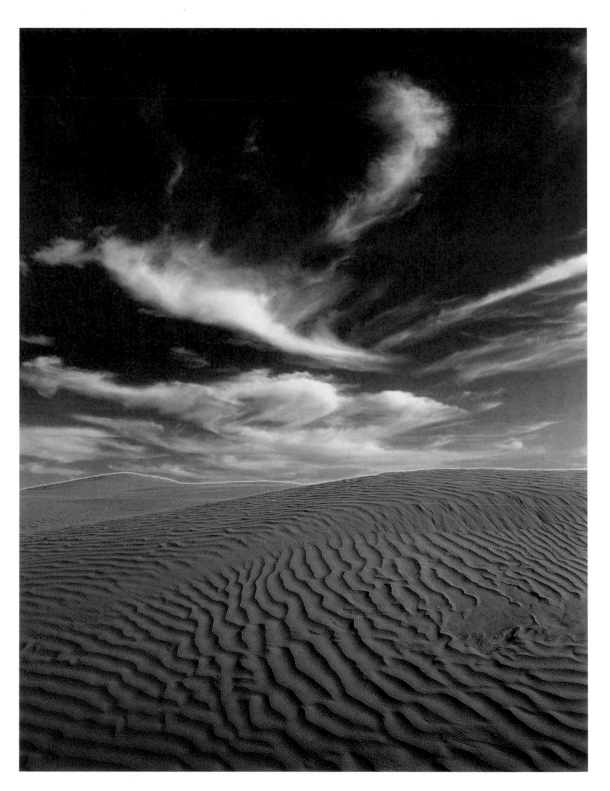

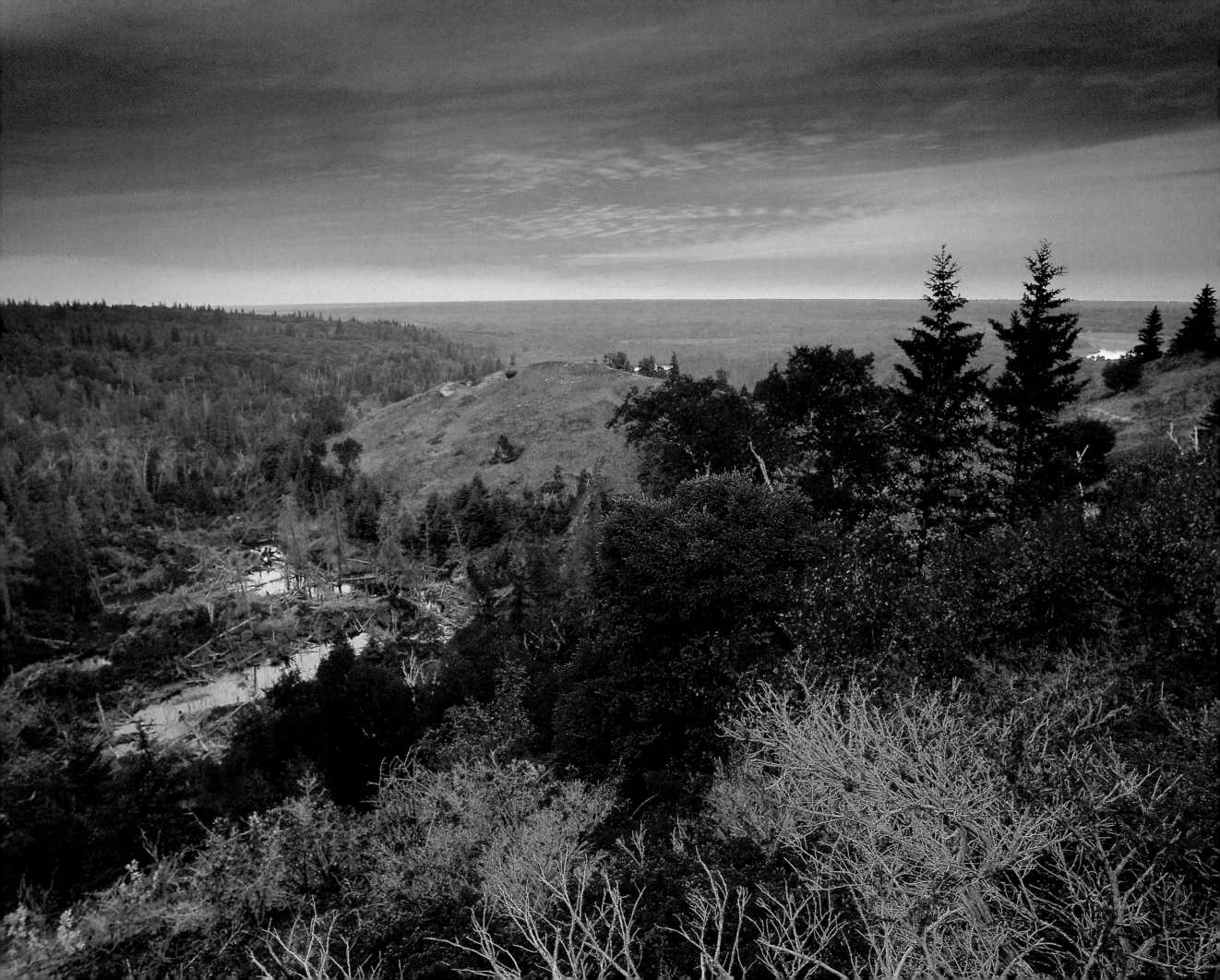

MANITOBA

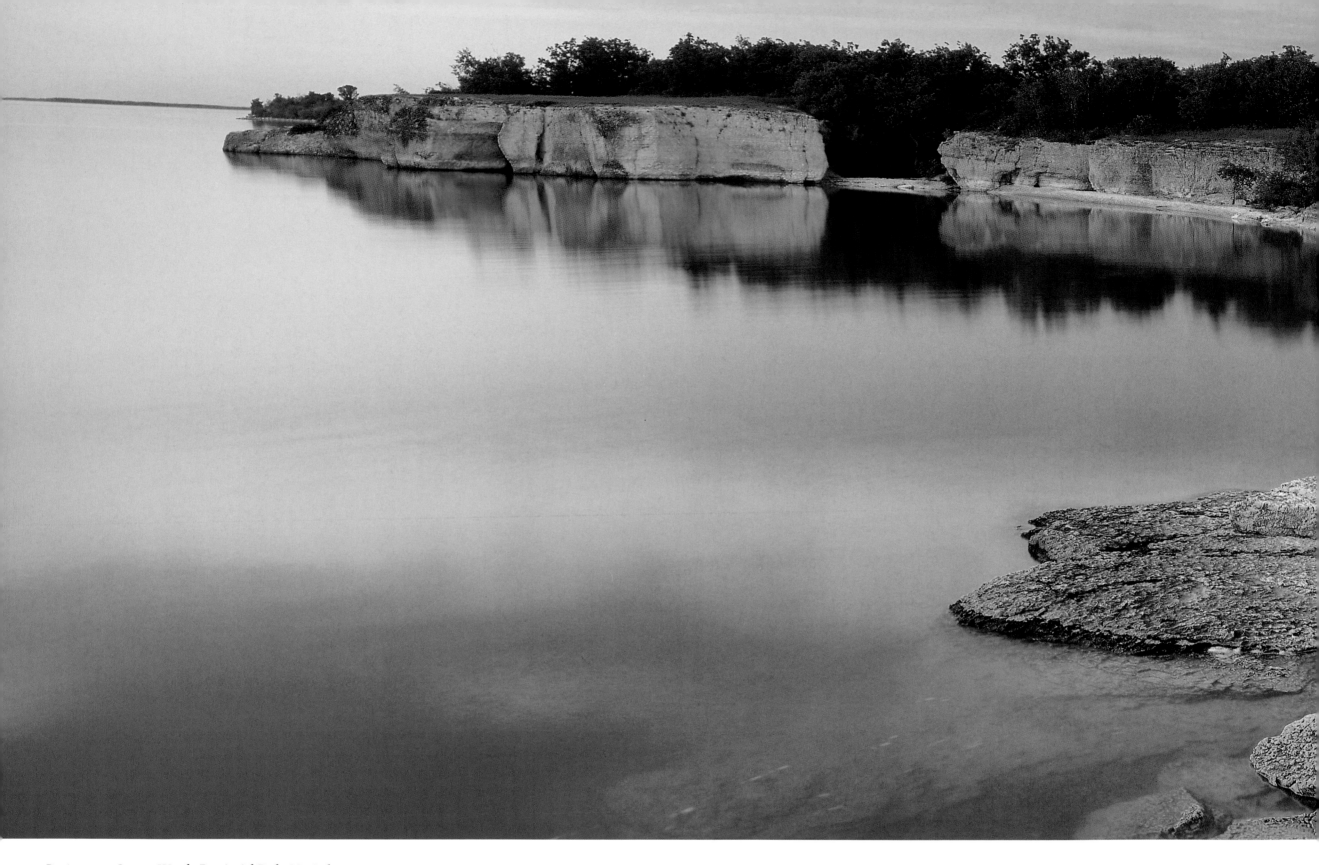

Previous page: **Spruce Woods Provincial Park, Manitoba**
This view of the Assiniboine River Valley from the "Hogsback" in Spruce Woods Provincial Park is special for me because it reminds me of my roots. My great-great-grandparents settled near here and helped clear and farm areas that are now part of the park. Nearly grown back to its natural state, there is little evidence that this land was once broken by the sweat of determined farmers.

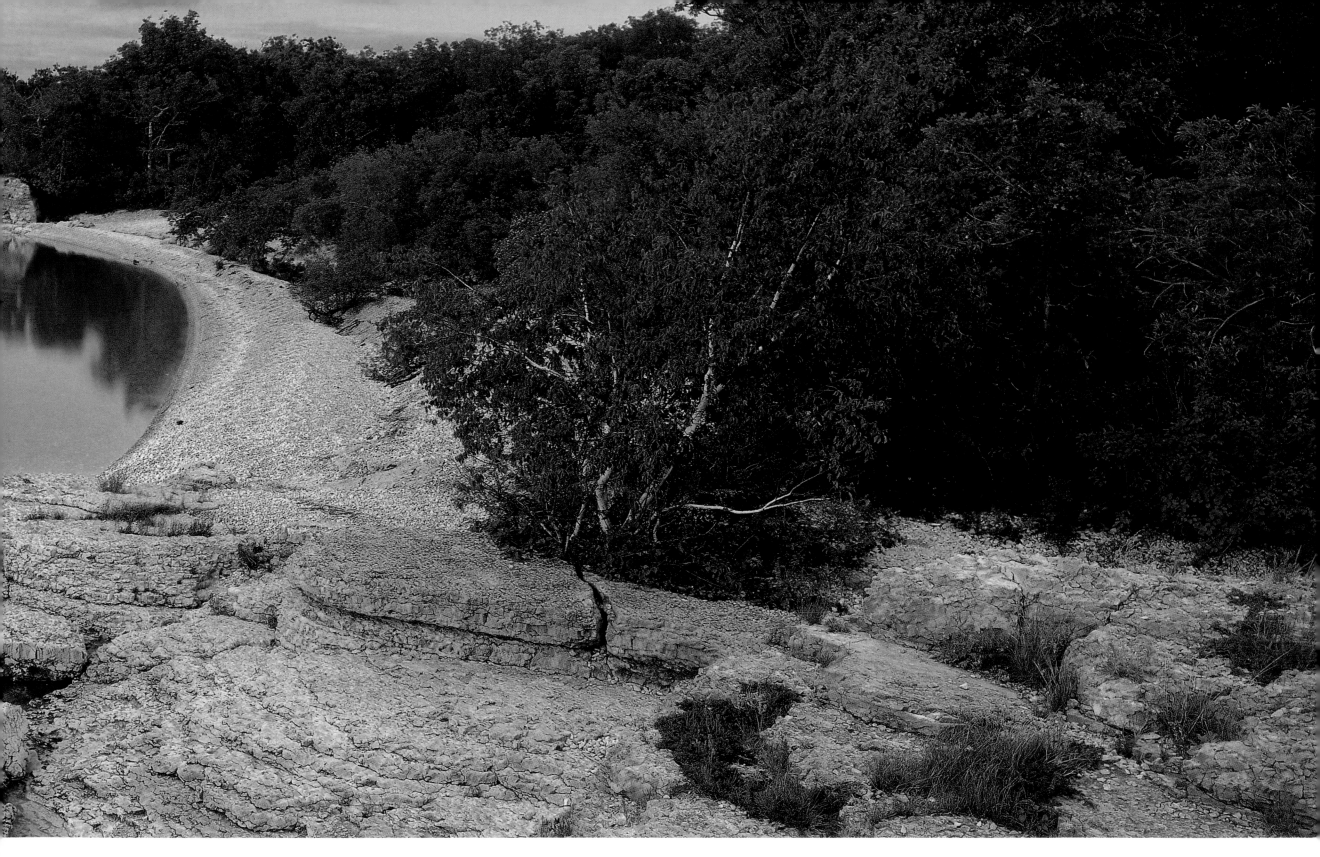

Portage Bay, Manitoba
Along the eastern edge of Portage Bay on Lake Manitoba, the limestone cliffs forge a jagged shoreline near the aptly named town of Steep Rock. I managed to capture the tranquillity of the lake before heavy black clouds of mosquitoes drove me to the refuge of my vehicle.

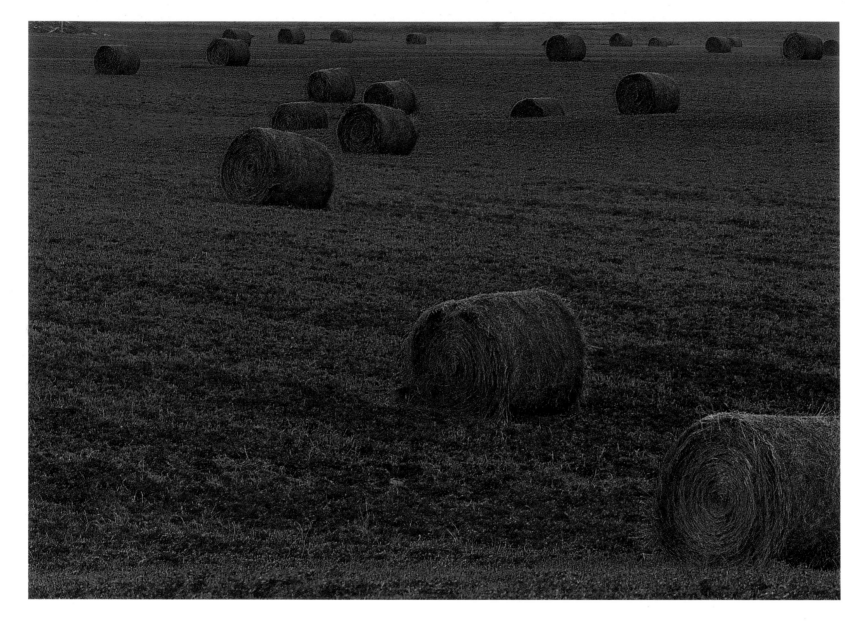

Minnedosa Area, Manitoba

Many photographers enjoy the rural mosaic of crop and pastureland in southern Manitoba. Fields of sky-blue flax, buttery canola, and golden wheat all demand to be photographed, but my favourite prairie subjects remain old barns and fields full of round hay bales. I shot these bales at sunset near Minnedosa in western Manitoba.

Right: **Holland Area, Manitoba**

Thunderstorms regularly rock southern Manitoba in June and July. One minute thunder crashes, lightning flashes, and the rain pelts down. The next minute the sun burns radiantly in a clear sky. While driving near Holland I saw these amazing dark storm clouds approaching, raced to the nearest canola field, and waited for the clouds to come into view. I only had time for three images before the storm closed in and drenched me with a solid wall of rain.

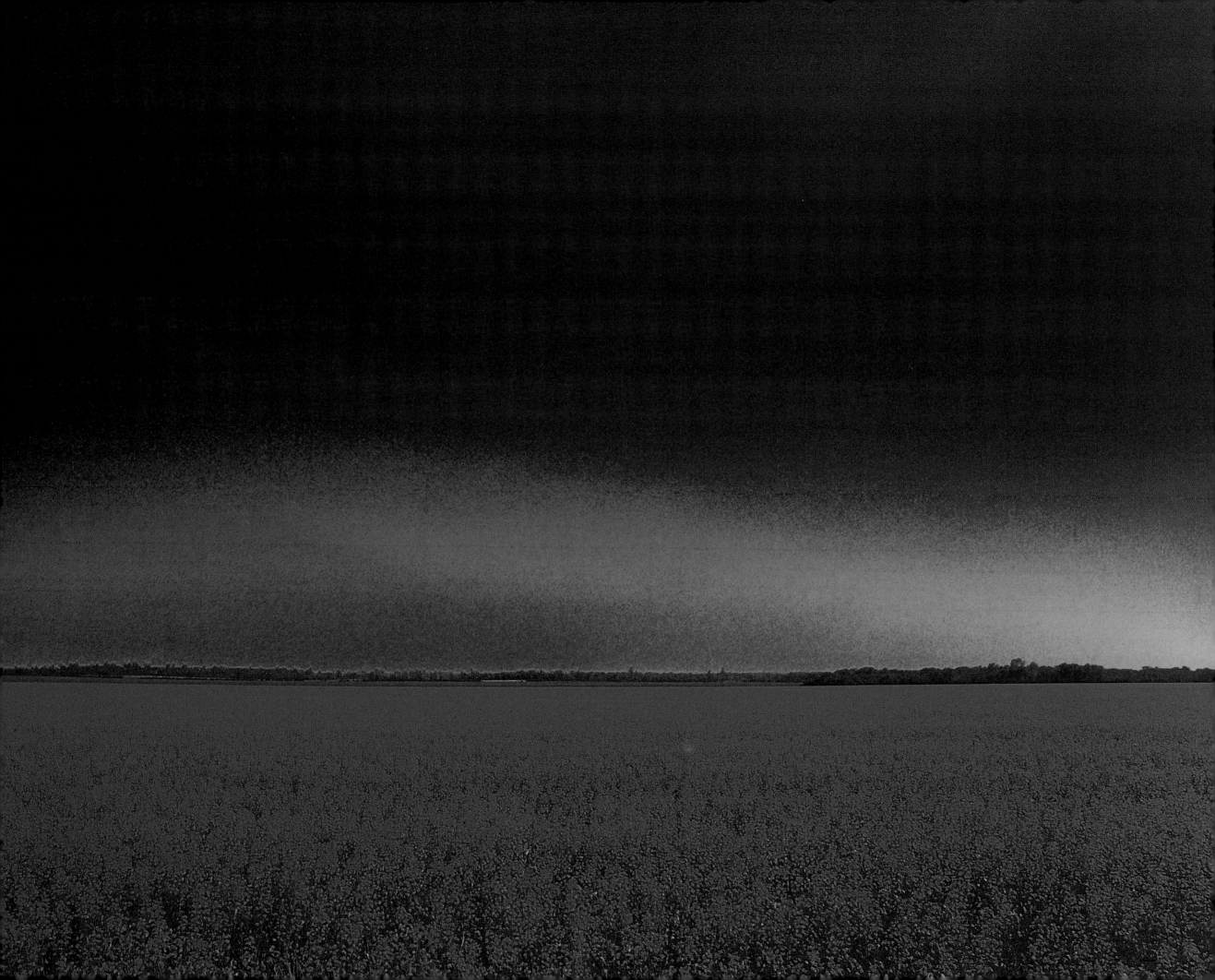

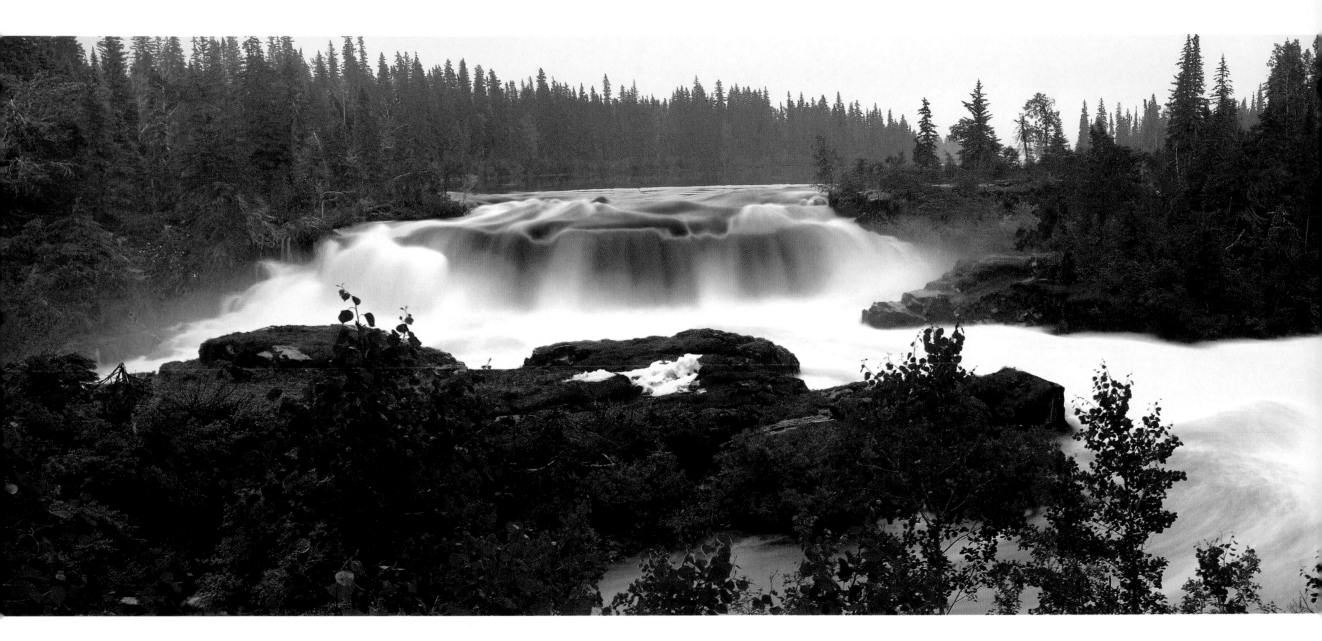

Pisew Falls, Manitoba
The Grass River, overburdened with spring runoff,
thunders over Pisew Falls, Manitoba's second-highest
waterfall. An elevated walkway and a large viewing
platform offer visitors safe access to this powerful
northern waterfall.

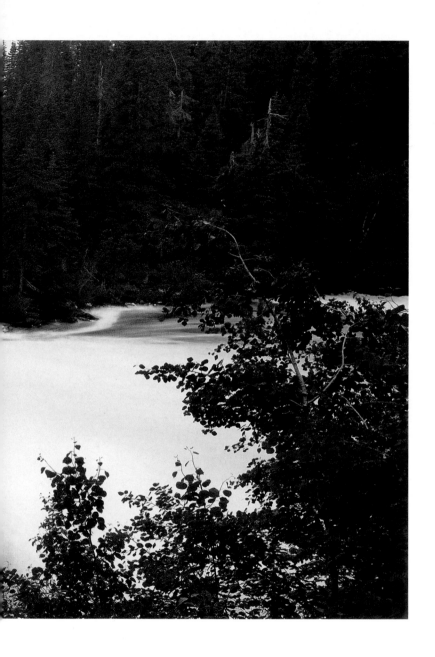

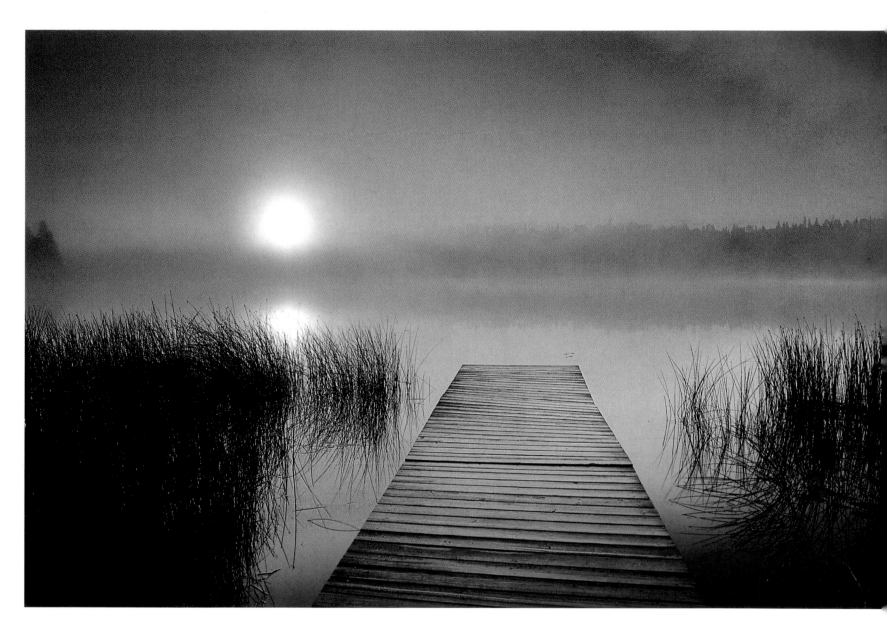

Grayling Lake, Manitoba
Sunrise is a magical time. I love to be up and out to watch the start of each new day. The world is calm, soft mists rise, and the light is absolutely sweet. Grayling Lake, a small, relatively nondescript lake in Riding Mountain National Park, is totally transformed by the mystical light of early morning.

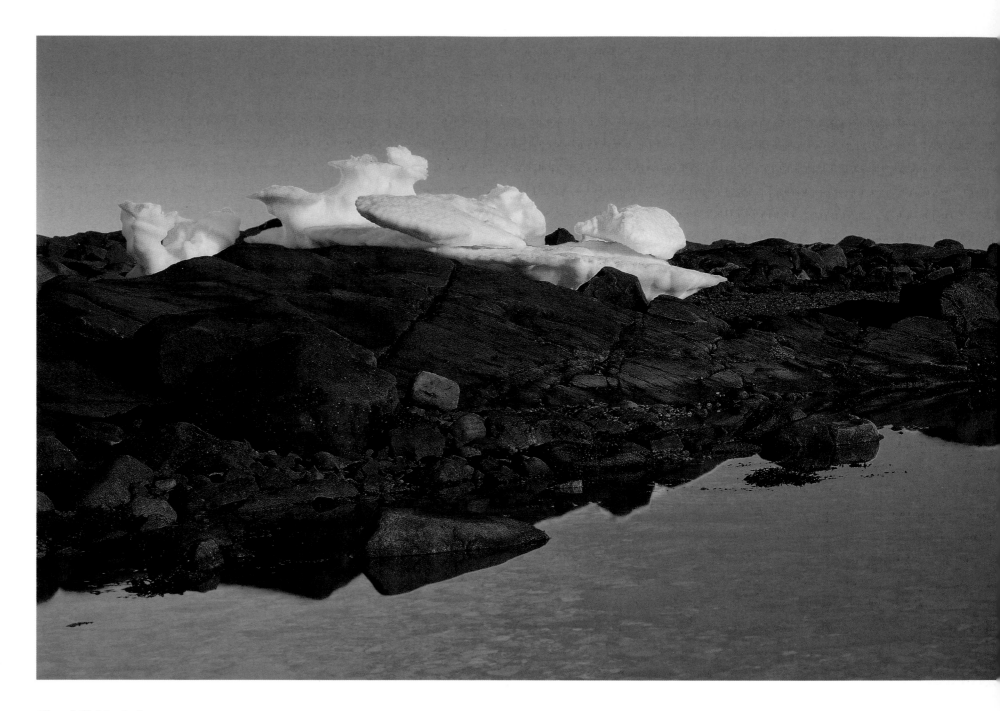

Churchill, Manitoba

Dubbed the polar bear capital of the world, Churchill is a landscape photographer's dream. Carpets of delicate tundra wildflowers, bound by polished outcroppings of the Canadian Shield and set against a backdrop of the icy Hudson Bay, make it easy to come away with striking photos. This image of ice stranded at low tide was made at 3:30 A.M., the start of another long northern summer day.

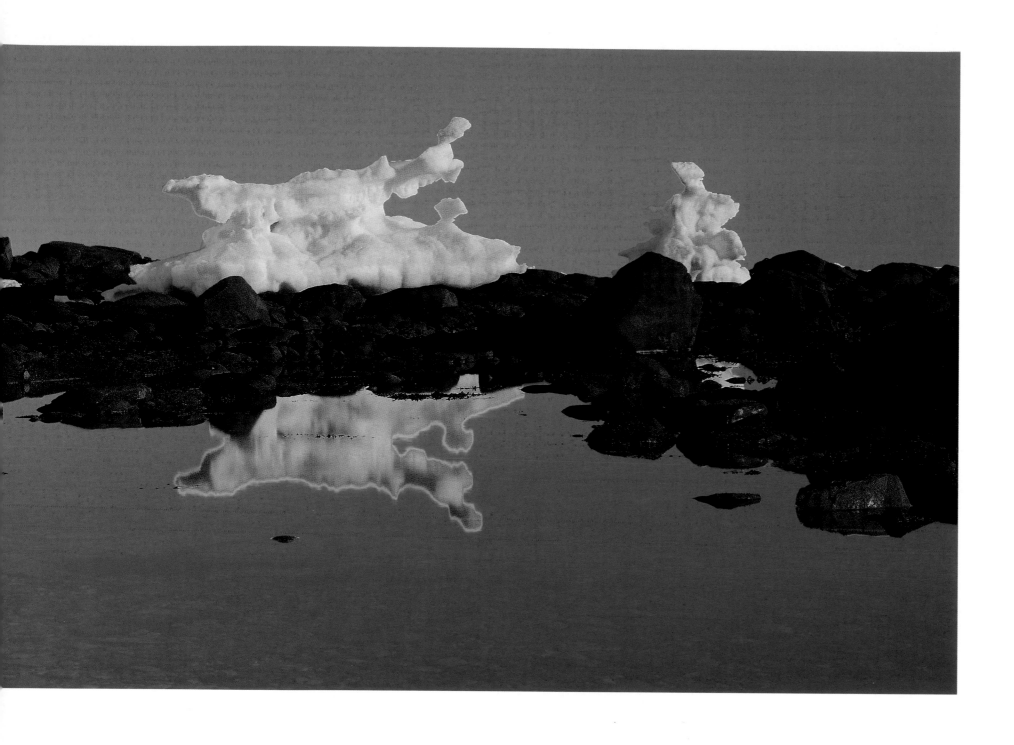

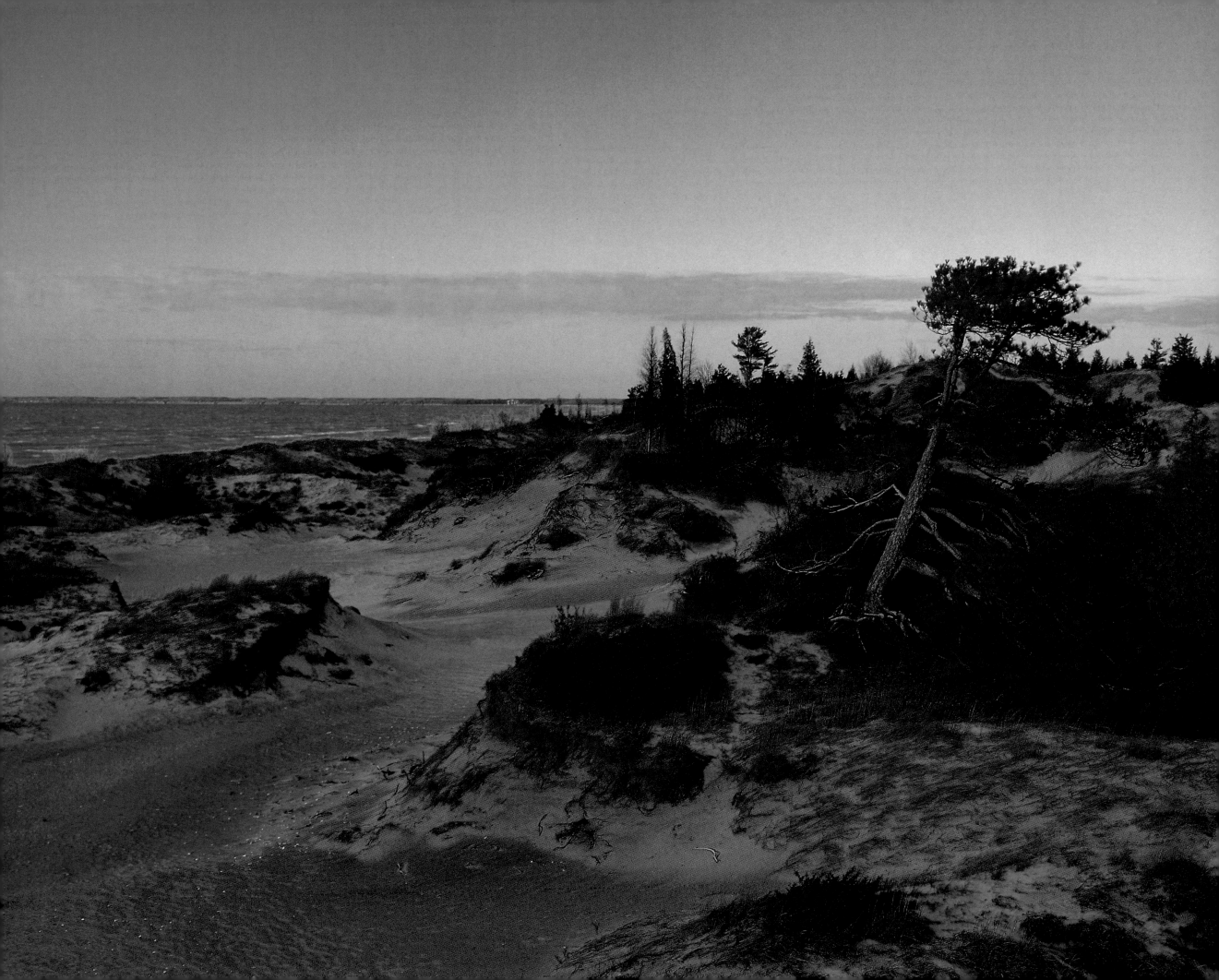

ONTARIO

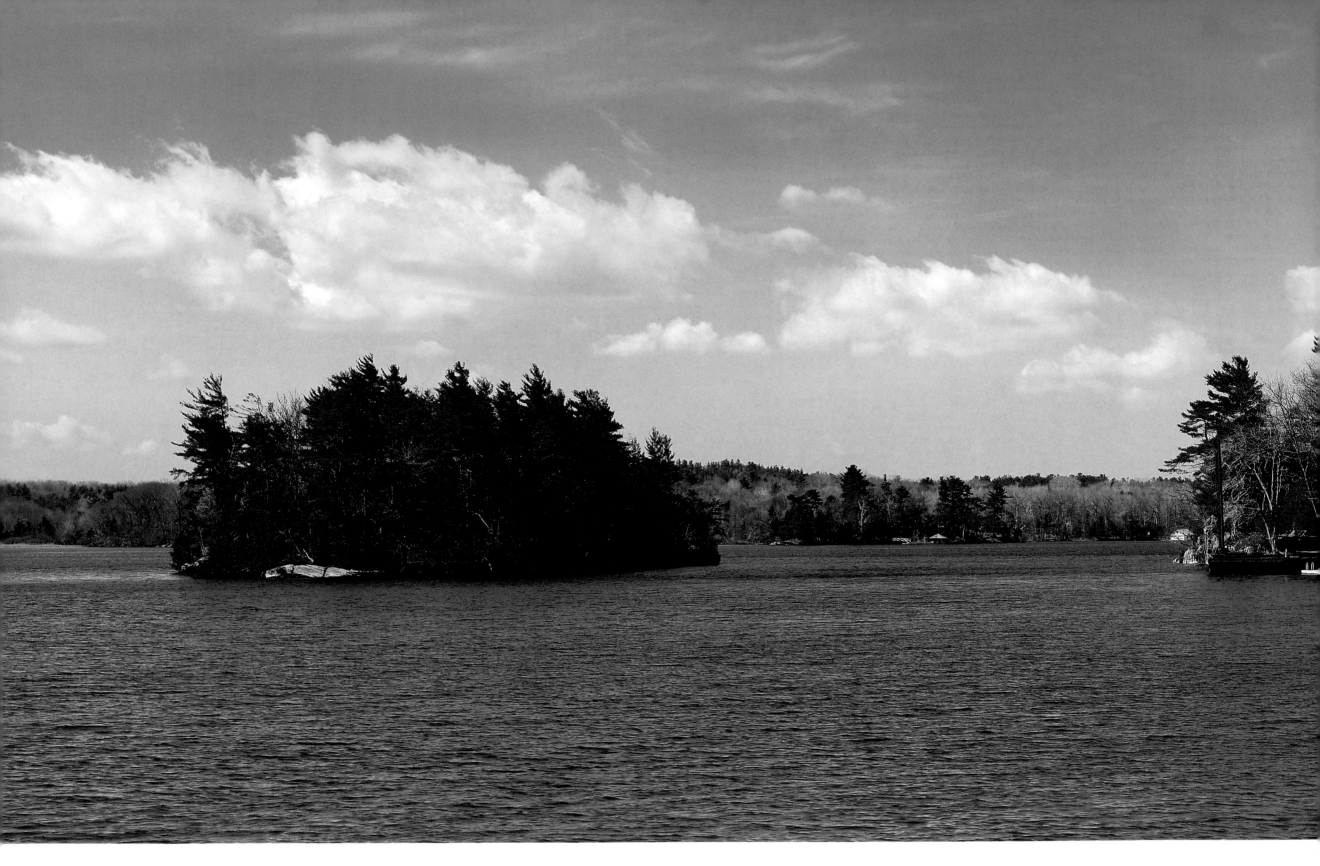

Previous page: **Lake Huron, Ontario**
On the eastern shore of Lake Huron near Grand Bend is Pinery Provincial Park. The park has sand dunes up to twenty-seven metres high that are home to the northernmost fringe of Carolinian forest. Along the shoreline active dunes with scattered clumps of trees and grasses cling to the wind-battered shore. Here low May sun colours the dunes at sunset.

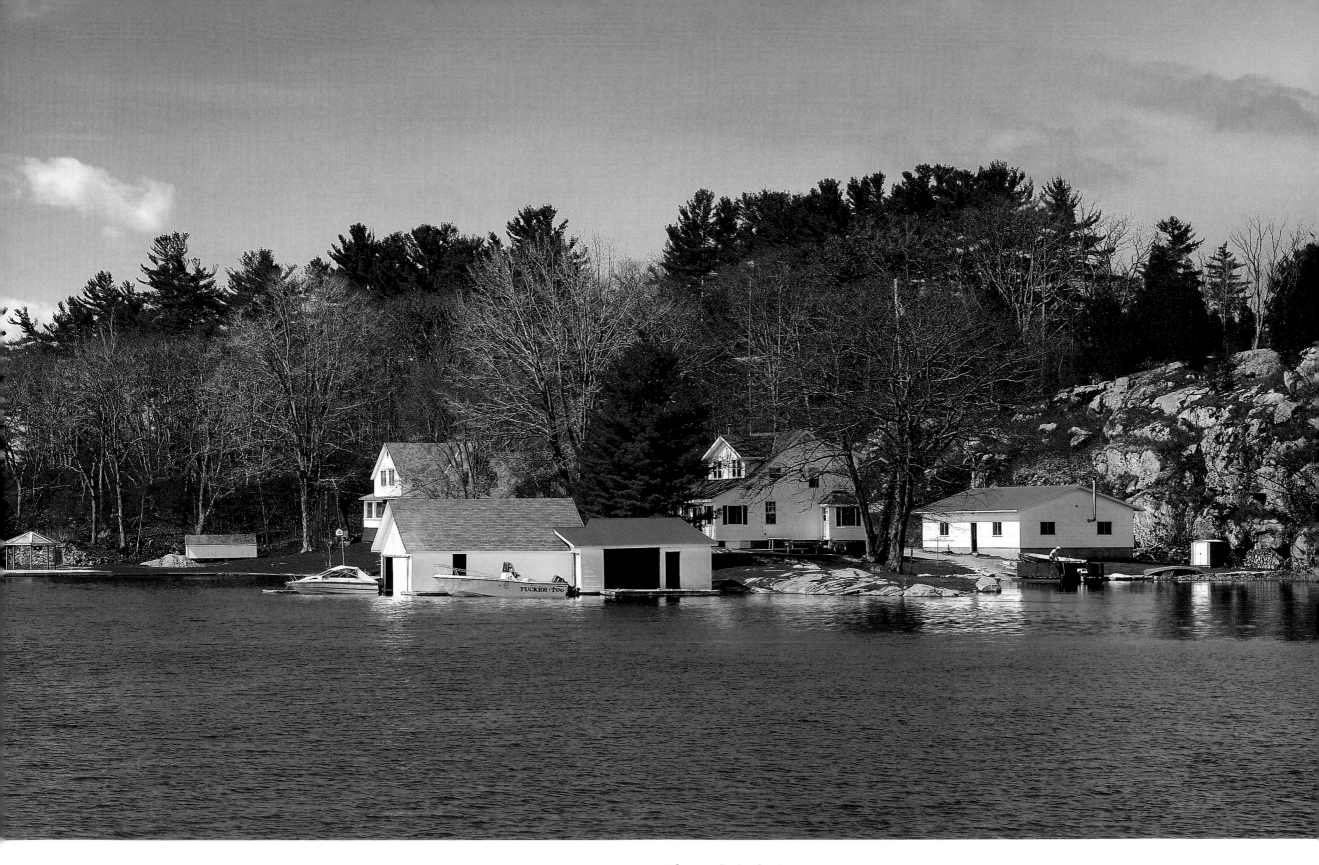

Thousand Islands, Ontario

Splashes of green on a river of blue decorate the fifty-six-kilometre stretch of the St. Lawrence River known as Thousand Islands. Some of the islands are lushly forested, while others are bare rock no larger than a house. Native legend says the Thousand Islands were created when paradise fell from the heavens and broke into hundreds of pieces. Today many of the islands are covered by cottages and homes where inhabitants have come to live on their own small piece of paradise.

Barron Canyon, Ontario

The mountains of western Canada aren't the only place where aerial panoramas of deep-walled canyons literally take your breath away. In Algonquin Provincial Park, 100-metre-deep Barron Canyon thrills both hikers and canoeists. Early one morning I was rewarded with this view as the sun underlit heavy clouds.

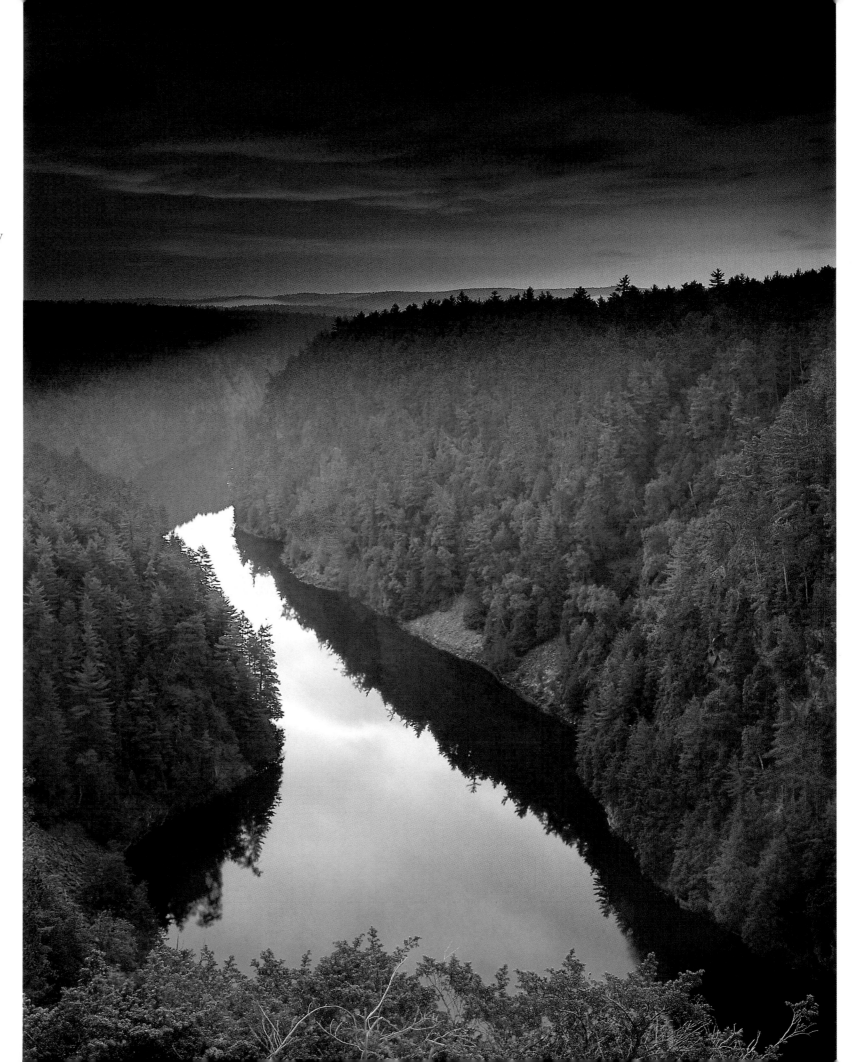

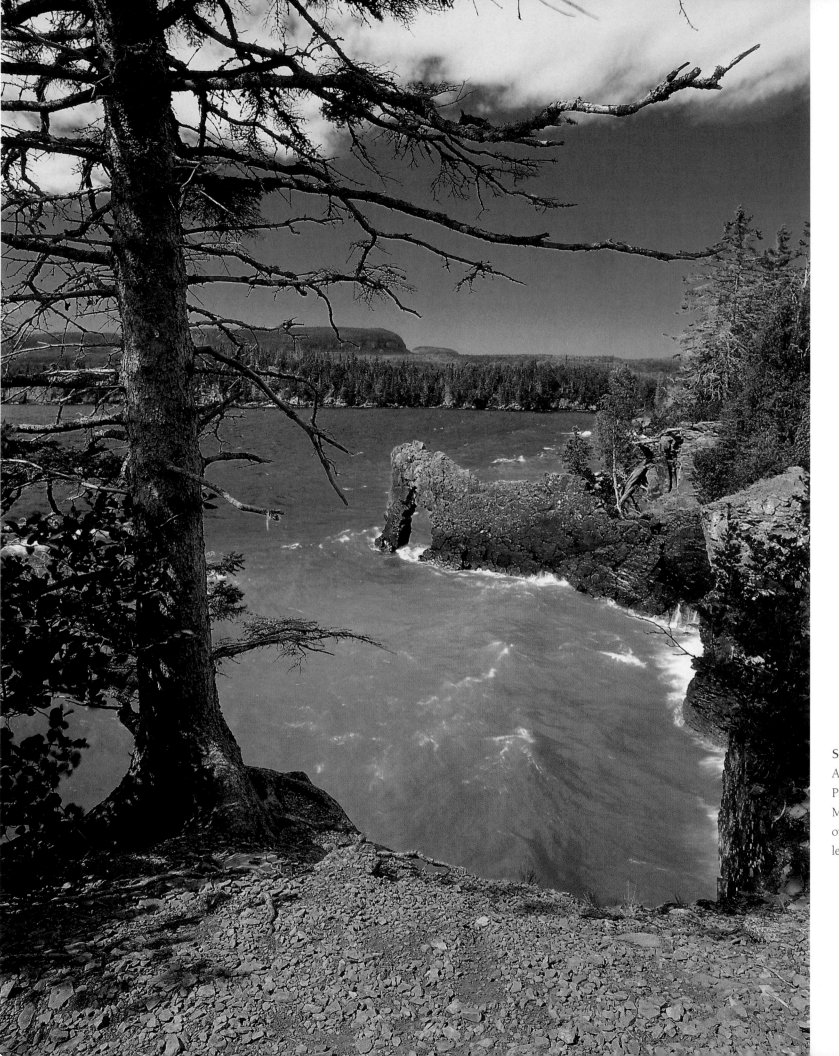

Sea Lion Rock, Ontario
A short hike to Perry Bay in Sleeping Giant Provincial Park leads to an arched rock known as the Sea Lion. Molten rock squeezed up into a crack, hardened, and over time the surrounding softer rock eroded away, leaving behind this remarkable landform.

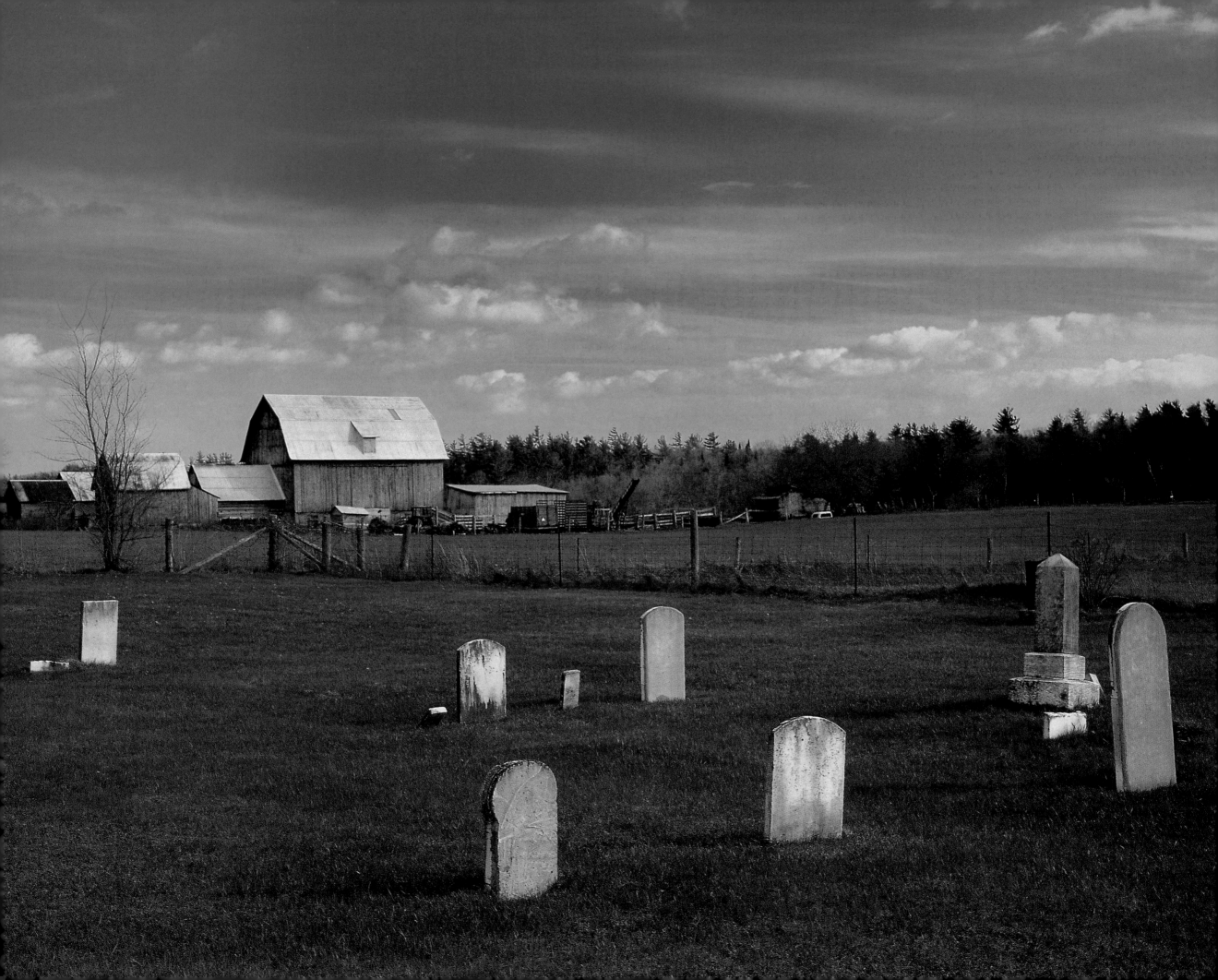

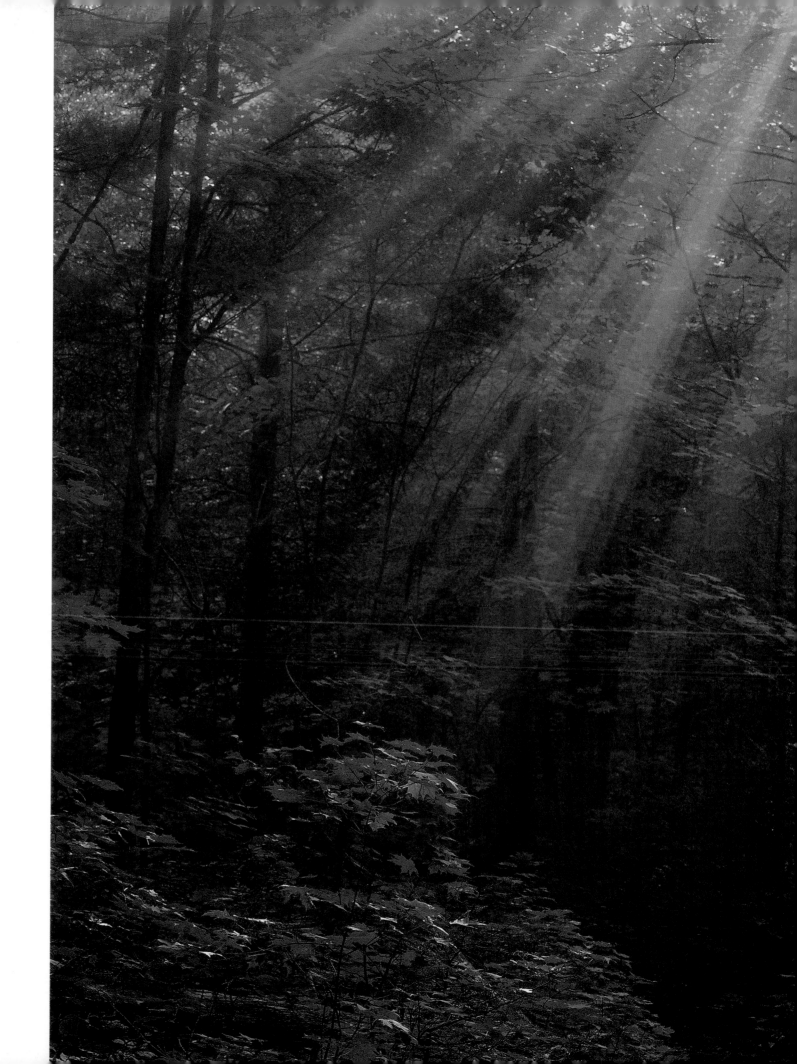

Left: **Forester's Falls, Ontario**

I often stop in graveyards. I find them to be calm, spiritual places that never fail to move me. As soon as I saw this small plot near Forester's Falls, I knew I had to photograph it. What a lovely place to be buried — on a quiet side road in the picturesque farming country of eastern Ontario.

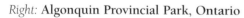

Right: **Algonquin Provincial Park, Ontario**

For this prairie boy the great forests of the east are claustrophobic. I'm used to unobstructed views from horizon to horizon. Here, in the forest, I could barely see the sky for the trees! But my phobias disappeared the minute I saw a little fog and some sunlight transform the forest into a magical wonderland.

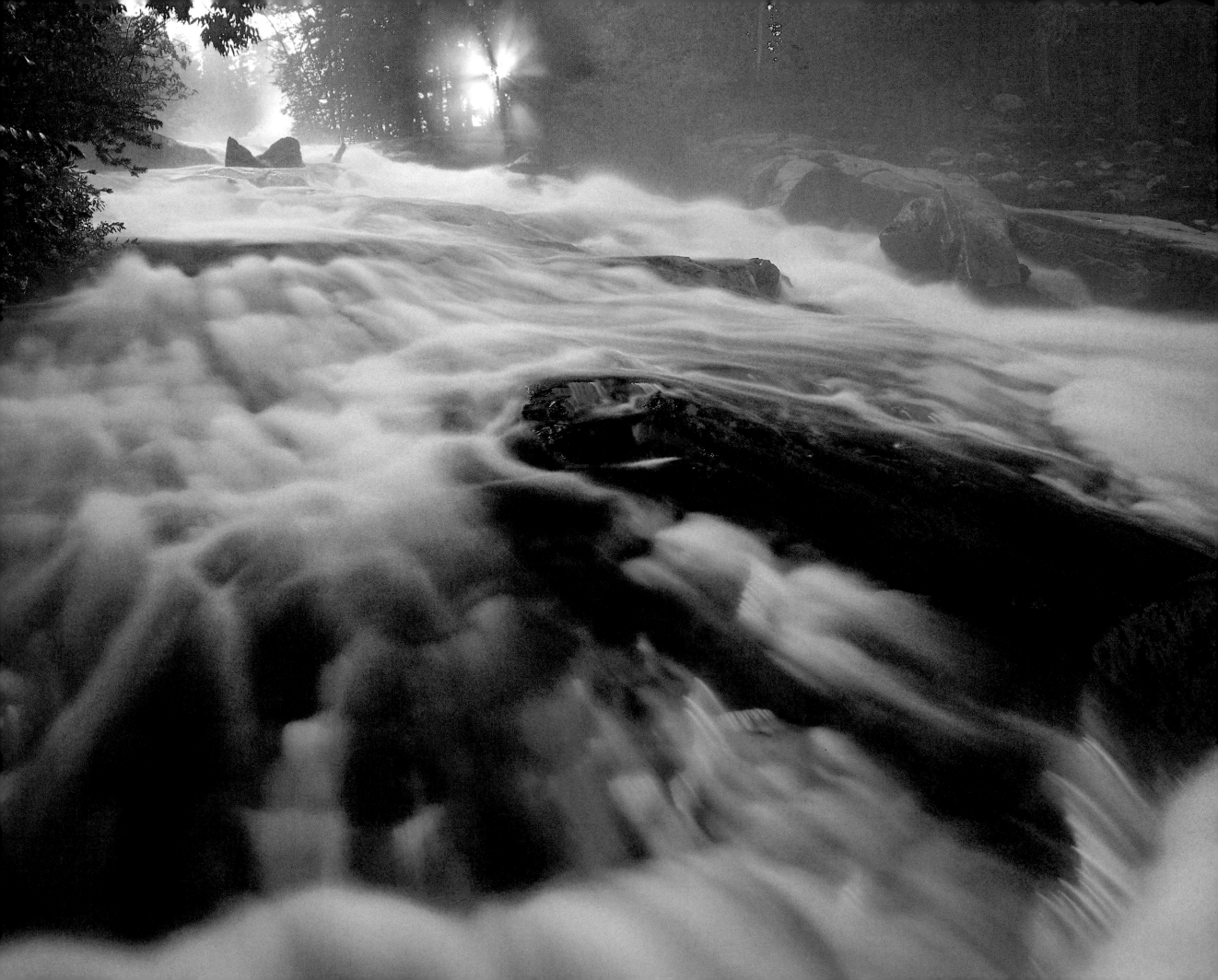

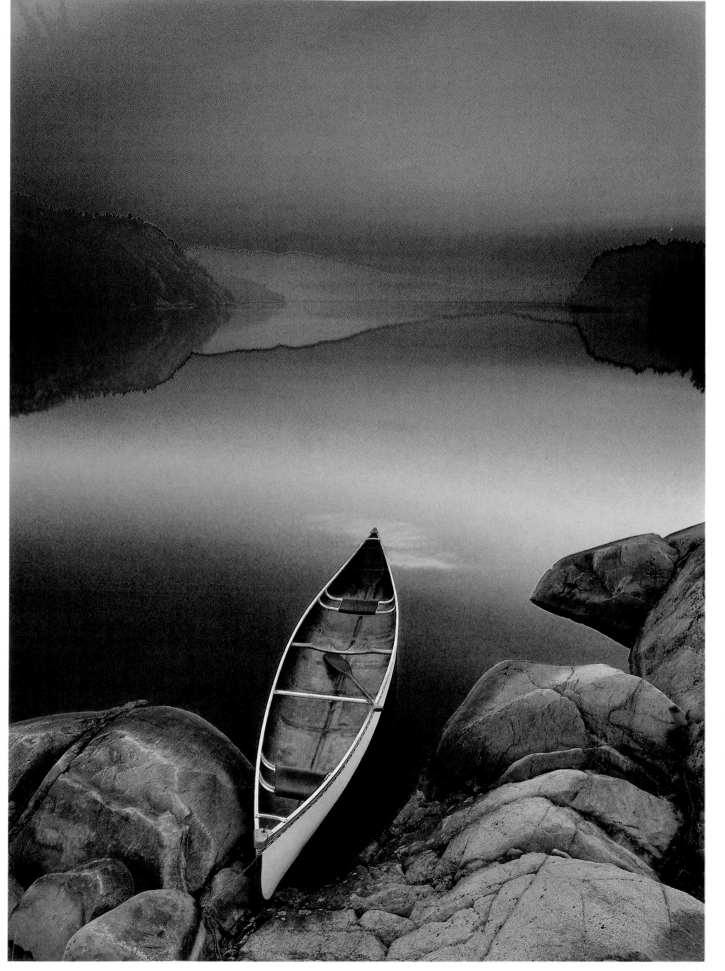

Left: Rushing River, Ontario

This ethereal image required an early rise and cold feet as I set my tripod up in the cold, shallow waters of the Rushing River. To exaggerate the sweep of this small section of white water, I lowered my wide-angle lens to within centimetres of the water. A shutter speed of eight seconds turned the churning rapids into flowing silk wrapped delicately around the deep cobalt rocks.

George Lake, Ontario

This image of a canoe on George Lake in Killarney Provincial Park is, for me, the definitive shot of Ontario. The province's name is derived from the Iroquois word for beautiful waters — an apt description considering the 250,000 lakes that dot the Ontario portion of the Canadian Shield.

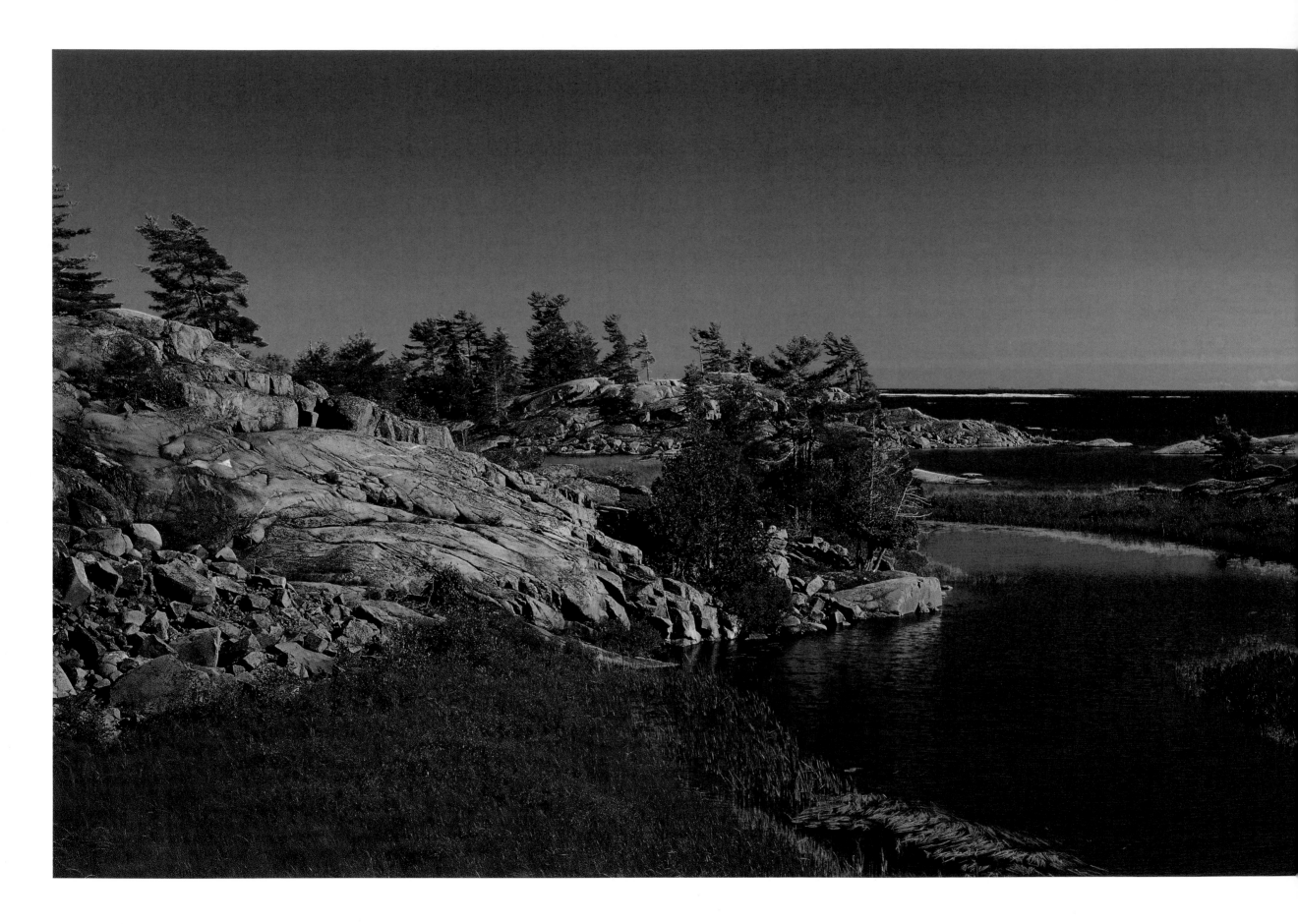

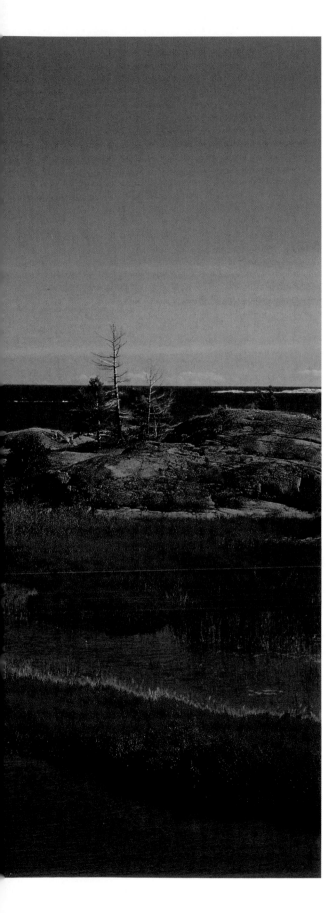

Left: **Chikanishing River, Ontario**
If this landscape reminds you of the paintings of the Group of Seven, it's no wonder. It was artists like A.Y. Jackson who led the movement to preserve what is now known as Killarney Provincial Park. Other painters who have immortalized the area include Robert Bateman and Eric Aldwinckle. Their paintings, like the park, are a priceless part of our Canadian heritage.

Right: **Bruce Peninsula, Ontario**
The shoreline cliffs of Bruce Peninsula are part of the Niagara Escarpment. It forms Niagara Falls and extends to Tobermory, where it plunges under the waters of Georgian Bay. The famous Bruce Trail runs along the escarpment and this view rewards hikers at Halfway Rock Point.

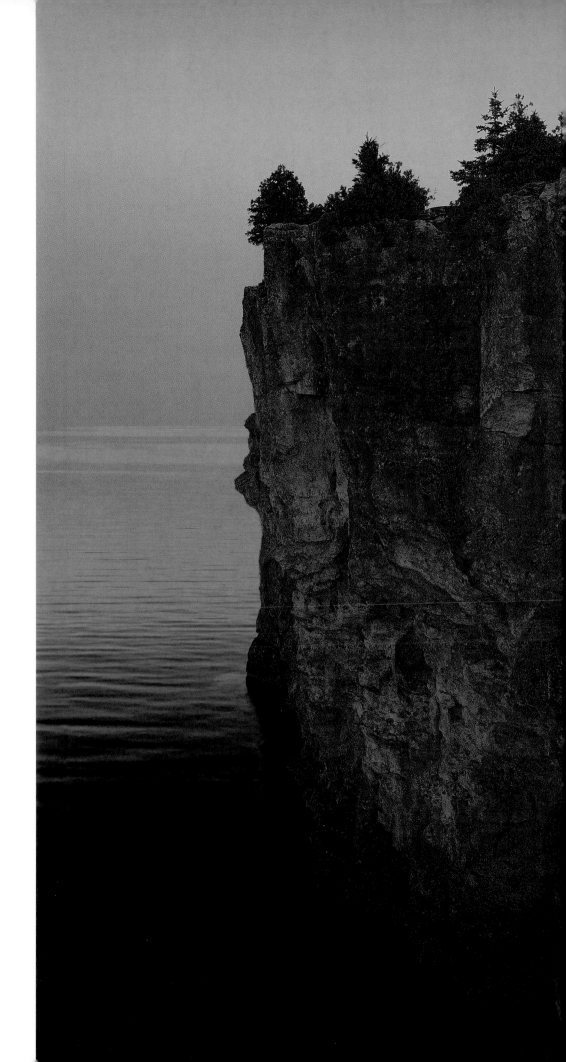

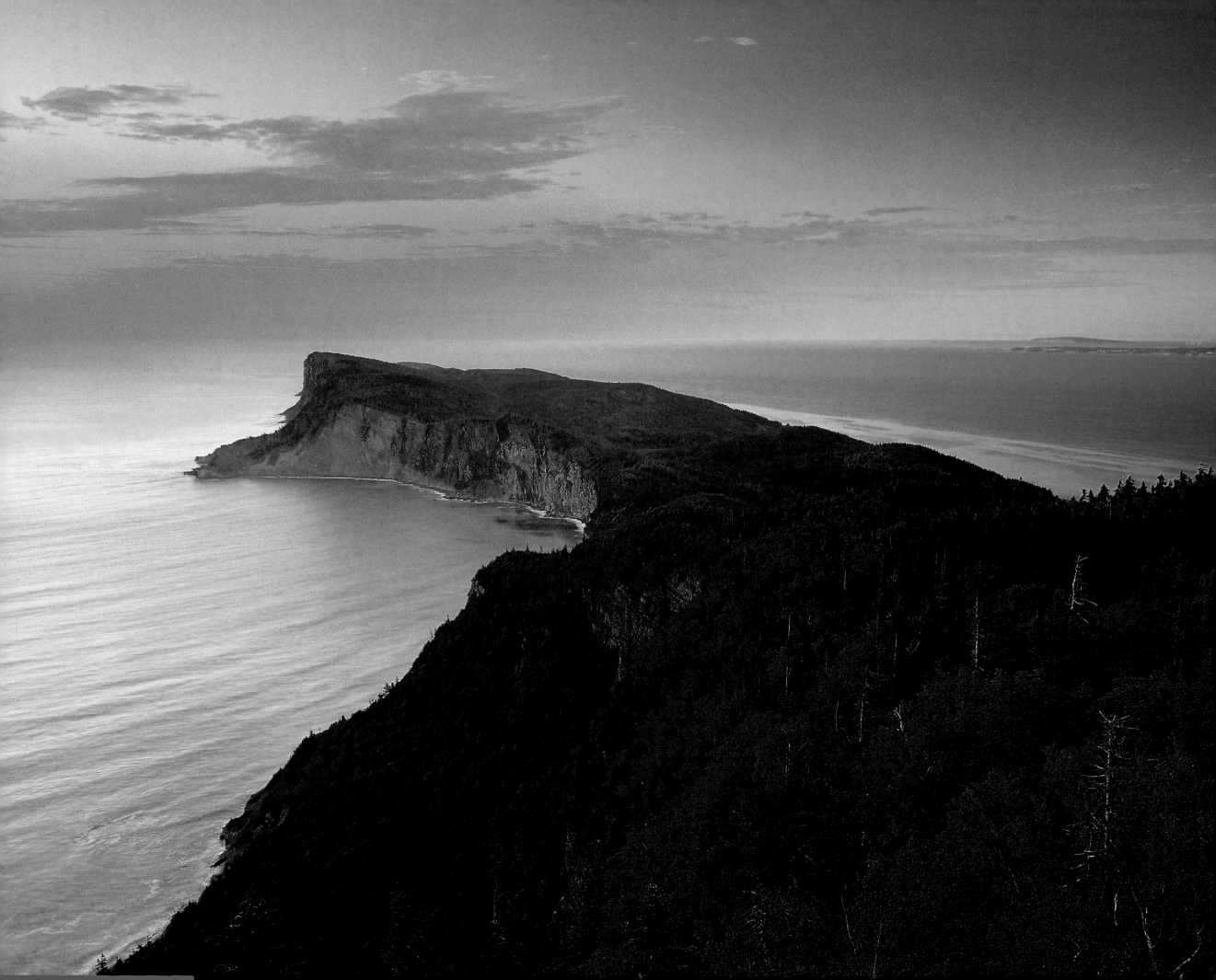

QUEBEC

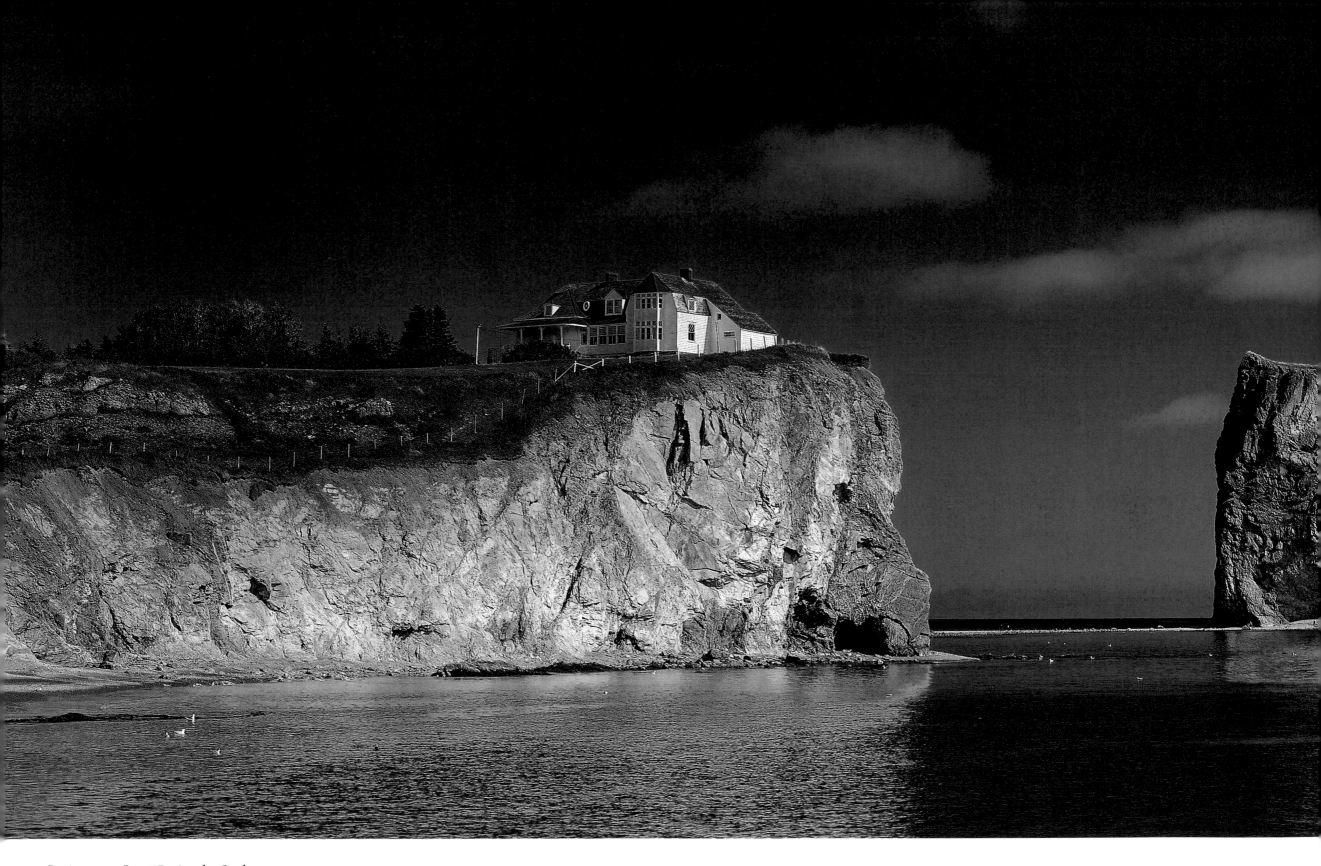

Previous page: **Gaspé Peninsula, Quebec**

The wild beauty of the Gaspé Peninsula reaches its climax at Forillon National Park. The park appears as a massive, tilted block emerging from the sea. This aerial view of the peninsula is the reward for the lung-burning hike up to the Cap Bon Ami viewing platform. In fact, it's not really that bad unless, like me, you try to race to the top before sunrise lugging 30 kilograms of camera gear.

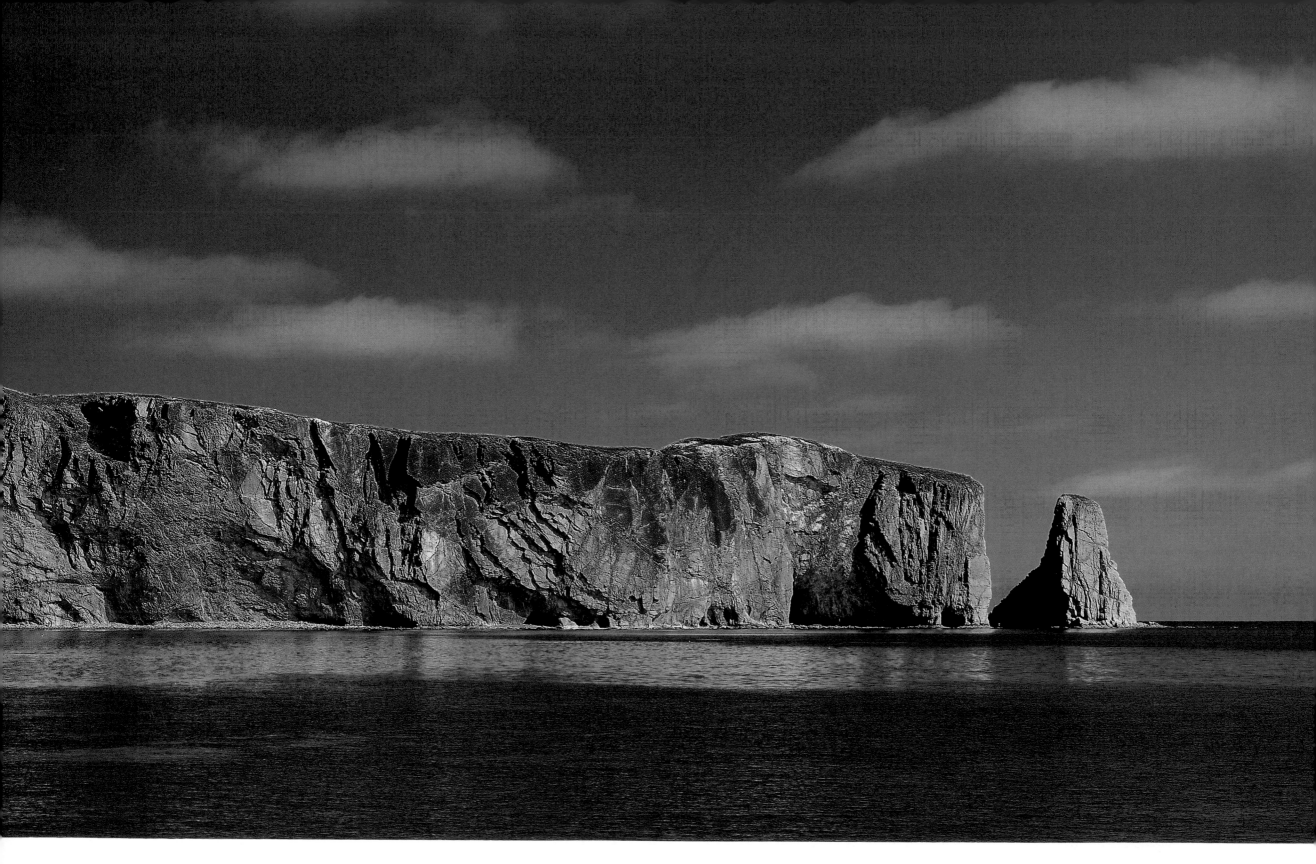

Percé Rock, Quebec

Percé Rock was named by Champlain for the natural arch (not visible here) at the east end of this enormous block of limestone. Except for Niagara Falls, no other natural landmark is as readily recognized in eastern Canada as Percé Rock. For days I tried to photograph it, but fog and clouds kept the sun away. Finally, just as I was about to give up, the skies cleared and brilliant sunshine bathed the scene in light. Many people think travel photography is a glamorous job but ninety percent of what I do is wait for light. Pushing the shutter is always the easiest part.

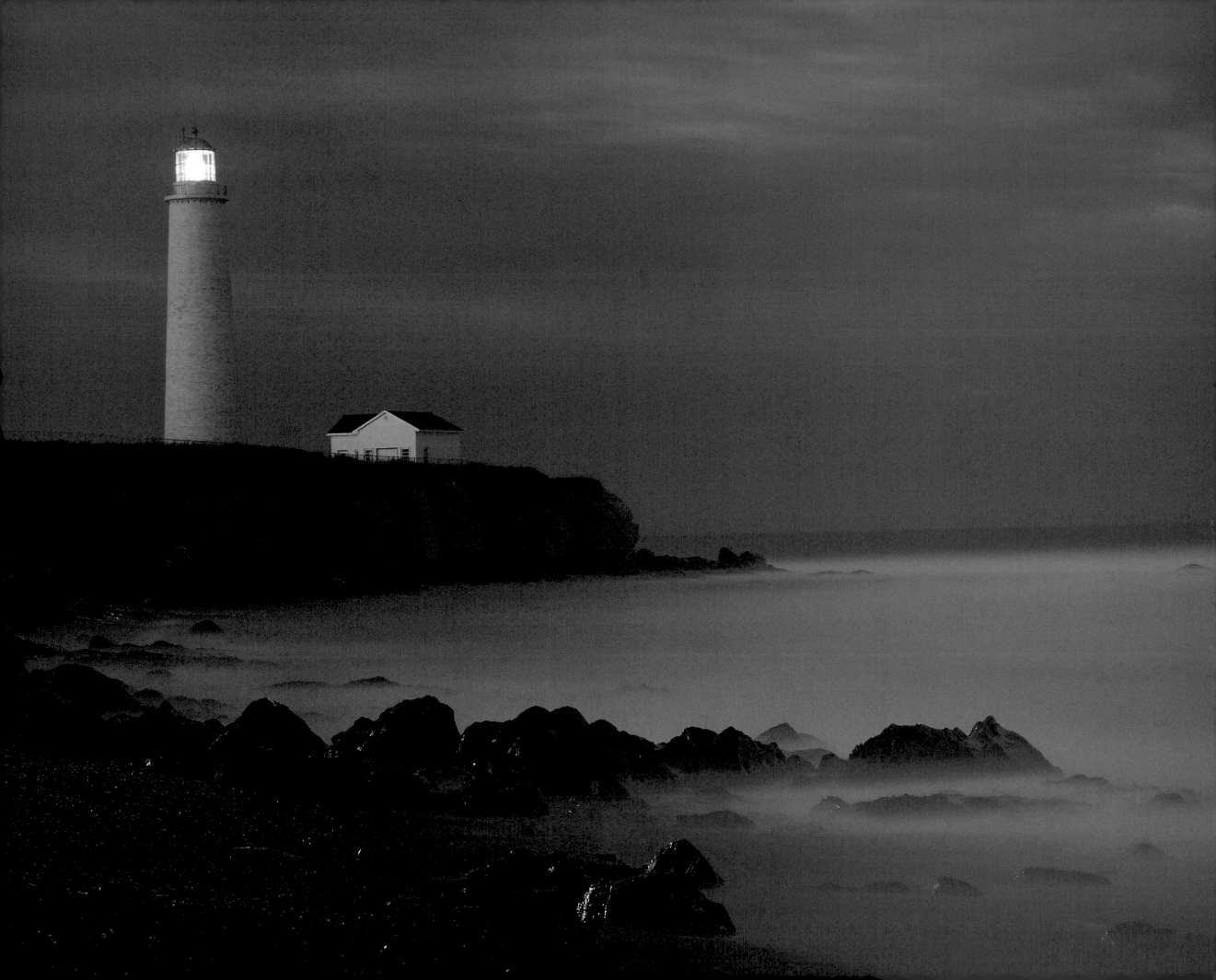

Left: **Cap-des-Rosiers, Quebec**

The Cap-des-Rosiers Lighthouse, the tallest in Canada, sends its beacon into the Gulf of St. Lawrence on a stormy summer evening. Huge breakers pounded the shoreline while I was photographing this scene, but a four-minute exposure turned the powerful surf into a soft delicate mist. Cameras don't just freeze time, they can also blend it.

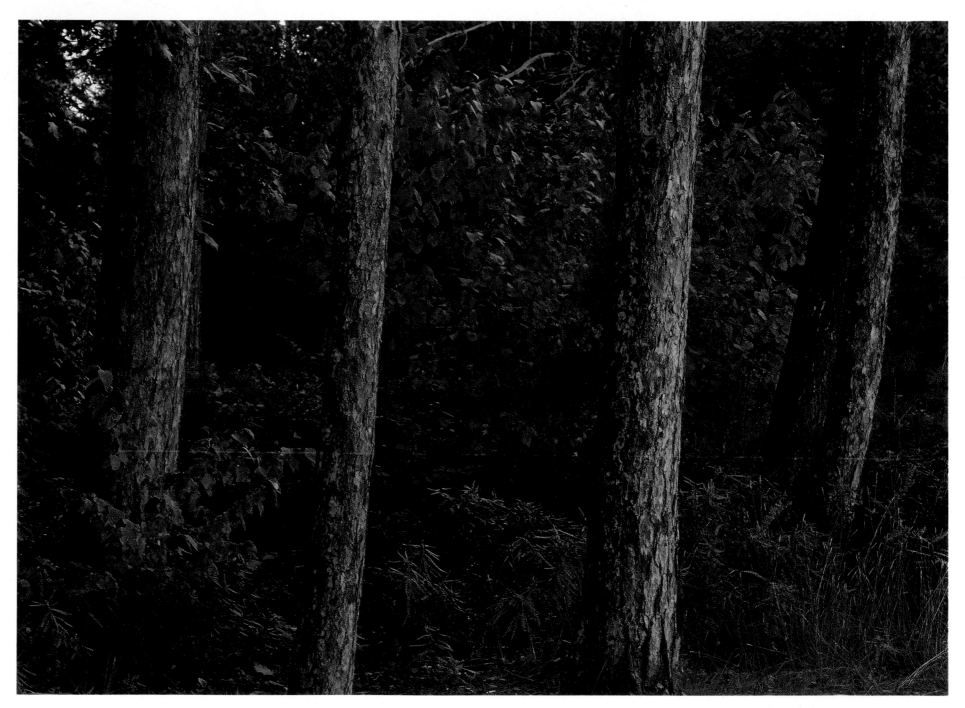

Right: **La Mauricie National Park, Quebec**

A plateau of rounded hills, dotted with lakes and separated by winding rivers, characterizes La Mauricie National Park in south-central Quebec. I had hoped to photograph the latticework of water and forest from some high viewpoint while visiting the park. Defeated after waiting three days under grey skies and drizzle, I headed back to my soggy tent to ponder my poor fortune. At sunset a small crack opened in the sky and lit the forest orange. I scrambled around, tripping over my tent, trying to find a good composition before the light faded. The result was this photo.

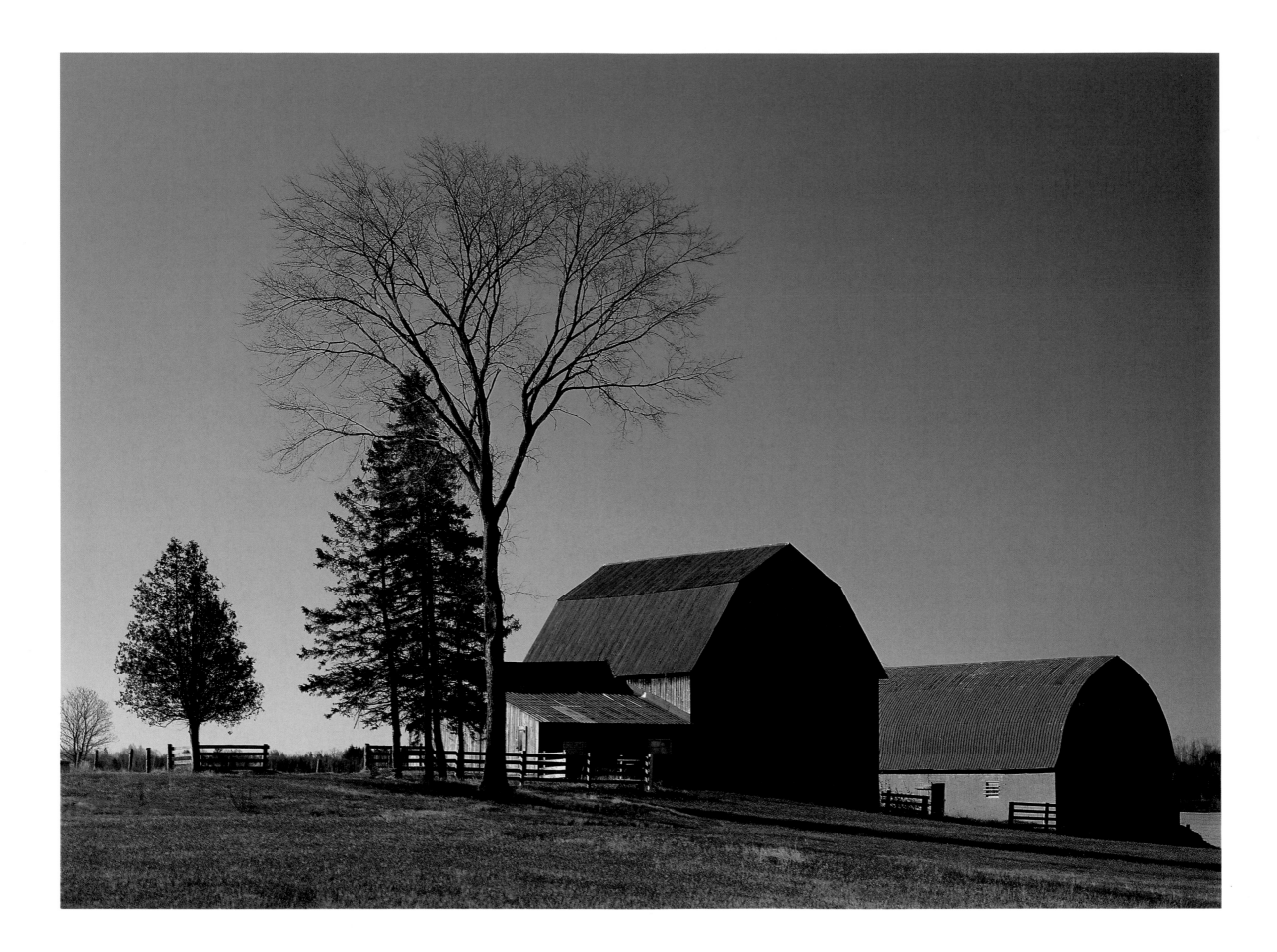

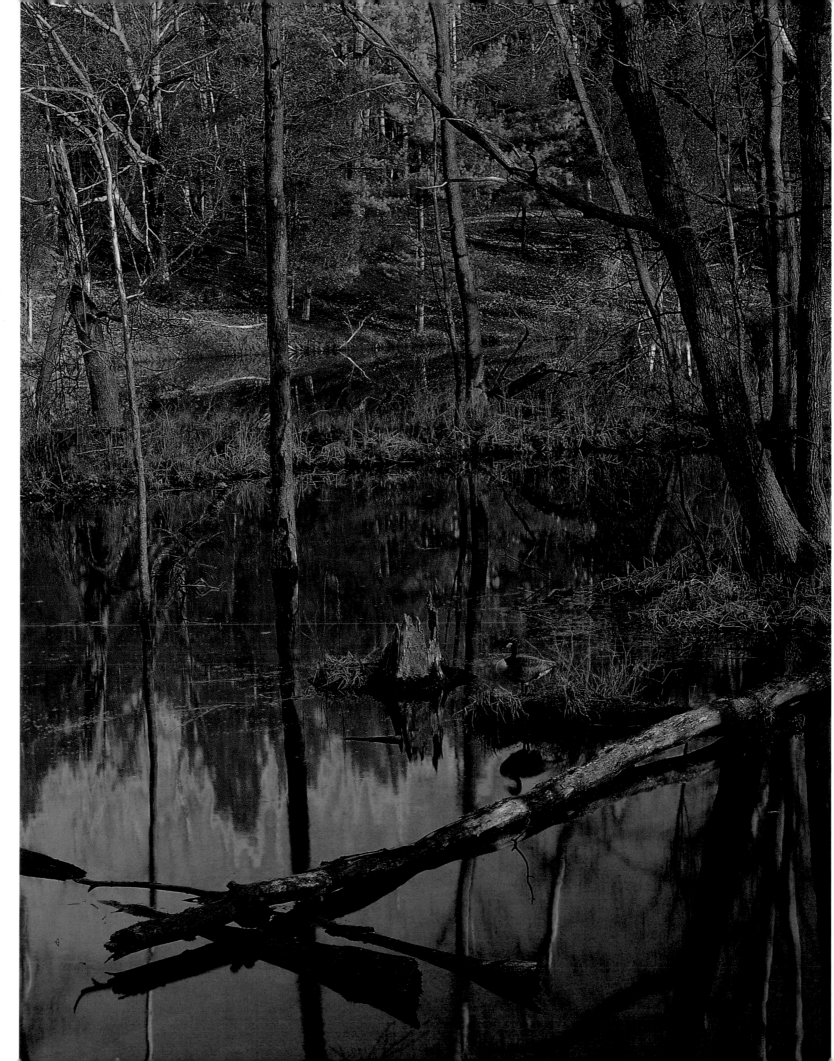

Left: **Portage du Fort, Quebec**

After seeing and photographing barns across the country I can now identify a region based on the architecture of the barn. The barns of Quebec look very different from the barns of the prairies or those of the B.C. rangelands. Building styles vary with when the barns were built, as well as the type of materials used in construction and the weather conditions.

Right: **Eastern Townships, Quebec**

The Eastern Townships are famed for their rural charm, scenic lakes, and forested mountains. I photographed this spring scene somewhere in the Bagot township after taking a wrong turn. The lone Canada goose stood perfectly still while I fumbled around with my camera trying to make a composition out of the tangled deadfall. It was still there, eyeing me suspiciously, as I pulled my map from my pack and tried to find that mysterious left that was supposed to be only two kilometres back.

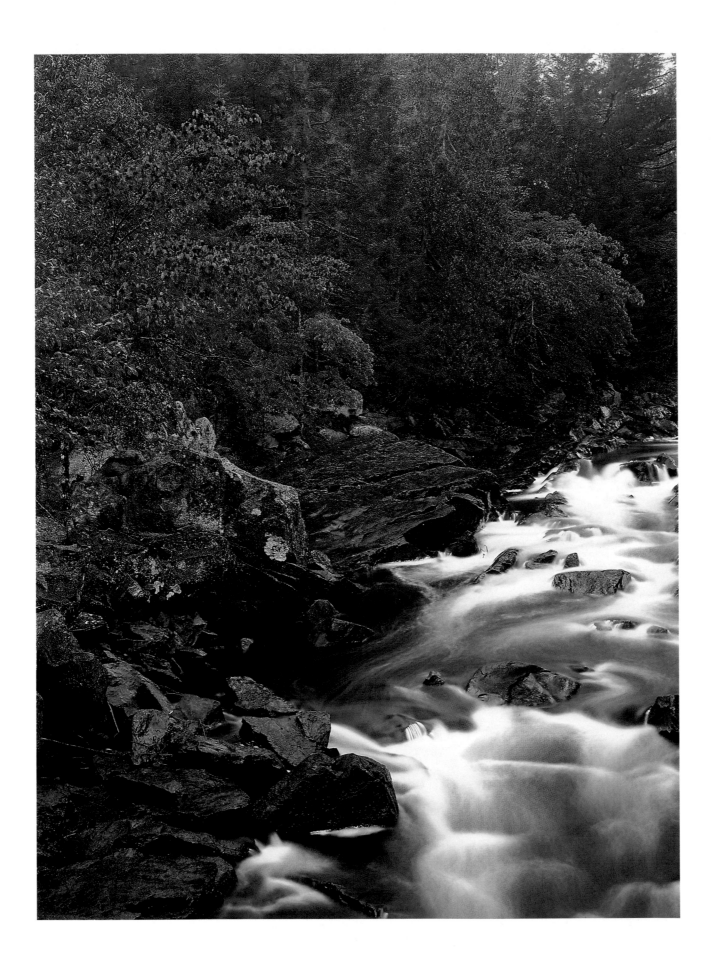

Left: **Diable River, Quebec**
In Quebec's oldest and most popular park, Mont-Tremblant, the scenic Diable River flows through the rugged Laurentian wilderness. Here I captured the first wisps of fall colour on a quiet misty morning. No wonder Quebec is known as La Belle Province; everywhere I went in Quebec the countryside was glorious.

Right: **Grande-Grave Historic Site, Quebec**
Grande-Grave Historic Site on the Gaspé Peninsula preserves the architecture and way of life of Gaspé fishermen and farmers. Nowhere else in Canada have I seen such a concentration of tremendous rural homes and gardens as in Quebec. There is a great pride in older buildings, many of which are not just preserved as museum pieces, but are occupied as homes. The gardens are park-like, with immaculately trimmed lawns and colourful hand-crafted lawn ornaments. This photo illustrates a former pasture grown wild with fireweed once the area was preserved as a historic site.

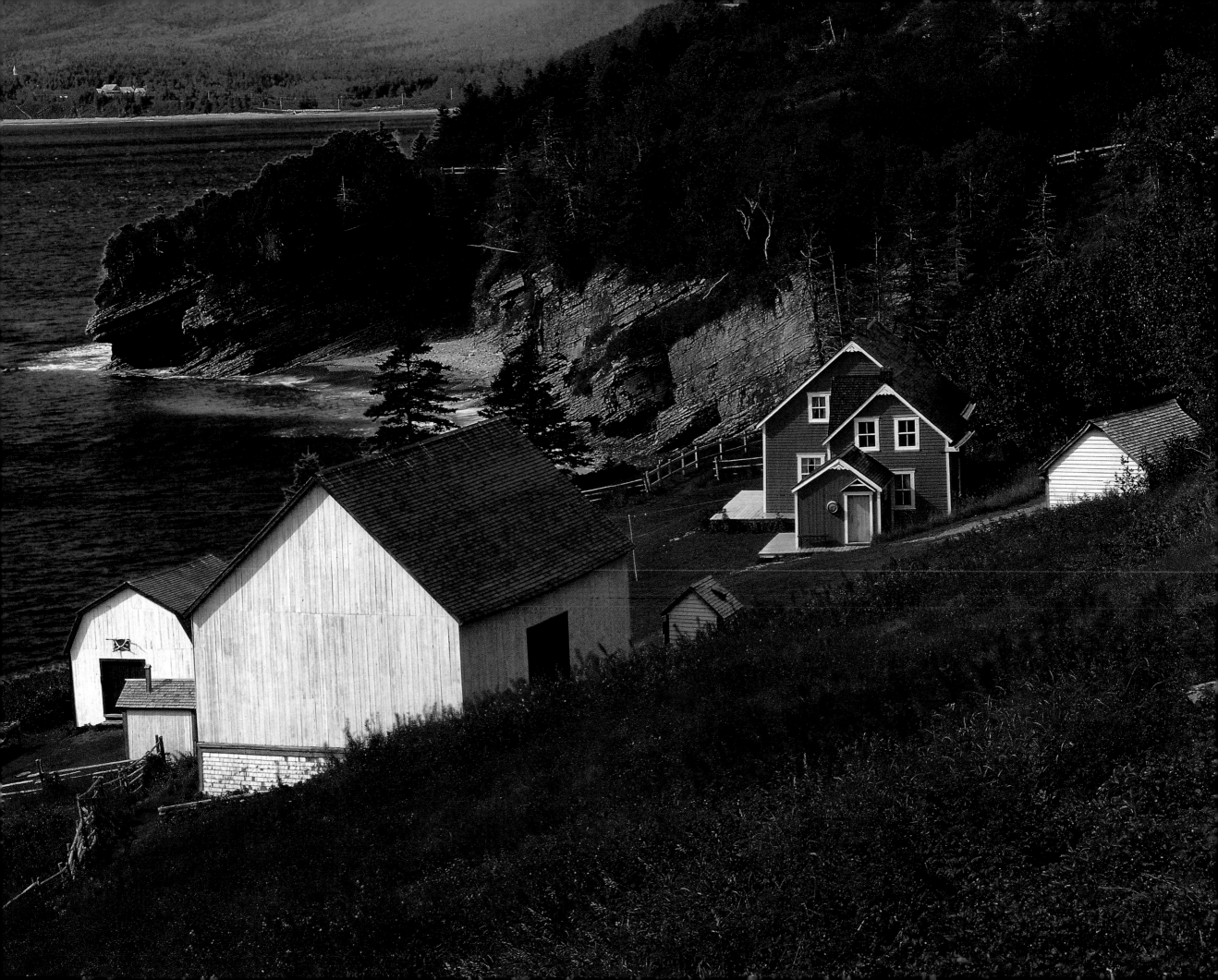

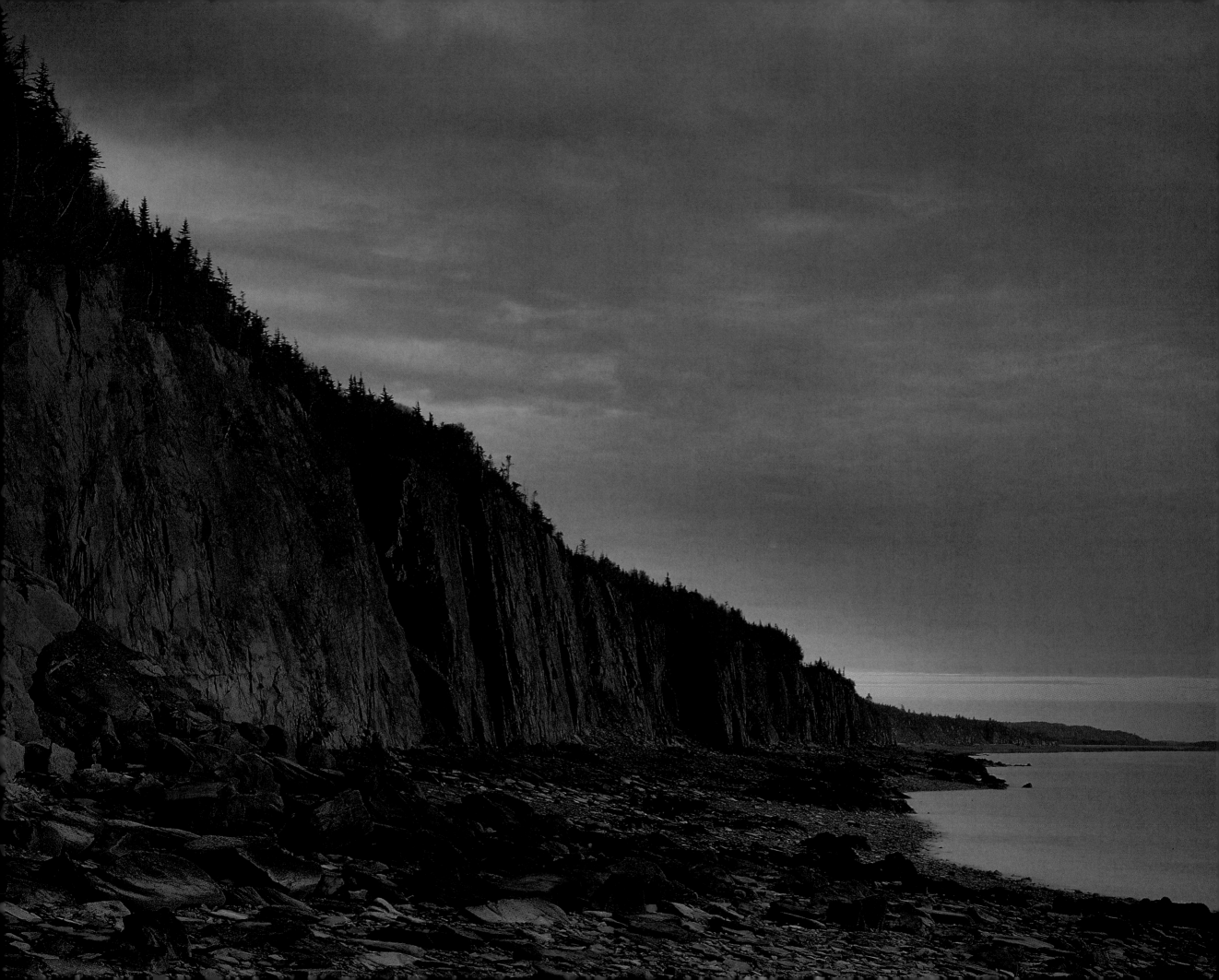

NEW BRUNSWICK

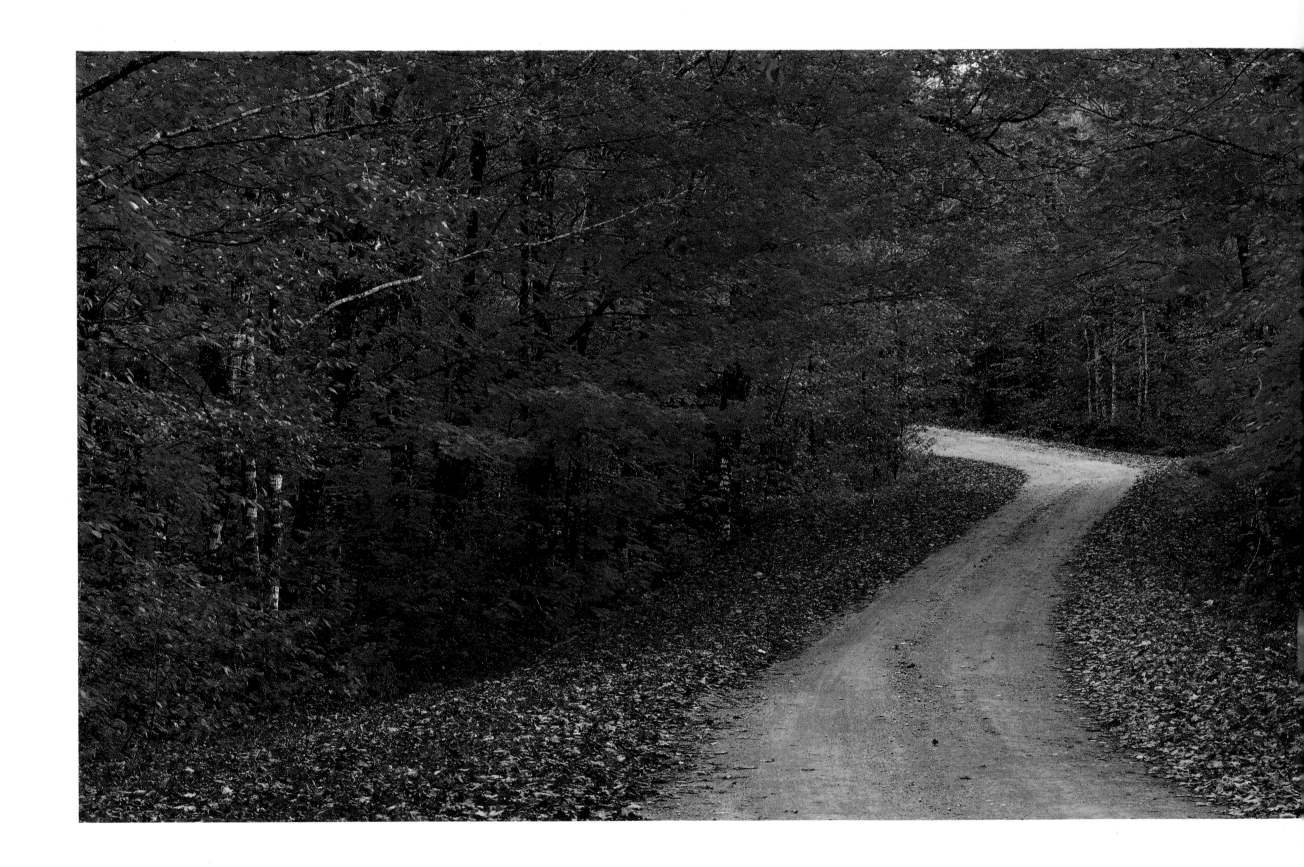

Previous page: **Cape Enrage, New Brunswick**
Sunrise colours the shale and sandstone cliffs of Cape Enrage an angry red. This short but intense flush of colour was followed by a fierce rain that had me running for cover. Later the sun returned and the wet cliffs sparkled brilliantly in the warm morning light.

Left: **Laverty Road, New Brunswick**
Southeastern New Brunswick is washed by some of the highest tides in the world, at times extending to a difference of twelve metres. Inland from the cliffs and surf of the Fundy shore, the forested Caledonia Highlands are incised by churning rivers and plunging waterfalls. On a backcountry road to Laverty Falls in Fundy National Park, I captured the full glory of the Caledonian forest draped in the golden colour of fall.

Right: **Point Wolfe Bridge, New Brunswick**
New Brunswick is famous for its covered bridges; seventy bridges are still standing. The Point Wolfe Bridge in Fundy National Park, built in 1910, received national attention when it collapsed in 1990. The bridge was rebuilt in 1992.

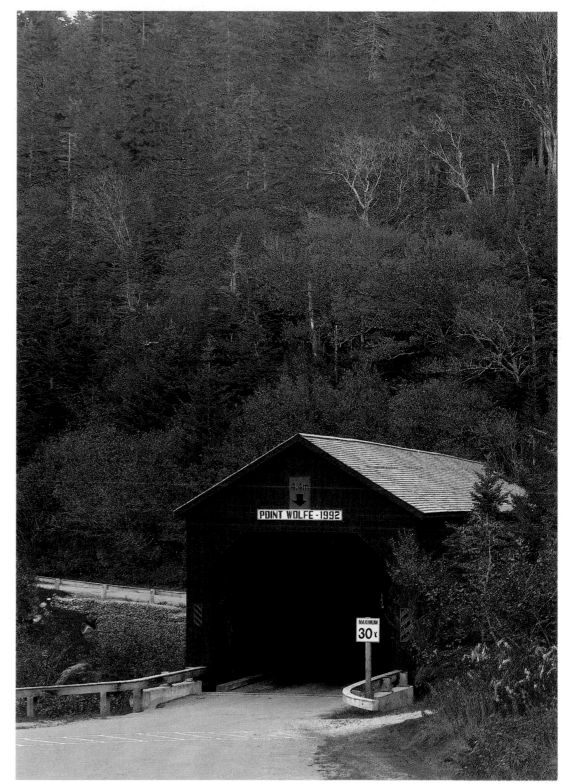

Kelly's Beach, New Brunswick
Boardwalks in Kouchibouguac National Park lead
to a twenty-five-kilometre sweep of tidewater lagoons,
beaches, sandbars, and grassy salt marshes. Inland
a forested cover of spruce, pine, aspen, and birch
provides a pleasing mix. This boardwalk at Kelly's
Beach leads to a popular summer swimming spot and
this shot, although taken in the fall, holds the promise
of a warm summer's day.

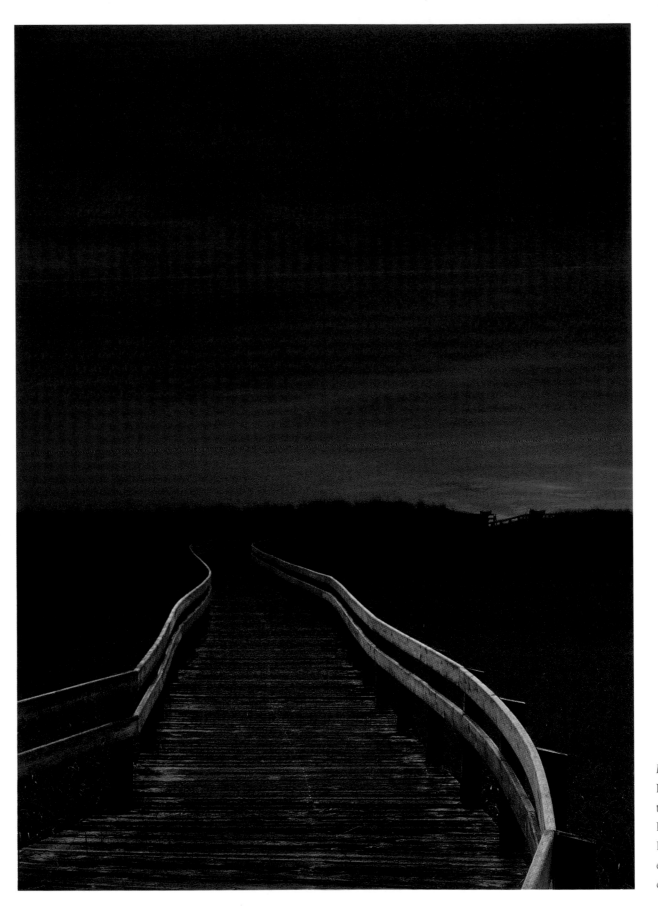

Right: **Miramichi River, New Brunswick**
Famous for angling, the Miramichi River courses
through the spectacular scenery of central New
Brunswick. Along the wide reach of the Miramichi,
I found this quiet reflection of colours in a still-water
eddy. Sometimes even the grandest views can't
compete with the intimacy of a small scene.

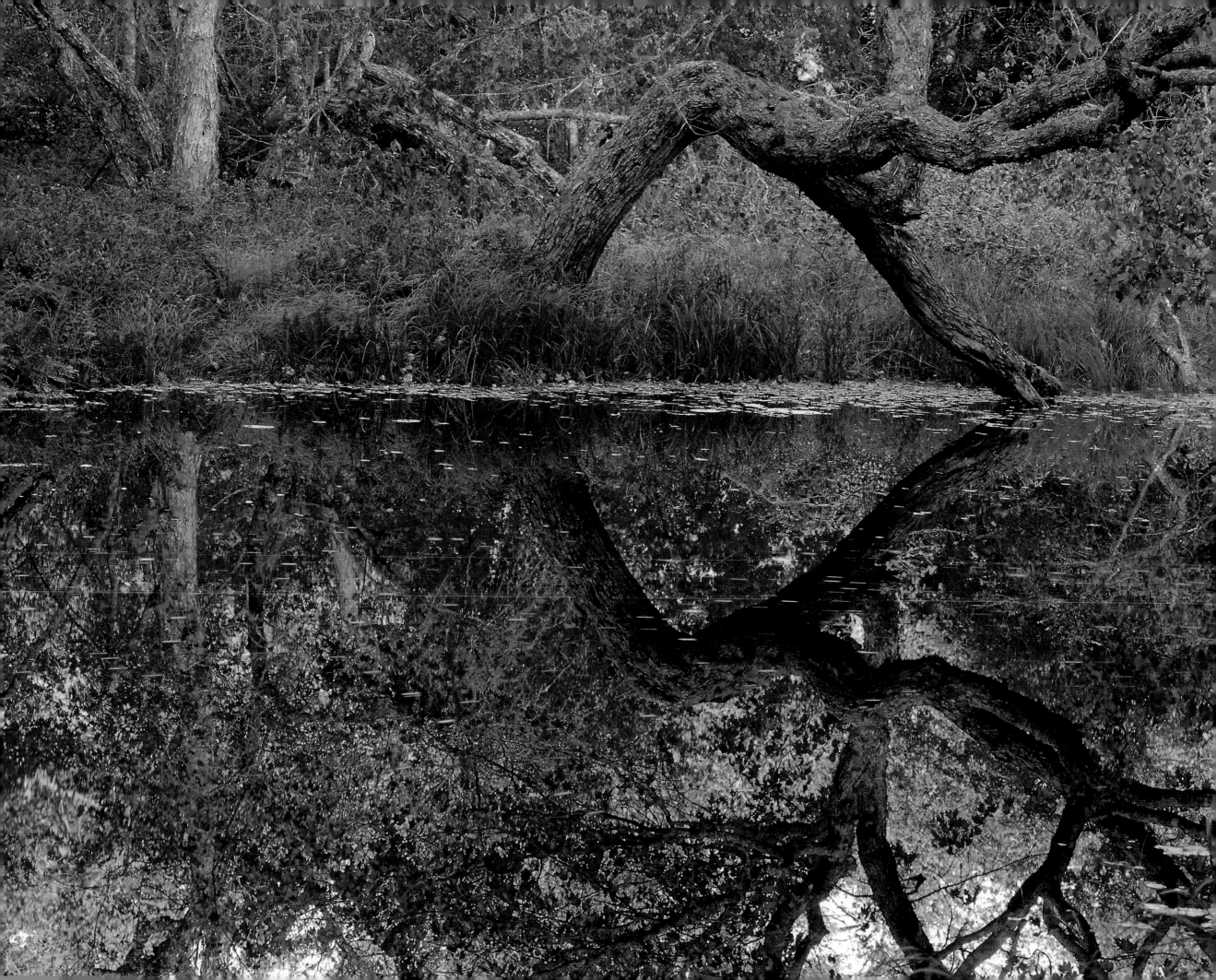

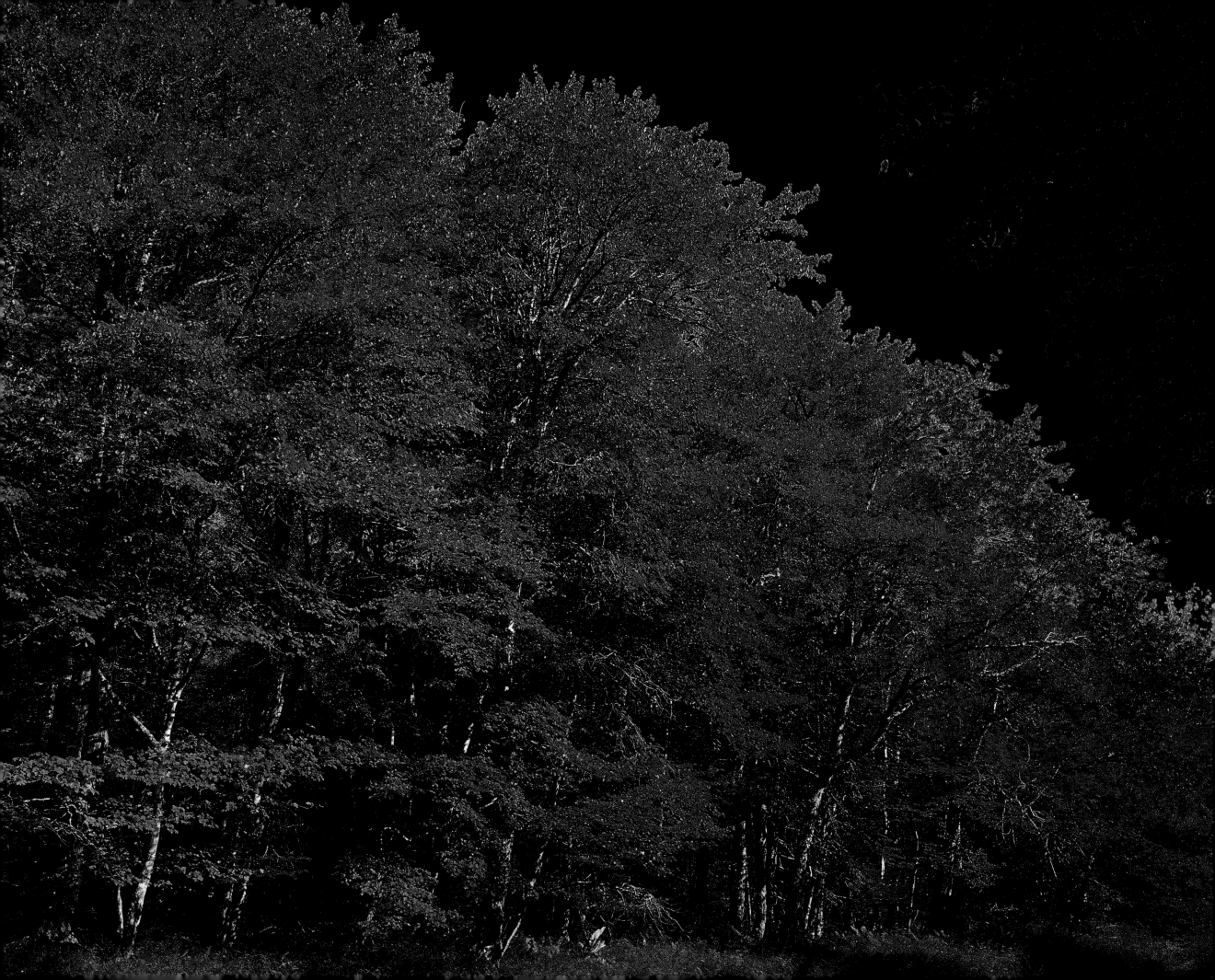

NOVA SCOTIA

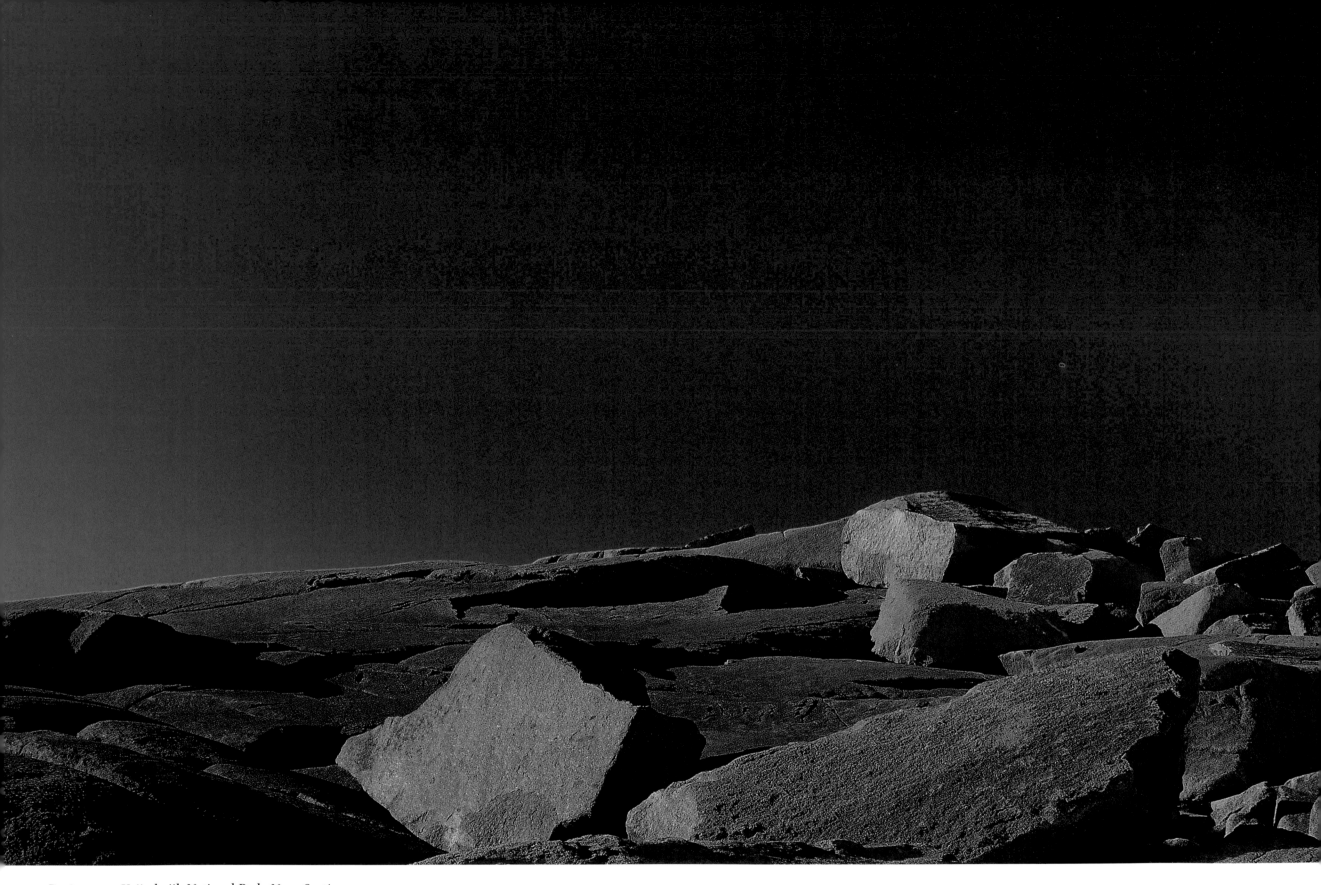

Previous page: **Kejimkujik National Park, Nova Scotia**

A gently rolling, forested landscape pocked with lakes and littered by rocks and bogs, what is now Kejimkujik National Park was never settled because the soil was totally unsuitable for farming. That's fortunate, because Kejimkujik nurtures an unusual mix of northern plants and animals along with rarer species generally only found in the southern United States. This fall scene was taken along the edge of the Mersey River.

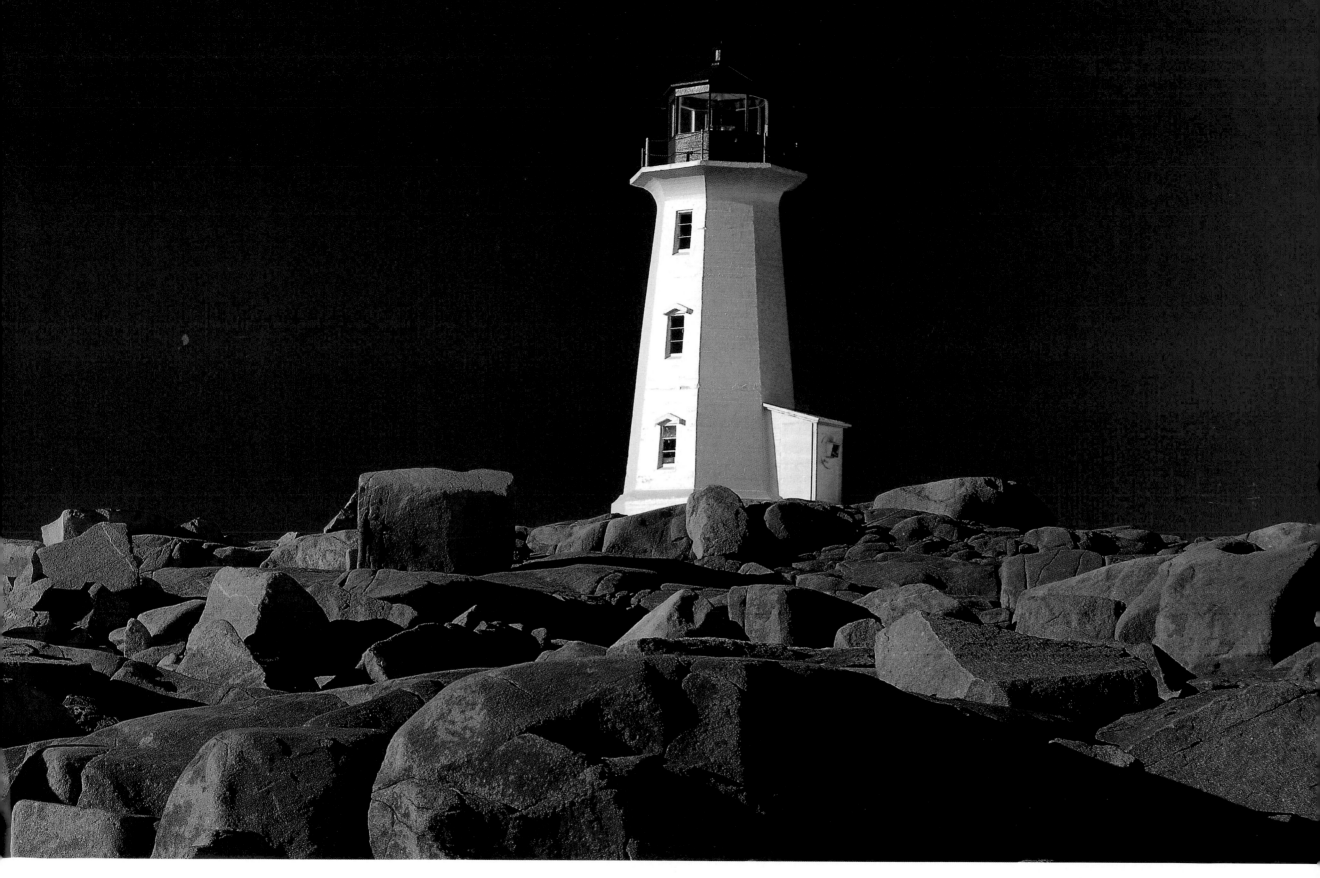

Peggy's Cove, Nova Scotia

Peggy's Cove, most photographed scene in the Maritimes, is famous for its granite shoreline, rustic dwellings, and the lighthouse with its sweeping ocean view. The community of a hundred residents typically has over a thousand sightseers a day. Even at 5:00 A.M. there were already ten other visitors there. By 9:00 A.M. it was so crowded I couldn't see the lighthouse for the people! I shot this photo at about 4:00 P.M. after waiting two hours for a view without tourists.

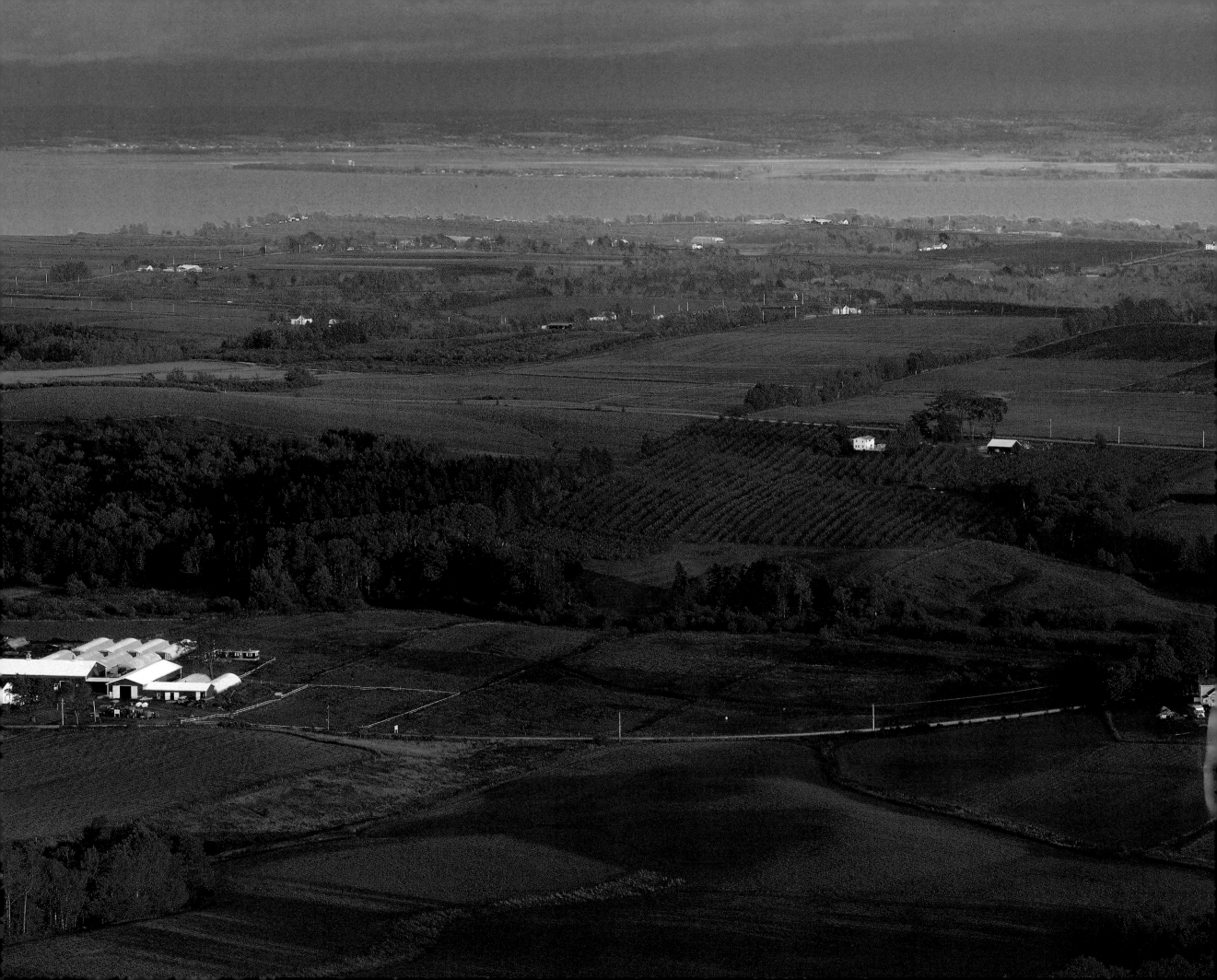

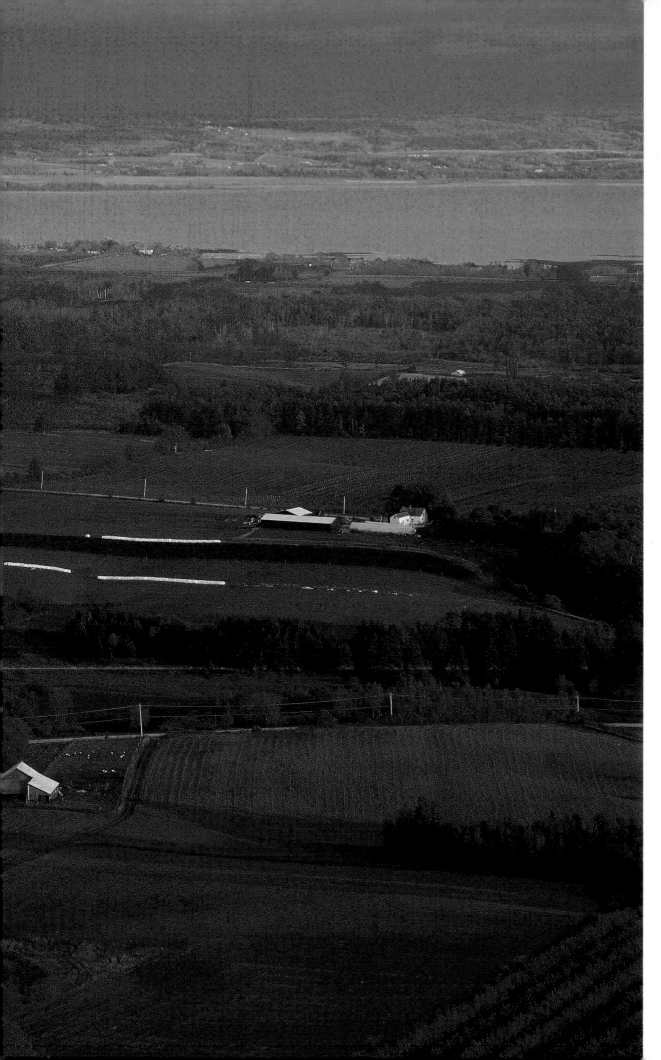

The Lookoff, Nova Scotia
Manicured farmlands spill across the countryside below Cape Blomidon. The name Blomidon is thought to be a corruption of "blow-me-down," a phrase early seamen used to describe the windy two-hundred-metre cliffs of the cape. Of the twenty frames I exposed of this scene, only two were sharp; the wind had ruined all the other shots.

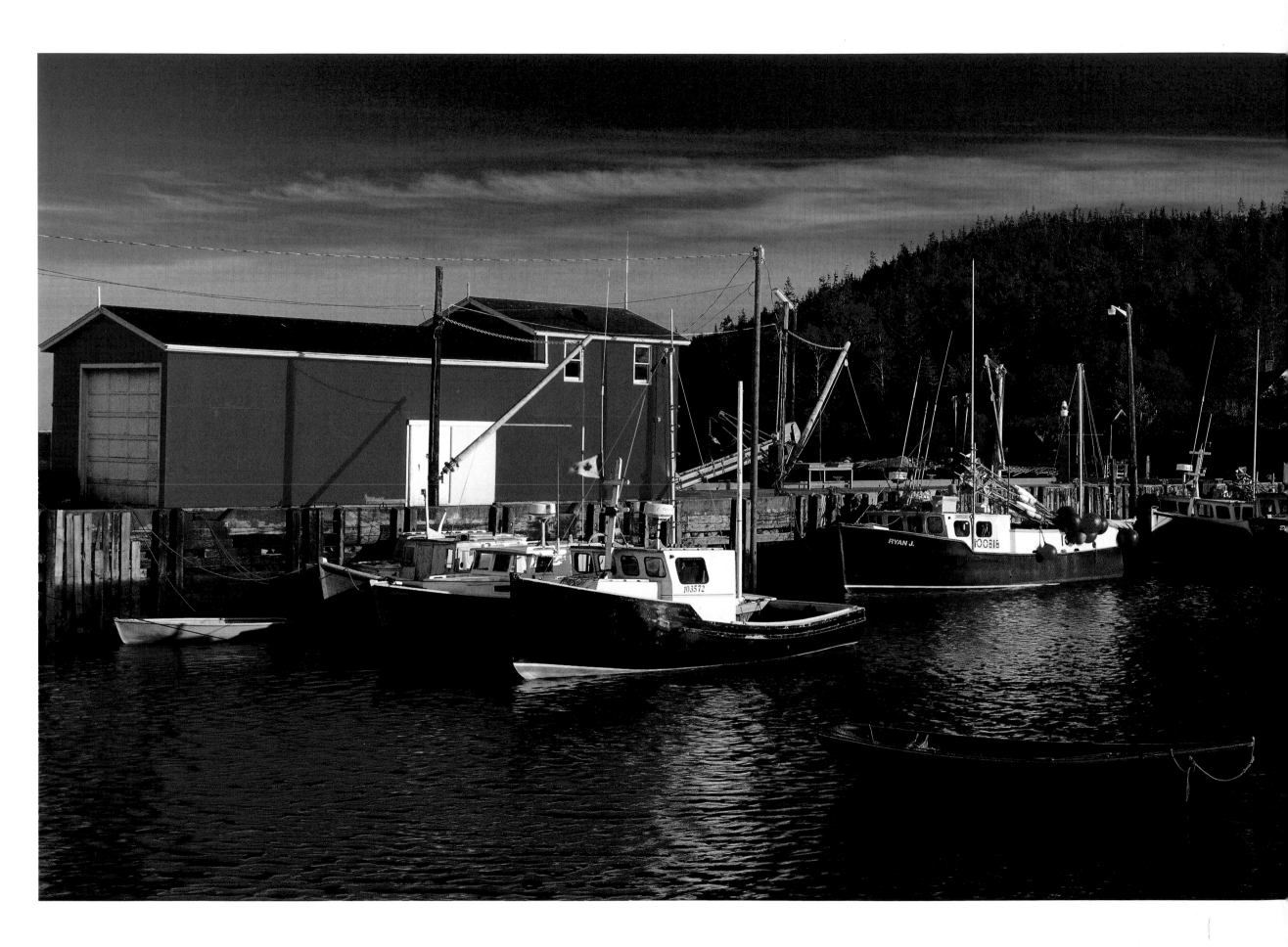

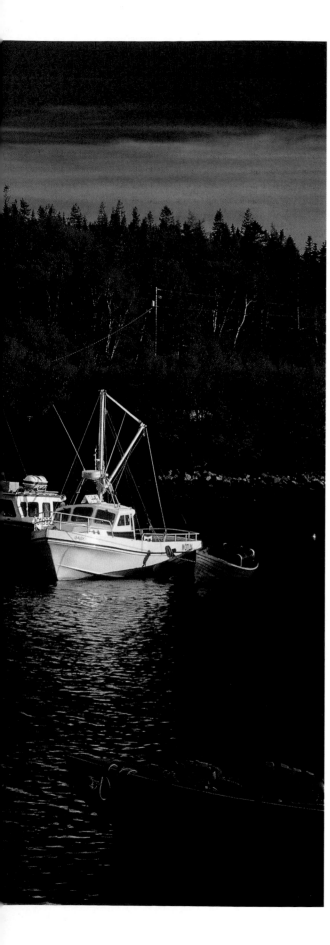

Northwest Cove Harbour, Nova Scotia
The striking thing about harbours in the Maritimes is the bold use of colour on both boats and buildings. Such rich colour is rare in west coast scenes. I wish I could offer some extraordinary insight into why these differences exist, but no one I spoke to on either coast had a satisfactory explanation. Whatever the reasons, these regional differences add charm and character to a country that is anything but homogeneous.

Balancing Rock, Nova Scotia
Balancing Rock is a strange geological anomaly — a large basaltic pillar balanced precariously on the edge of a cliff overlooking the ocean. It appears to defy the harshest moods of nature and the silliest notions of men. Several years ago, someone in a fishing boat tried to pull the pillar down with a rope and failed. I'm sure that most visitors try to push the rock over but it weighs more than thirty tonnes.

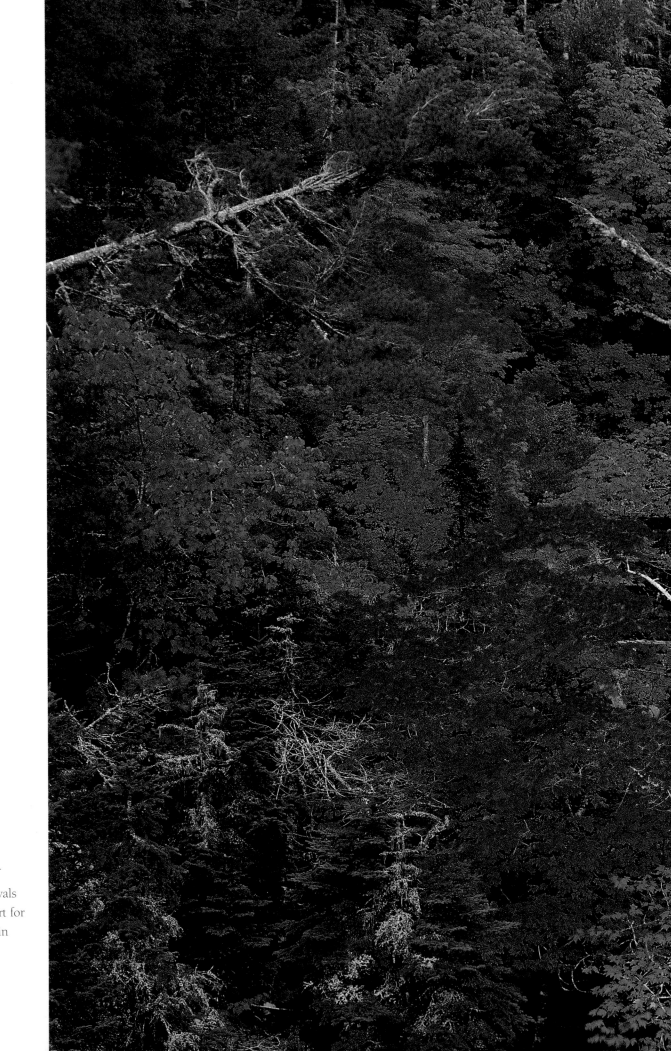

Cape Breton Highlands, Nova Scotia
"I have travelled around the globe. I have seen the
Canadian Rockies, the Andes and the Highlands of
Scotland. But for simple beauty, Cape Breton outrivals
them all," wrote Alexander Graham Bell. As support for
Bell's position I offer this image of Mary Ann Falls in
Cape Breton Highlands National Park.

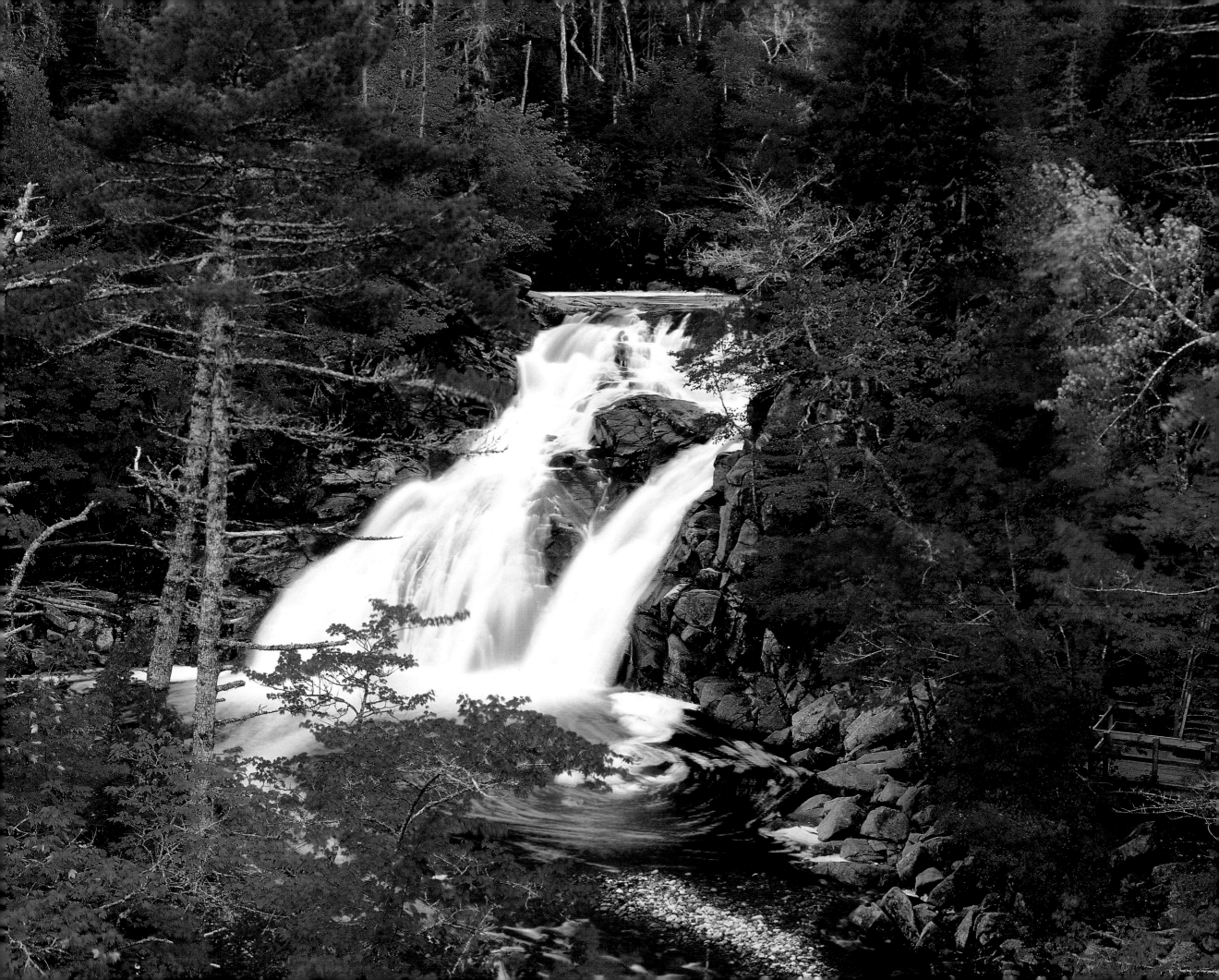

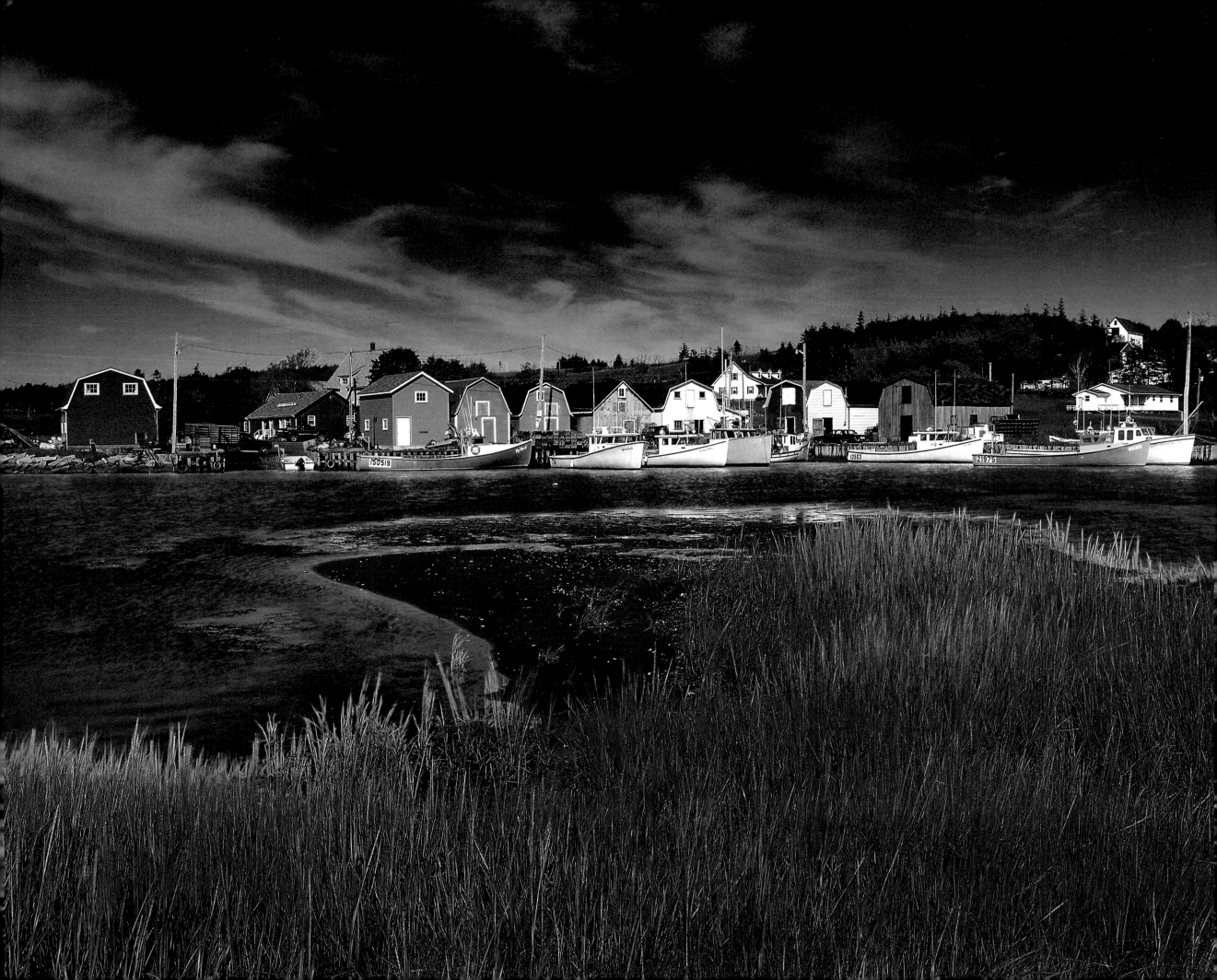

PRINCE EDWARD ISLAND

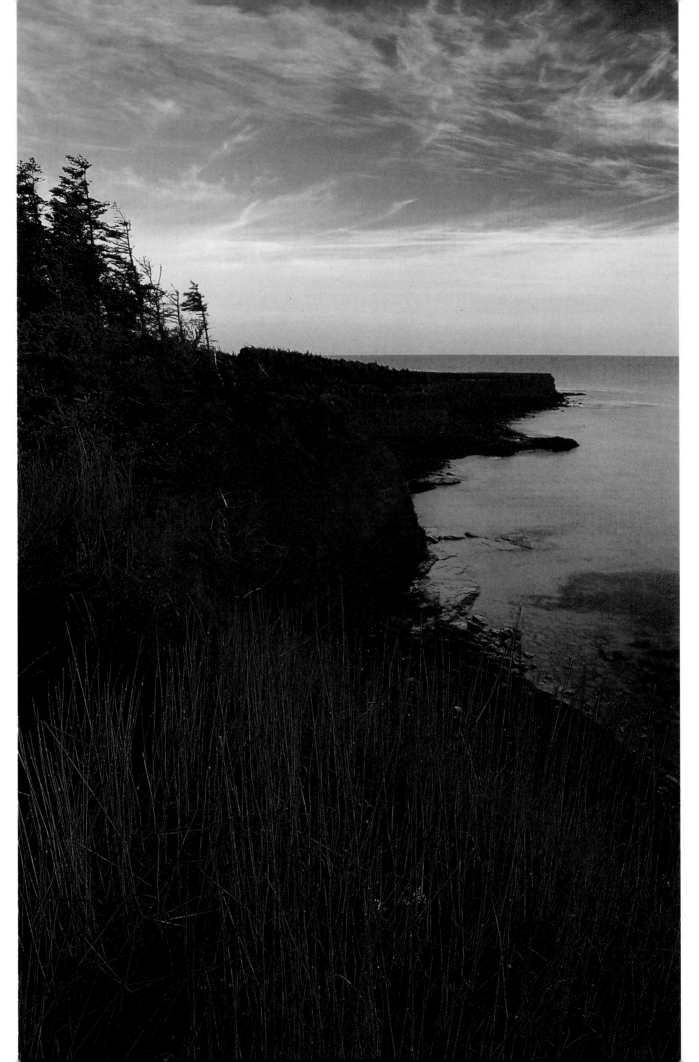

Previous page: **French River, Prince Edward Island**
French River is one of the most photographed and
famous of Prince Edward Island's quaint fishing villages.
A pull-off on Highway 6 provides an expansive overview
of the harbour, but for this shot I got closer and photo-
graphed the village from the opposite side of the bay.

Cape Turner, Prince Edward Island
Between North Rustico Harbour and Orby Head are
more than nine kilometres of red sandstone cliffs
up to thirty metres high. The cliffs contrast with the
grass-covered dunes and beaches in the rest of Prince
Edward Island National Park. The warm light of sun-
rise enhances the oranges of this scene.

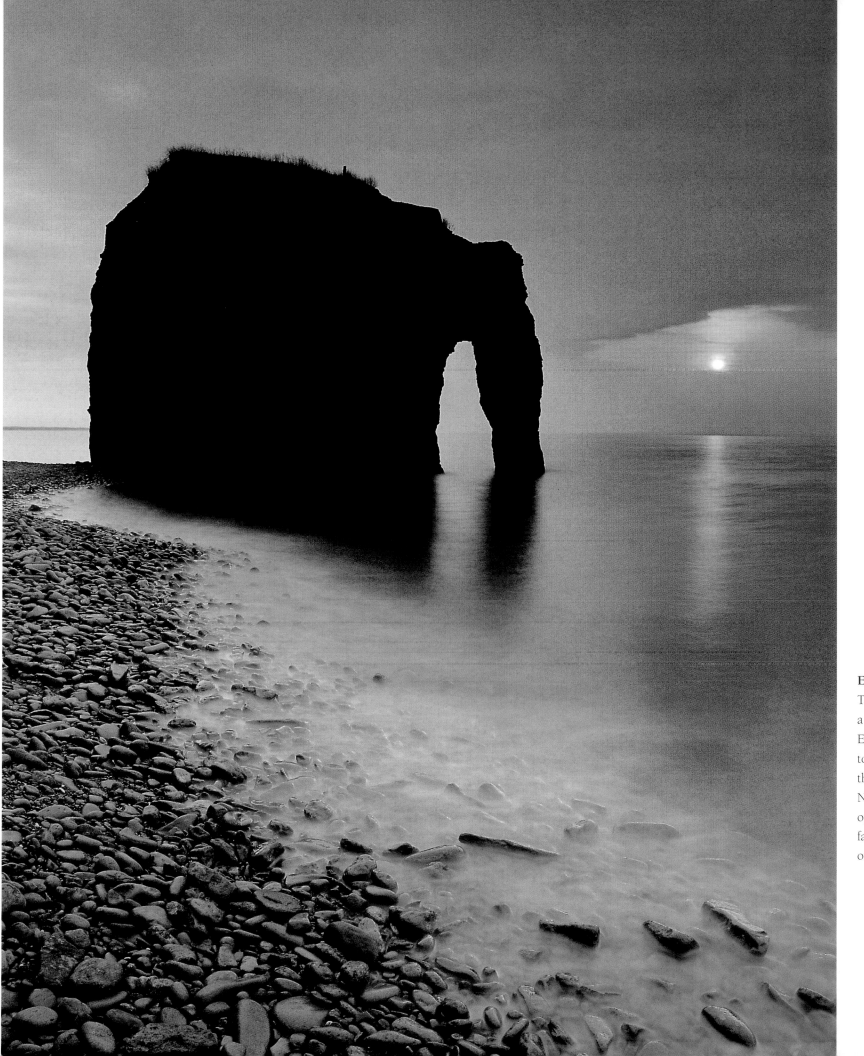

Elephant Rock, Prince Edward Island
This geological formation needs no explanation — it's a big rock that looks like an elephant! One of Prince Edward Island's most famous characters, second only to Anne of Green Gables, this big pachyderm inhabits the red shale cliffs on the northwest tip of P.E.I. near Norway. (It's a great place to take kids and a wonderful opportunity to test your imagination as you make up far-fetched stories to explain the presence of an elephant on a rocky Canadian coastline.)

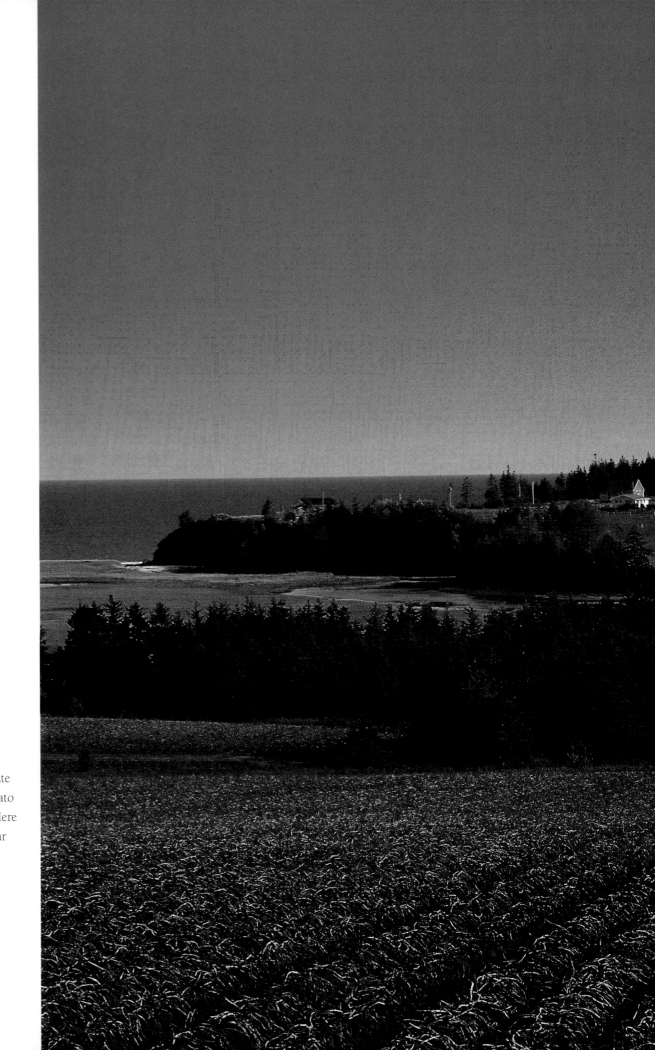

Little Harbour Area, Prince Edward Island
The common white potato, introduced by settlers in the 1700s, thrives in Prince Edward Island's temperate climate and red soil. Throughout "Spud Island," potato fields adorn the undulating red hills and flatlands. Here I've captured the patterns of a sloping tilled field near Little Harbour in northeast Prince Edward Island.

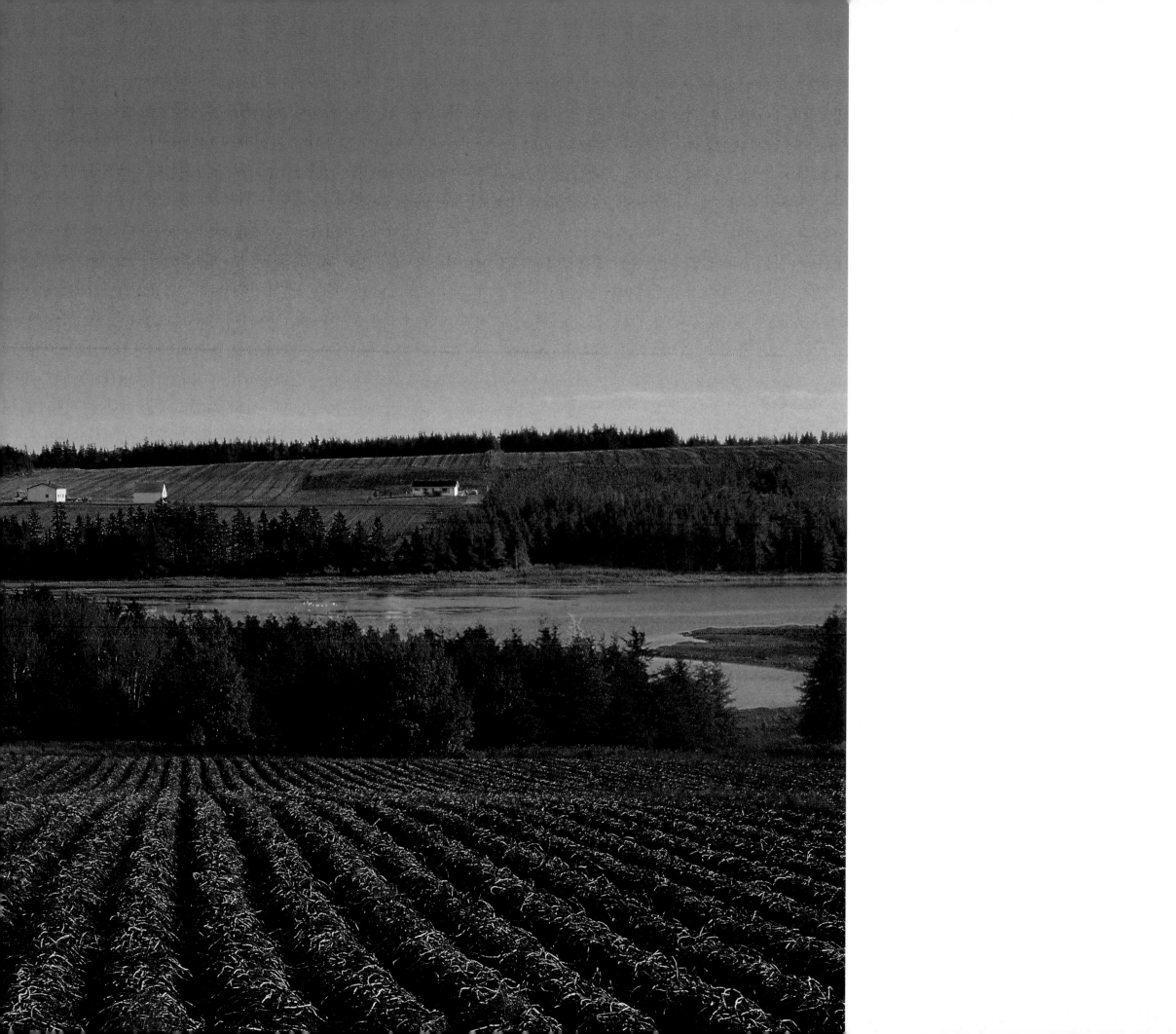

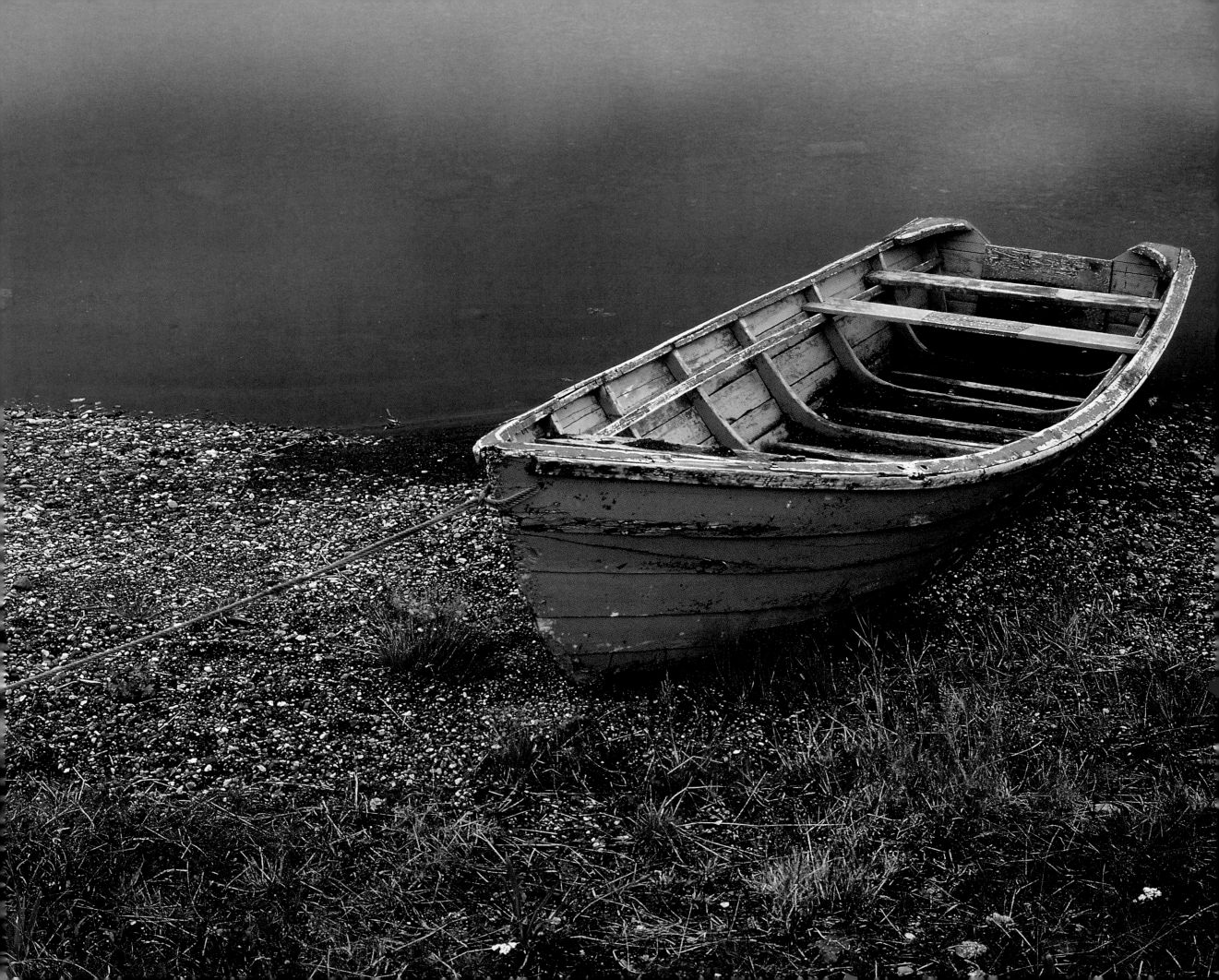

NEWFOUNDLAND

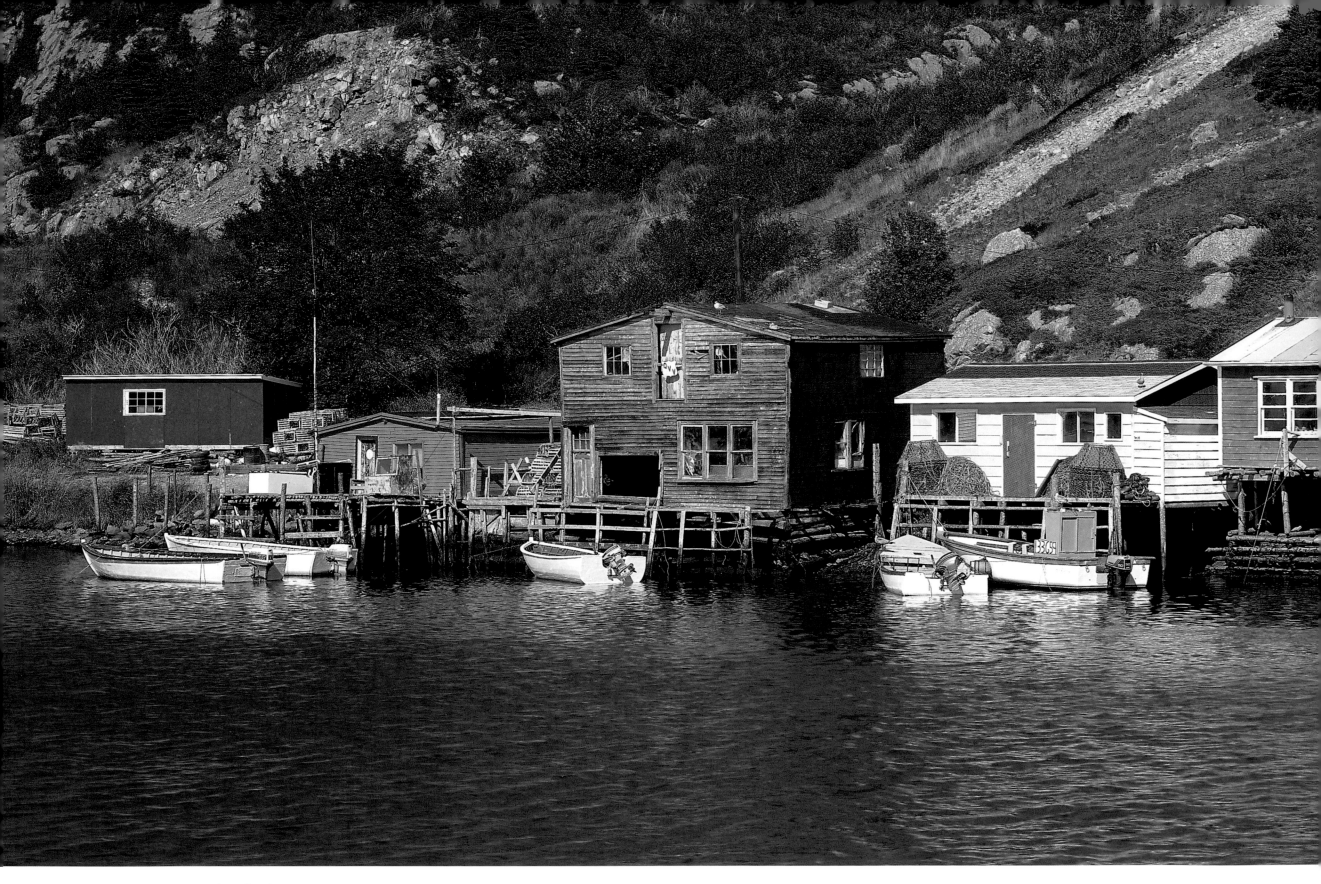

Previous page: **Trout River, Newfoundland**

Weathered boats, like old barns, are nearly impossible to resist as photographic subjects. The problem in Newfoundland is that too many boats are doing nothing but weathering. A declining fishery, moratoriums on fishing, and a poor economy will guarantee a rich harvest of dead and decaying boats unless something is done to preserve the lifestyle of eastern fishermen.

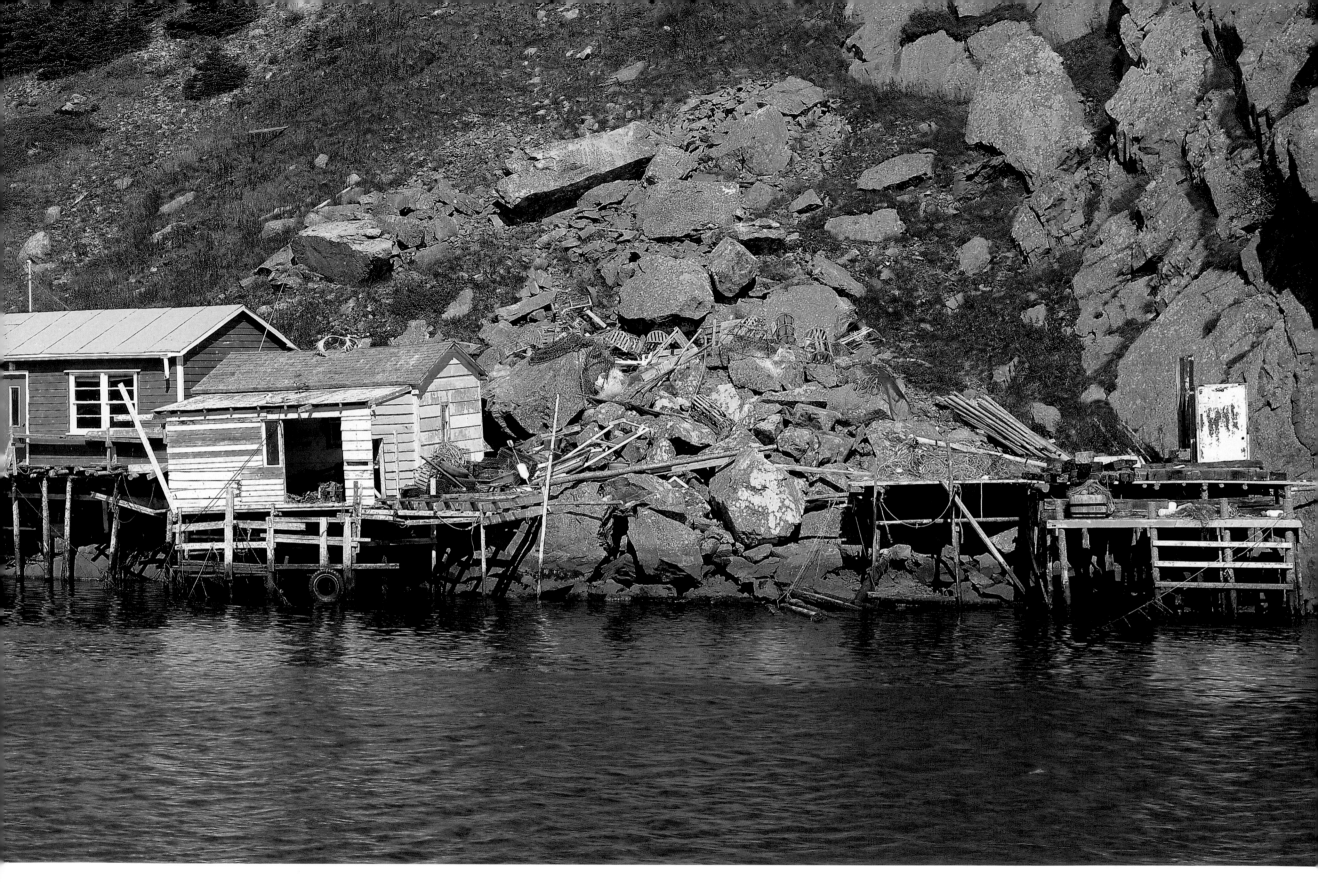

Quidi Vidi Village, Newfoundland
Nowhere else in Canada does human habitation blend
so wonderfully with nature as it does in Newfoundland.
Weathered wharves, rustic buildings, and textured wood
all seem to grow from the same forces that spawned the
island and eroded the rocks.

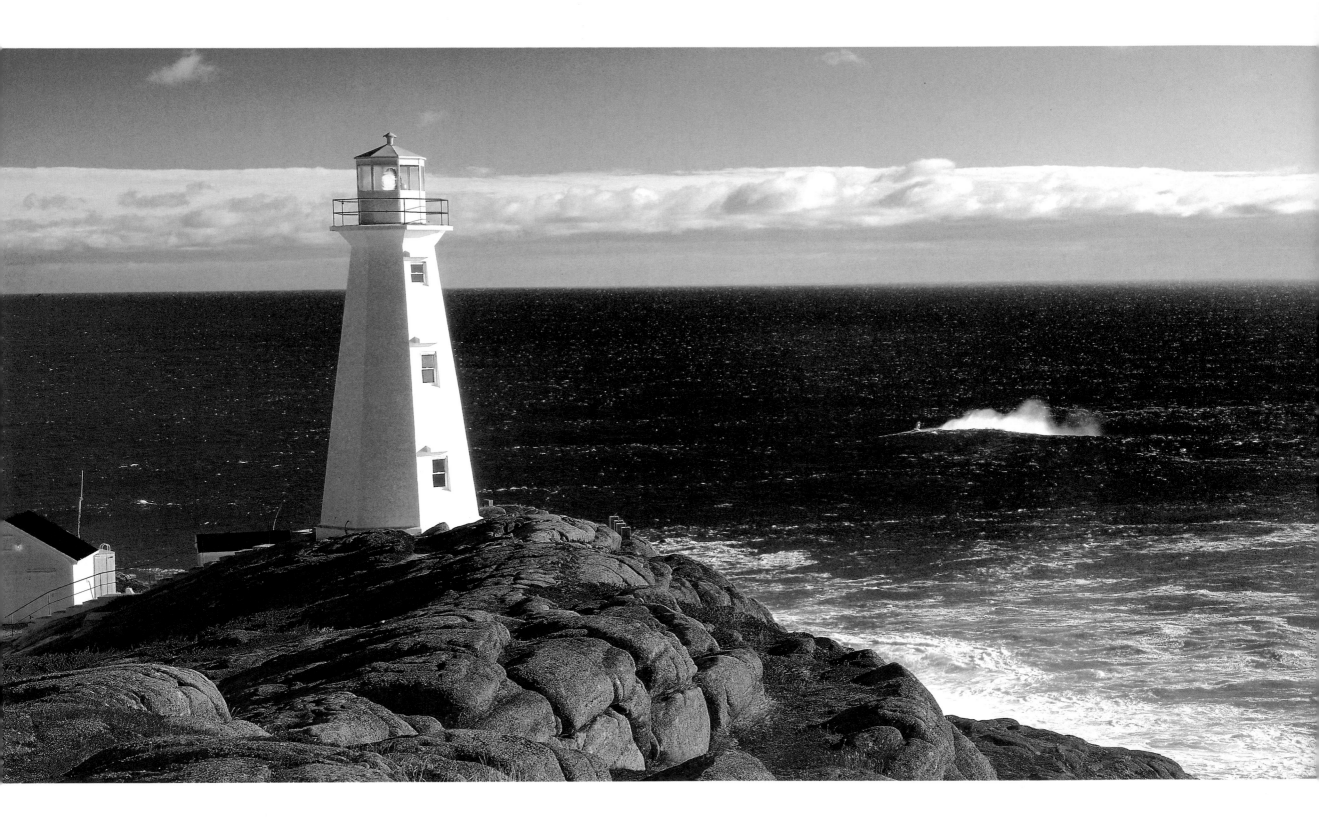

Cape Spear, Newfoundland
Cape Spear is North America's most easterly point and the site of Newfoundland's first coastal lighthouse. Only eleven kilometres from downtown St. John's, the cape is a favourite destination for visitors to the province.

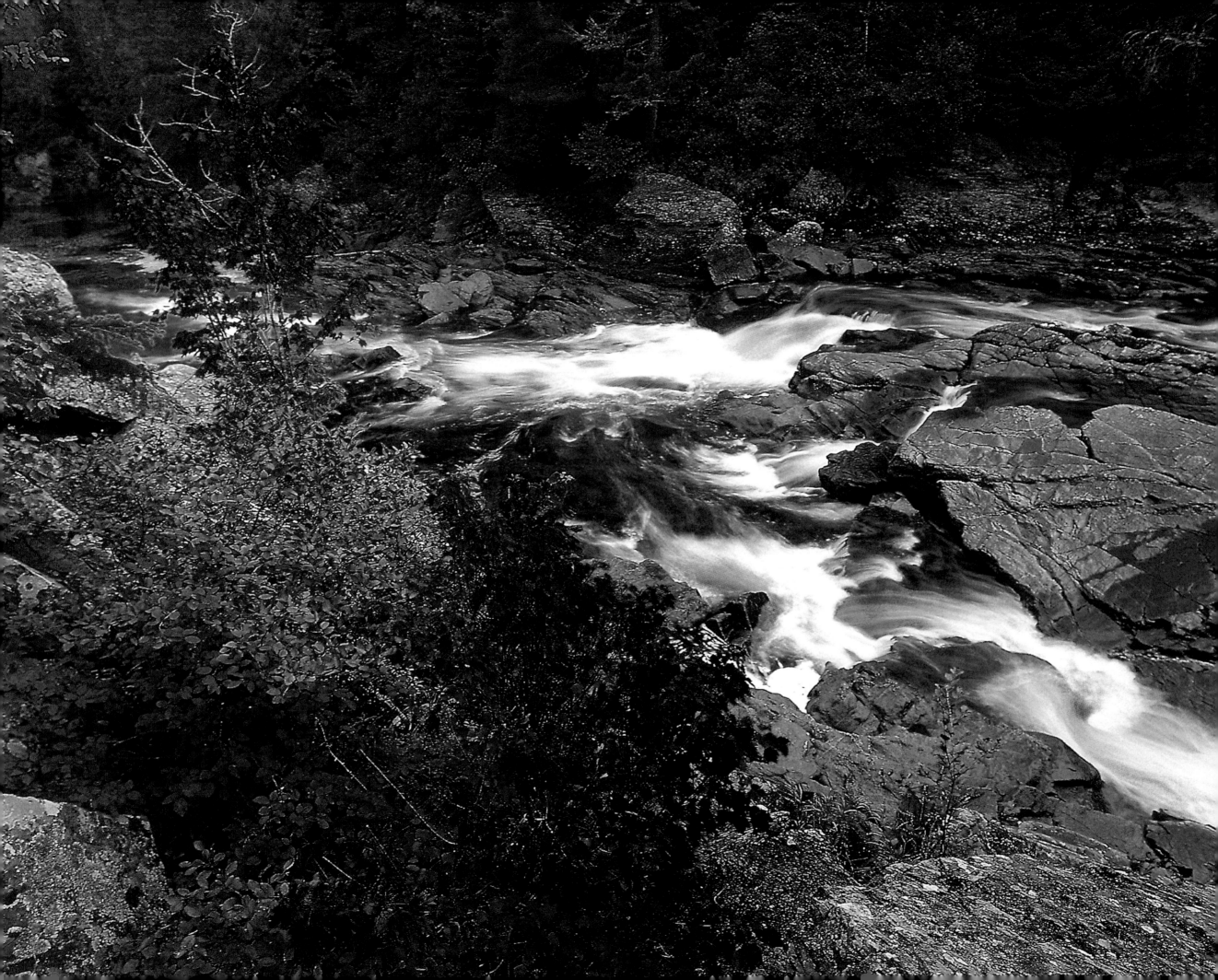

Left: **Northwest River, Newfoundland**

Forming the southern border of Terra Nova National Park, the Northwest River rushes down to Clode Sound. Several days after I captured this scene, the river, swollen with muddy water from torrential rains, tore through its channel, obscuring the rocks and ripping the leaves off the foreground trees.

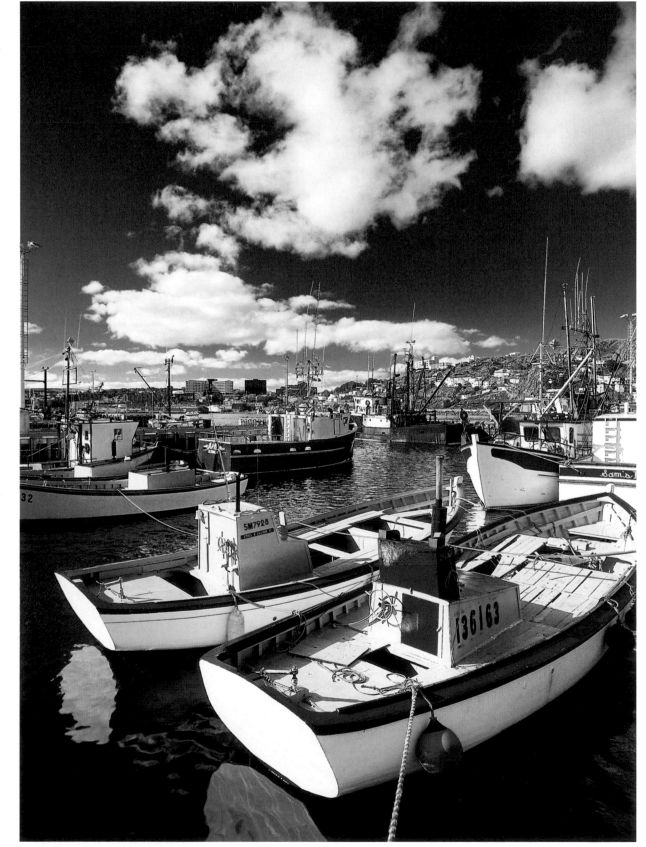

Right: **St. John's Harbour, Newfoundland**

One of North America's oldest cities, St. John's is situated in a stunning, almost landlocked natural harbour. Soaring cliffs and a narrow passage into the harbour guaranteed strategic defence in the early days. Today ships large and small ply the Narrows to find berth in the commercial or small boats section of the harbour. Despite being surrounded by ancient armaments and defensive structures, modern-day St. John's residents are some of the friendliest people I've ever met.

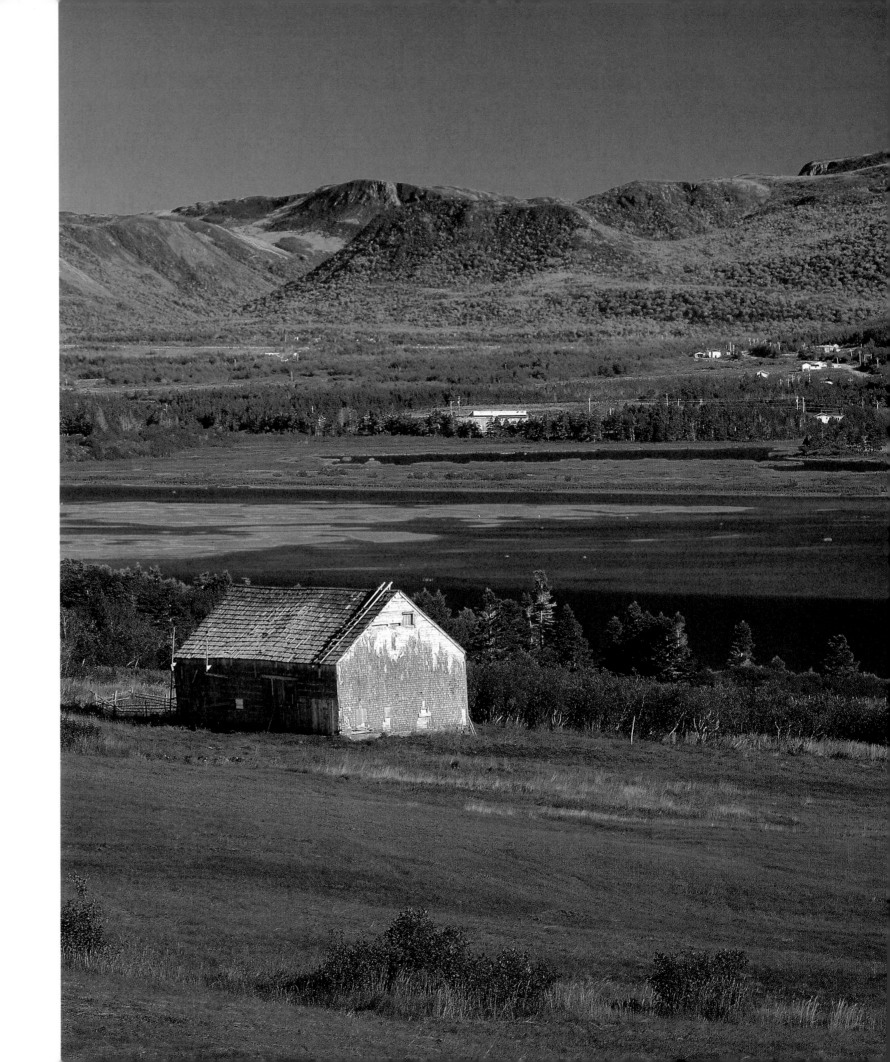

Codroy Valley, Newfoundland

The Codroy Valley was one of the first areas settled in
western Newfoundland. The Long Range Mountains
rise to form a wilderness backdrop to this pastoral area,
which has the best agricultural land in the province.
When I returned home and was browsing through
books in the library, I came upon a photo that was
remarkably similar to this one. The photographer had
shot the same building and even composed the image
similarly. Some scenes, like this one and Peyto Lake,
just seem to have one classic viewpoint.

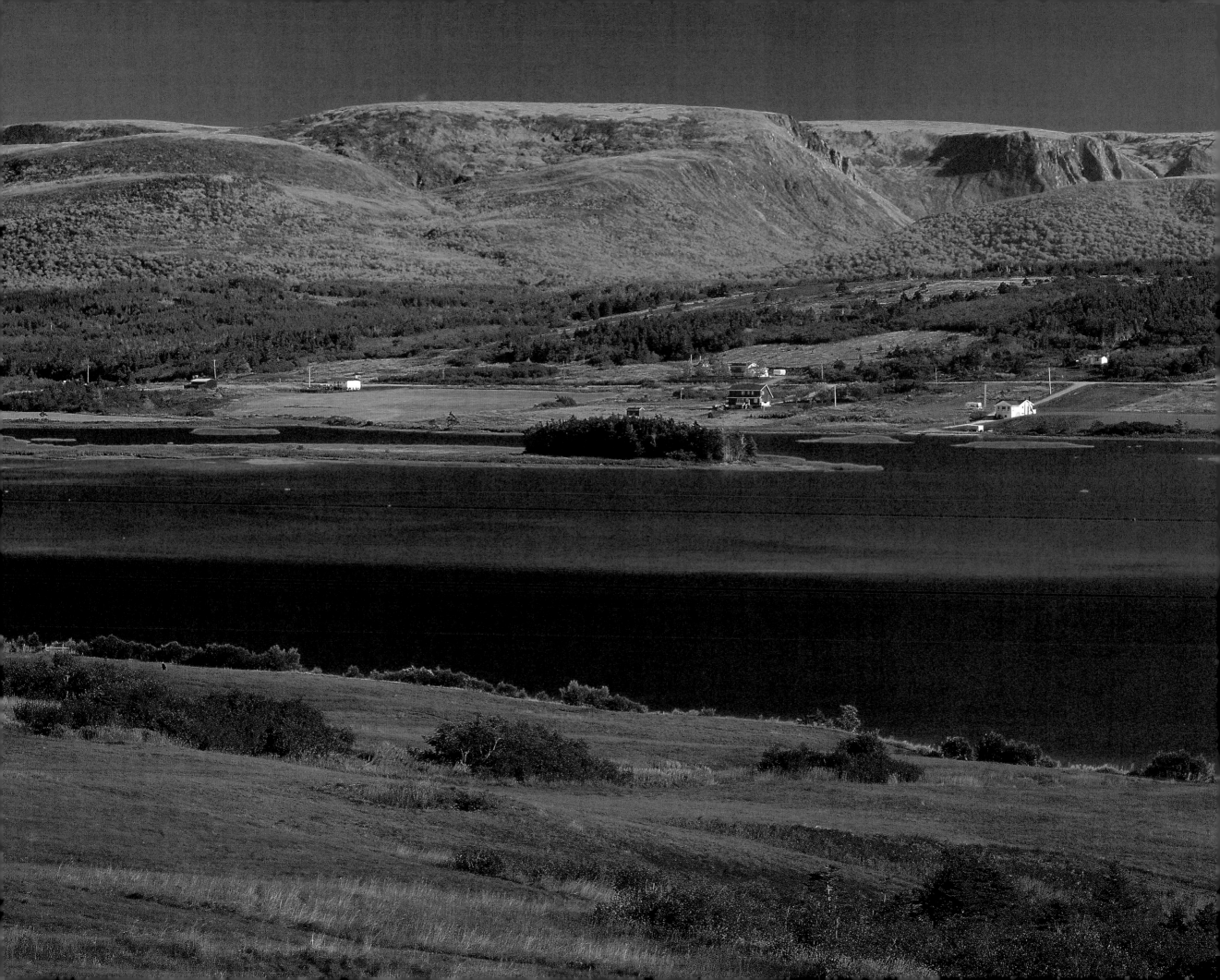

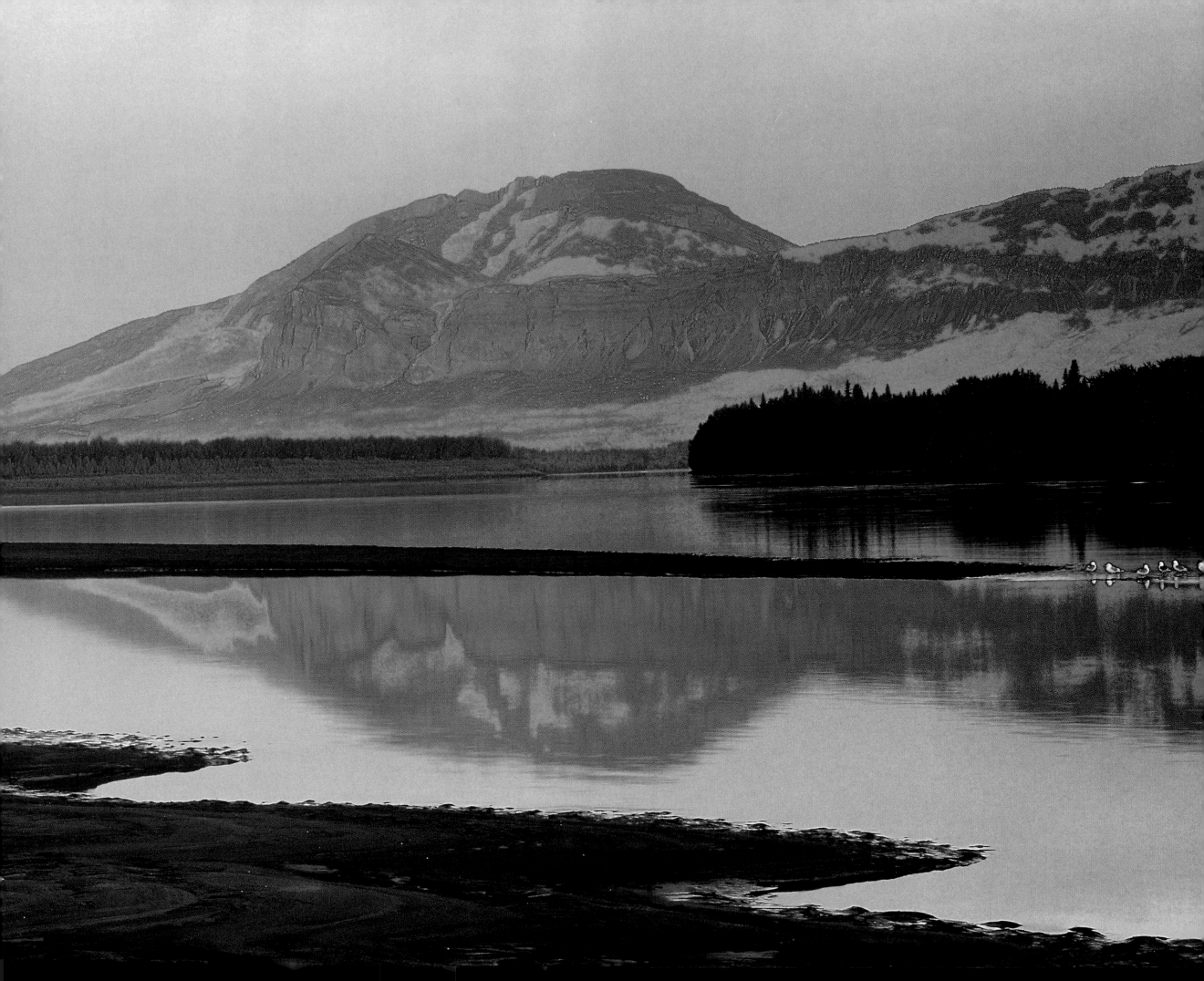

NORTHWEST TERRITORIES

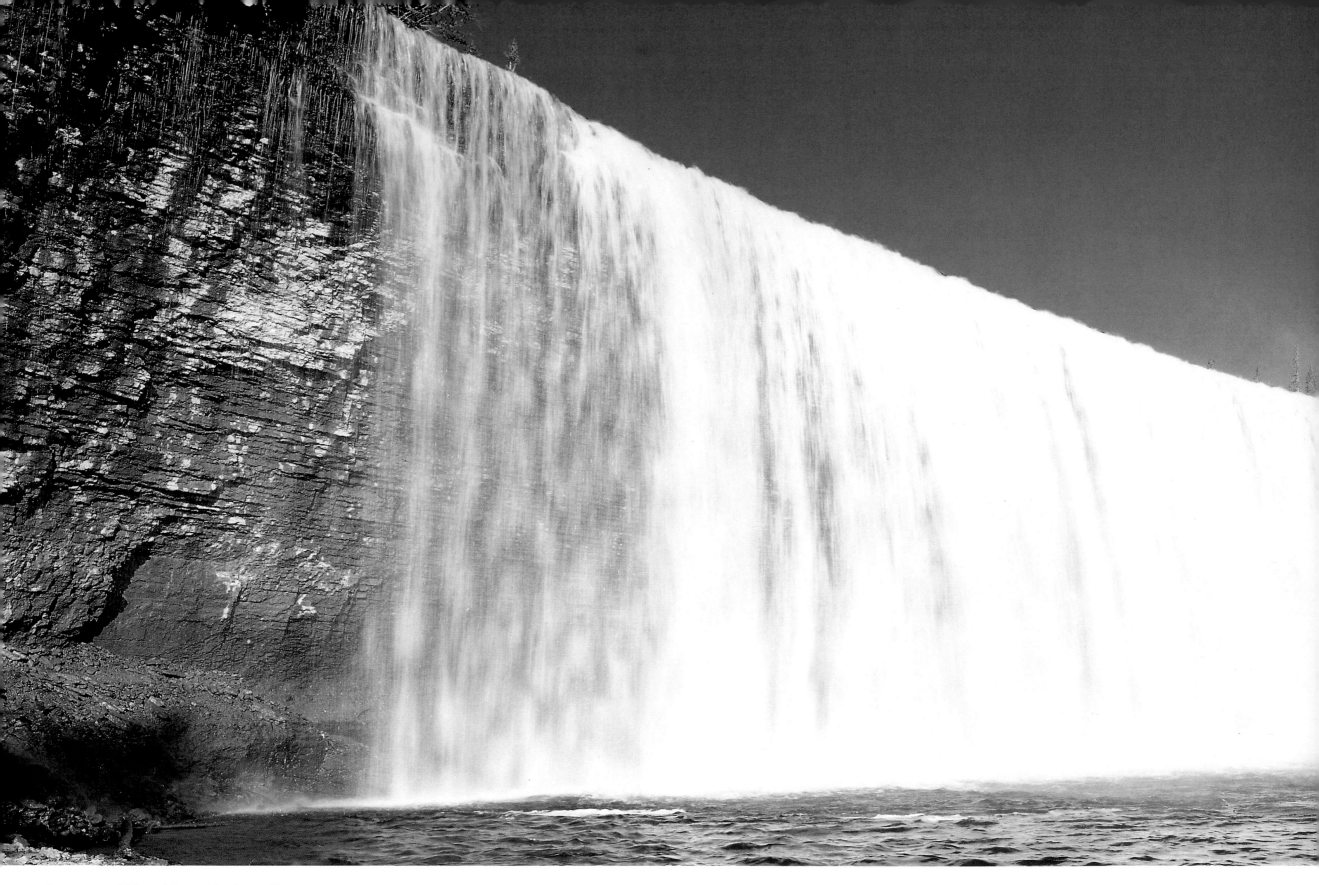

Previous page: **Nahanni Butte, Northwest Territories**

Nahanni National Park, a magnificent corridor of wilderness along the South Nahanni River, can only be reached by float-plane, helicopter, or canoe. The casual traveller can see the edge of the Nahanni Range by stopping at Blackstone Territorial Park. This view of Nahanni Butte is taken from across the Liard River near the park office.

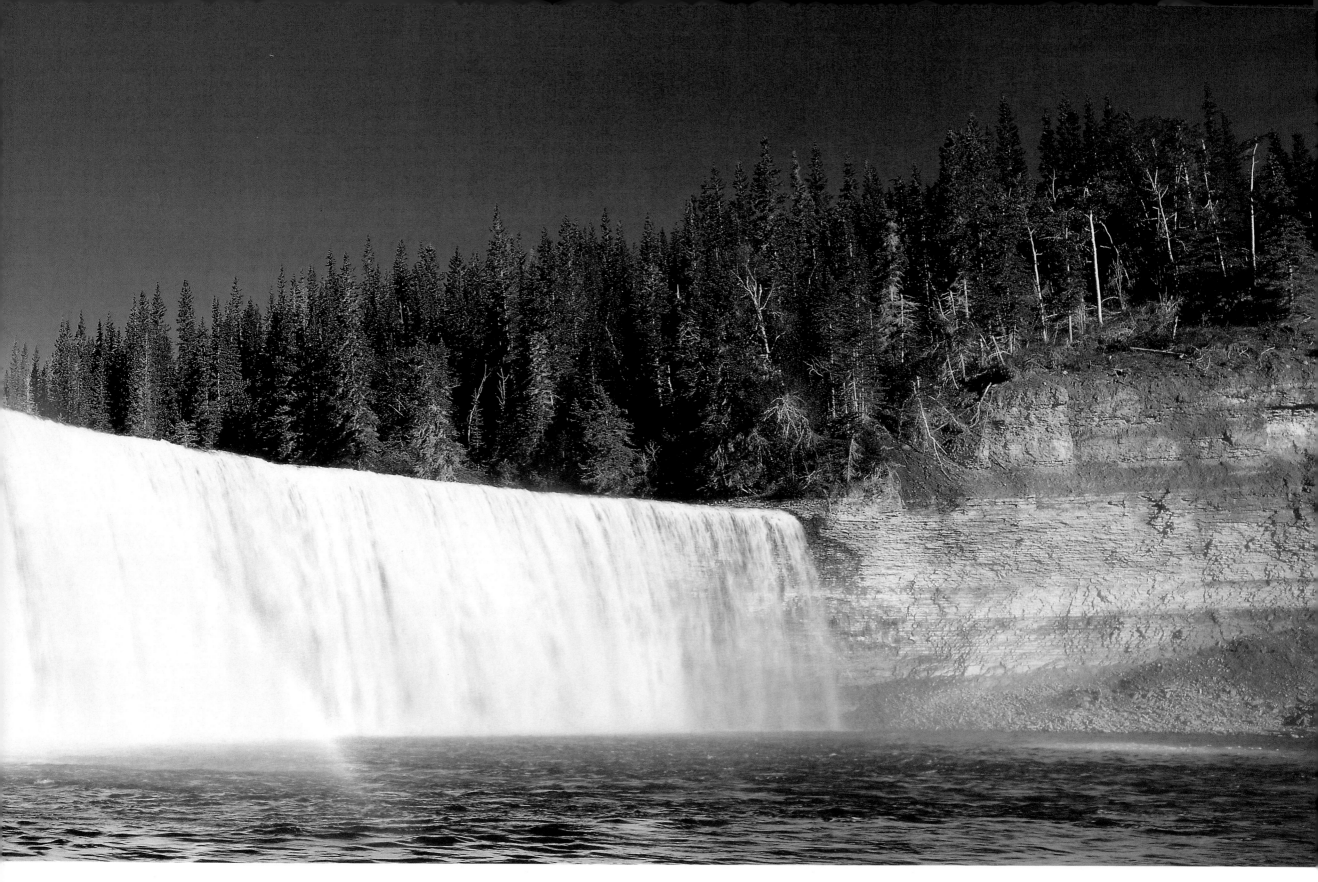

Lady Evelyn Falls, Northwest Territories

The Mackenzie Highway plows through the thick boreal forest of the southern Northwest Territories. Here the scenery is subtle, the land decorated only with flat stretches of black spruce and muskeg. Along the way, Lady Evelyn Falls spices up the mix with an elegant, crescent-shaped veil of plunging water. A swim in the pool below the falls is a refreshing way to beat the surprisingly hot days of the northern summer.

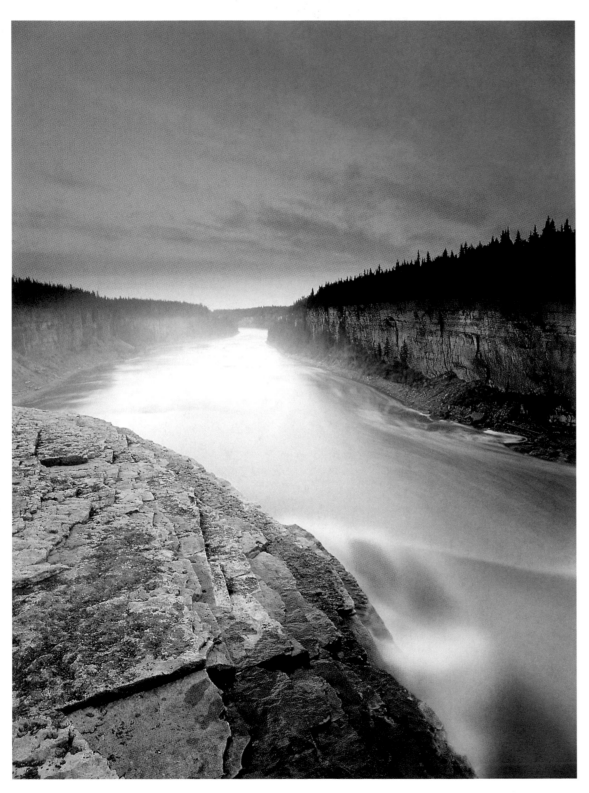

Left: **Alexandra Falls, Northwest Territories**
Near Enterprise, the Hay River carves a deep chasm through the northern boreal forest. Along the way the river is punctuated by plunging waterfalls, churning rapids, and steep-sided cliffs. I chose this view, perched on the lip of thirty-three-metre-high Alexandra Falls, to emphasize the danger and power of this great northern river.

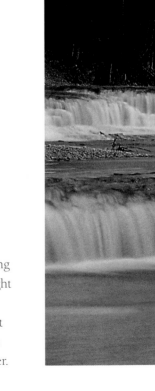

Right: **Kakisa River, Northwest Territories**
In the north, I reversed my daily schedule — sleeping in the afternoon and staying up during the short night to capture sunrise and sunset which are only hours apart in the summer. It was never really dark even at night, and the twilight glow allowed me to get shots like this one of the moon rising over the Kakisa River.

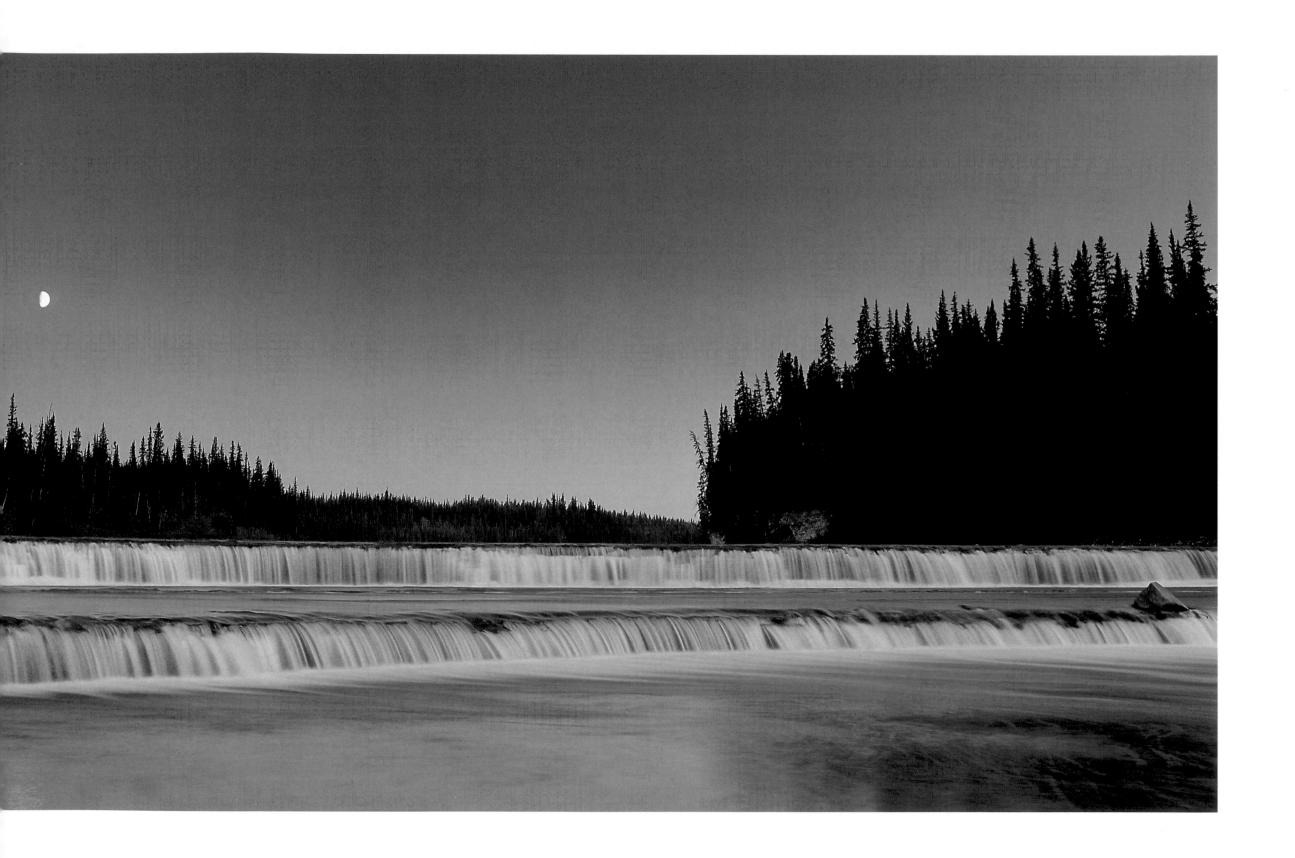

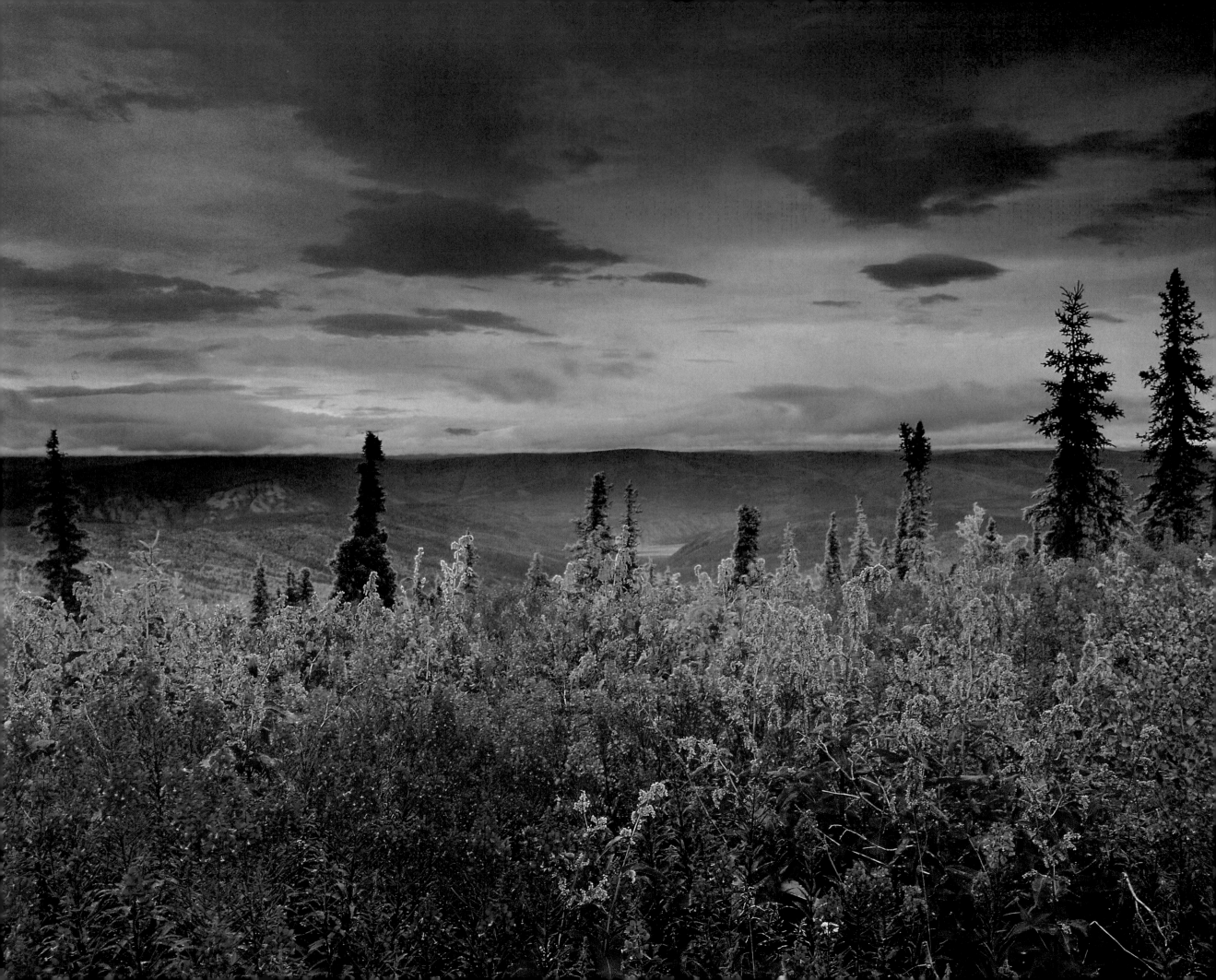

YUKON TERRITORY

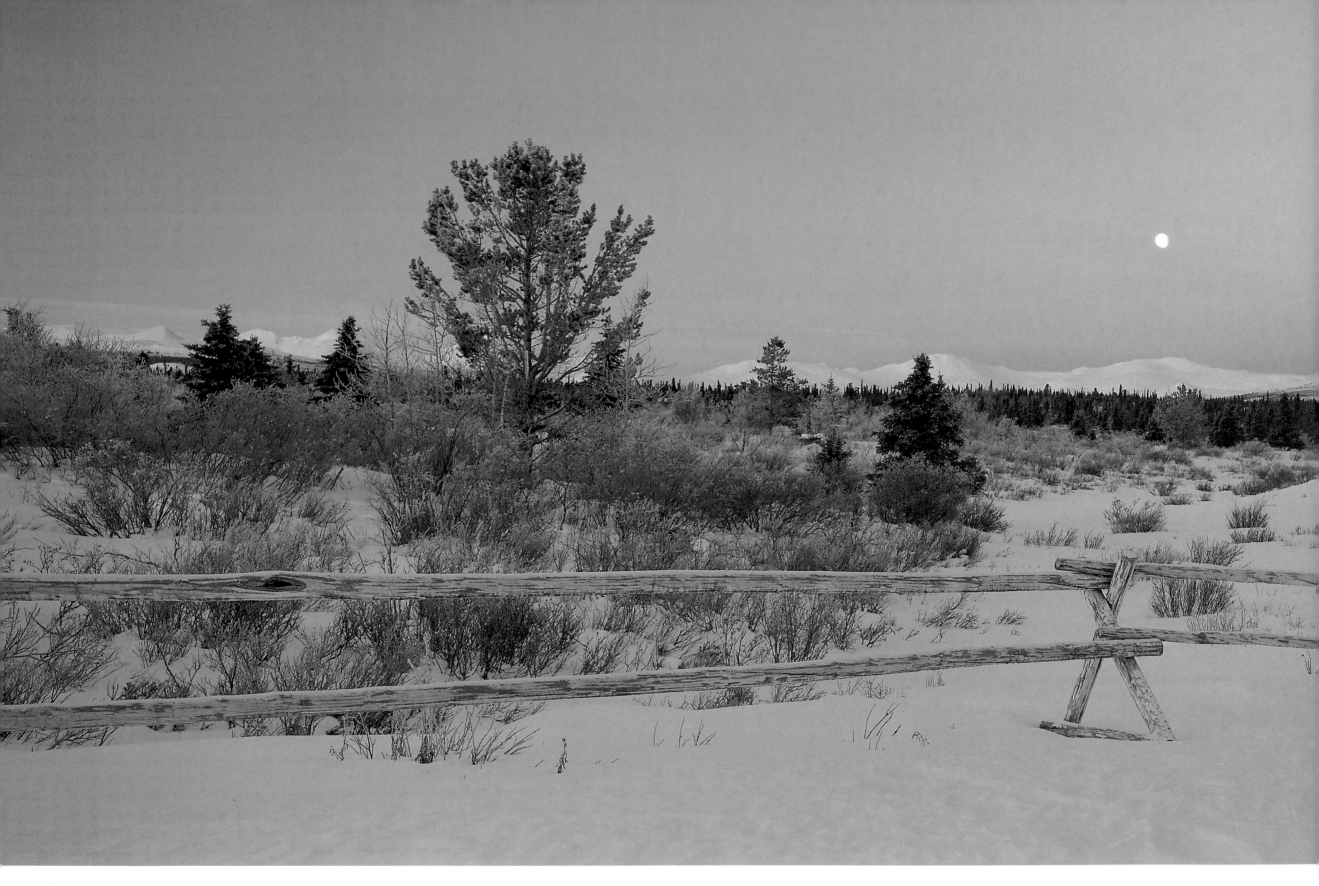

Previous page:

Top of the World Highway, Yukon Territory

From Dawson City in the east to the Alaska/Yukon border in the west, the Top of the World Highway snakes across a backbone of lush alpine meadows with plunging, panoramic views of rounded mountains in the distance. I had stopped on the edge of the road to get a snack from the cooler when I realized that even this view from the ditch was worth a photograph.

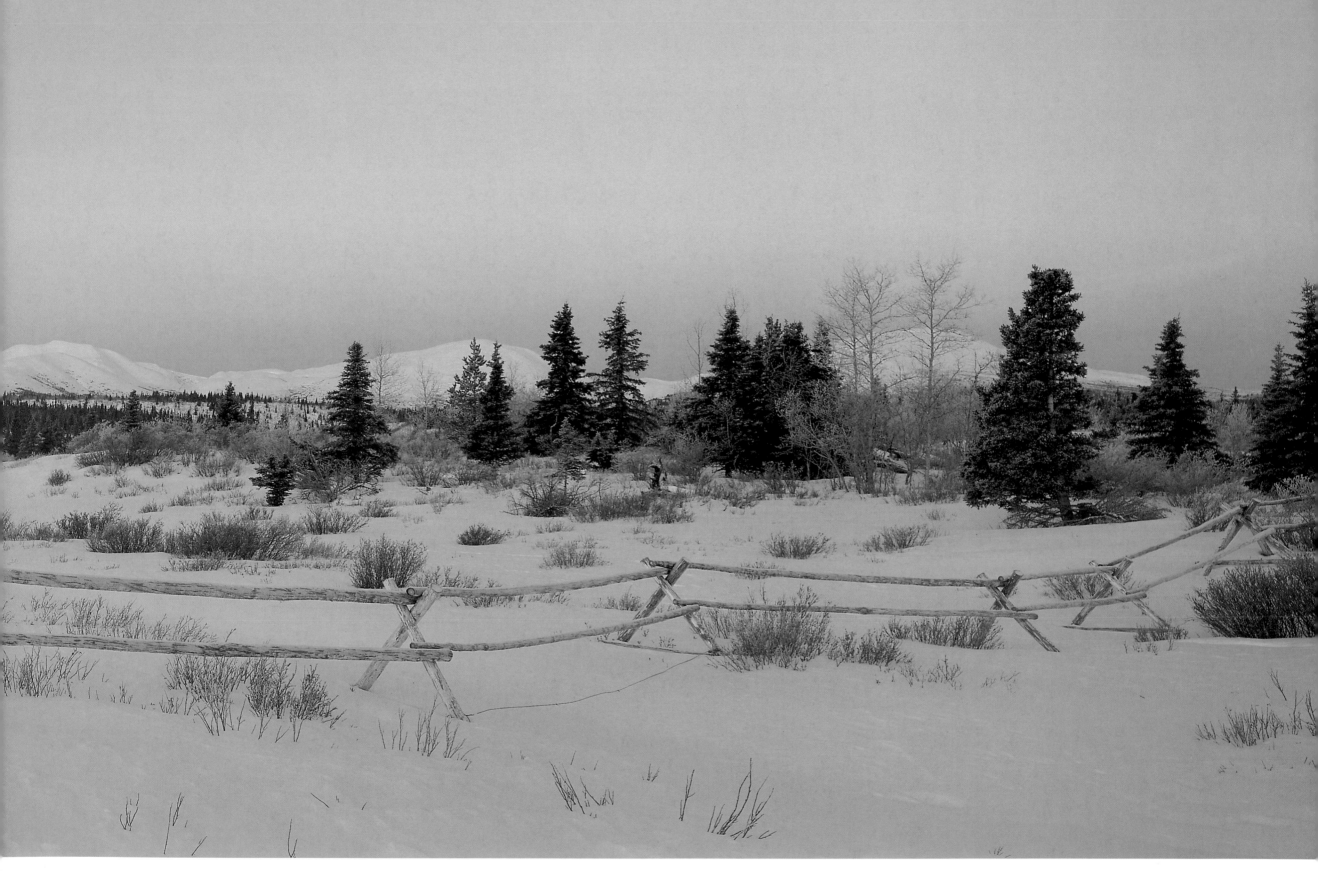

Whitehorse, Yukon Territory

Whitehorse is a rural city with wide-open spaces and scattered subdivisions. This view along the Fish Lake Road is typical of the countryside in and around Whitehorse. The city has all the conveniences of modern life with wilderness only steps away. Several times while walking through the city's extensive green belts I've glimpsed wolves as they dashed through the forest.

117

Eagle Plains, Yukon Territory

Dense wet black muskeg north of Eagle Plains discourages any off-road hiking, but fortunately views like this are common along the Dempster Highway in northern Yukon Territory. Muskeg, although pretty, is also the perfect breeding ground for mosquitoes as big as sparrows, so don't forget your bug dope.

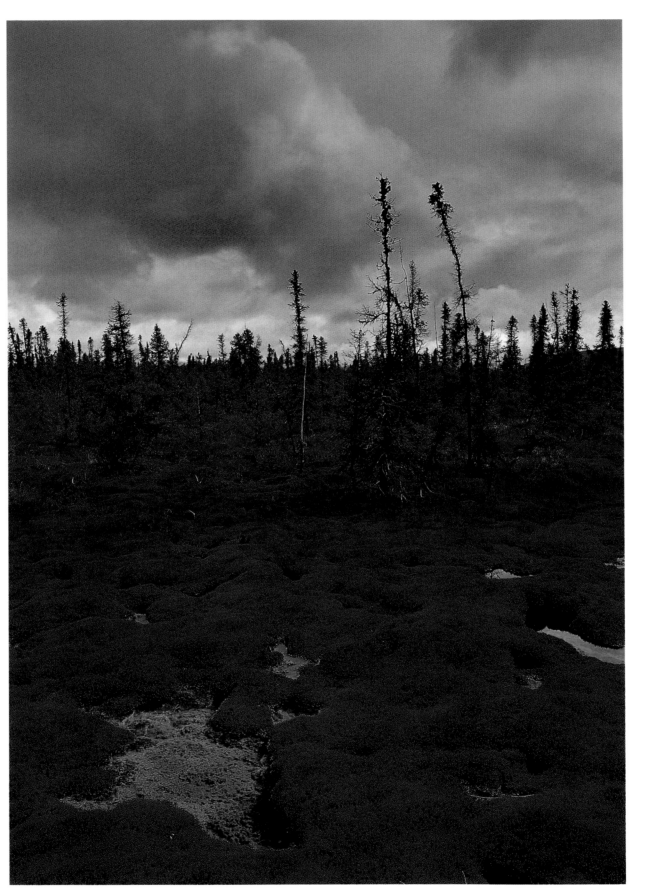

Right: **Kathleen River, Yukon Territory**

Kluane National Park, in the southwest corner of the Yukon, is a land of superlatives, with the highest mountains in Canada and the most extensive nonpolar icefields in the world. Although much of Kluane is inaccessible to all but expert mountaineers, everyone can enjoy the beauty of the park's front ranges from the Haines and Alaska highways. This view from the Kathleen River bridge is typical of the dazzling scenes you can expect along these roads.

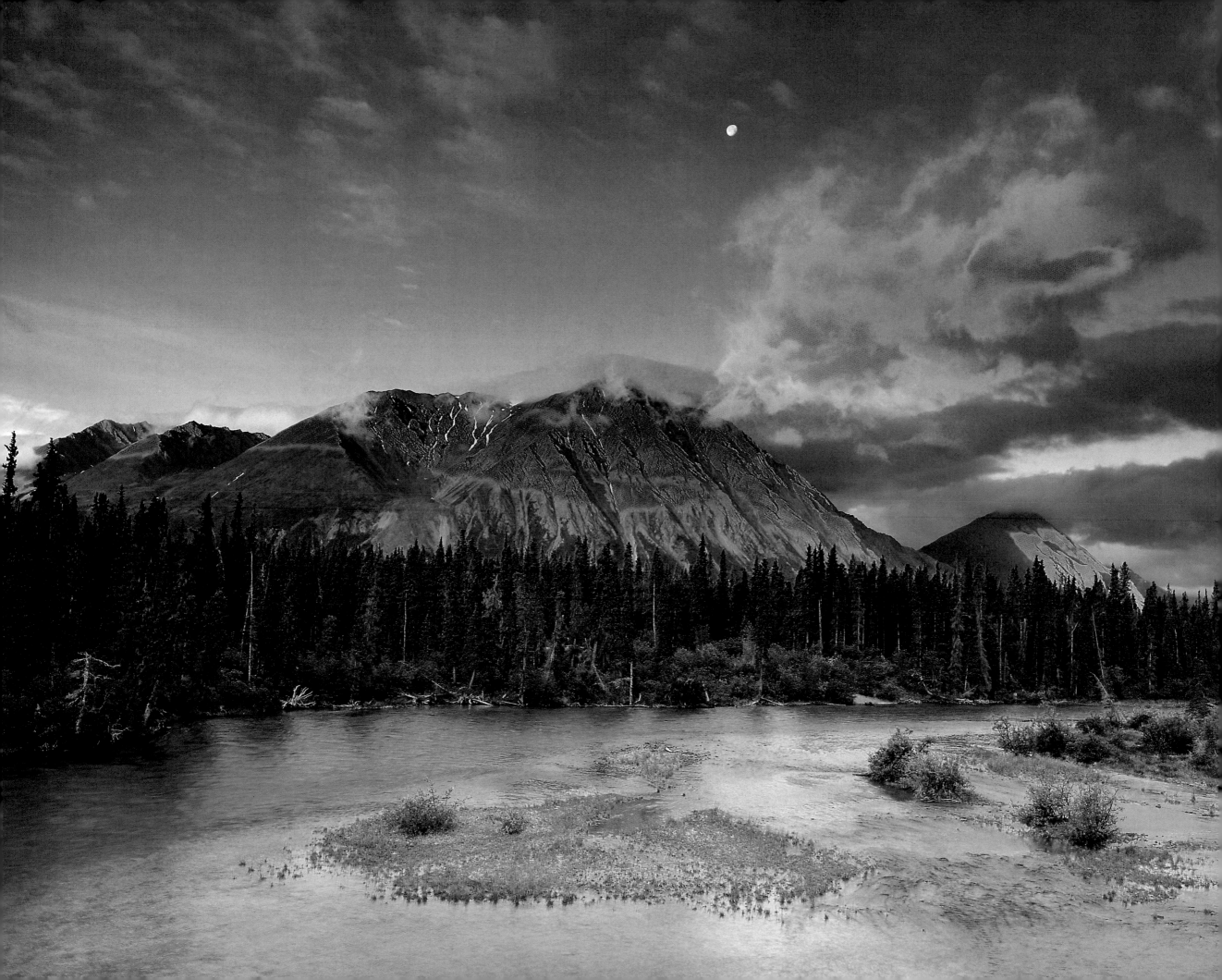

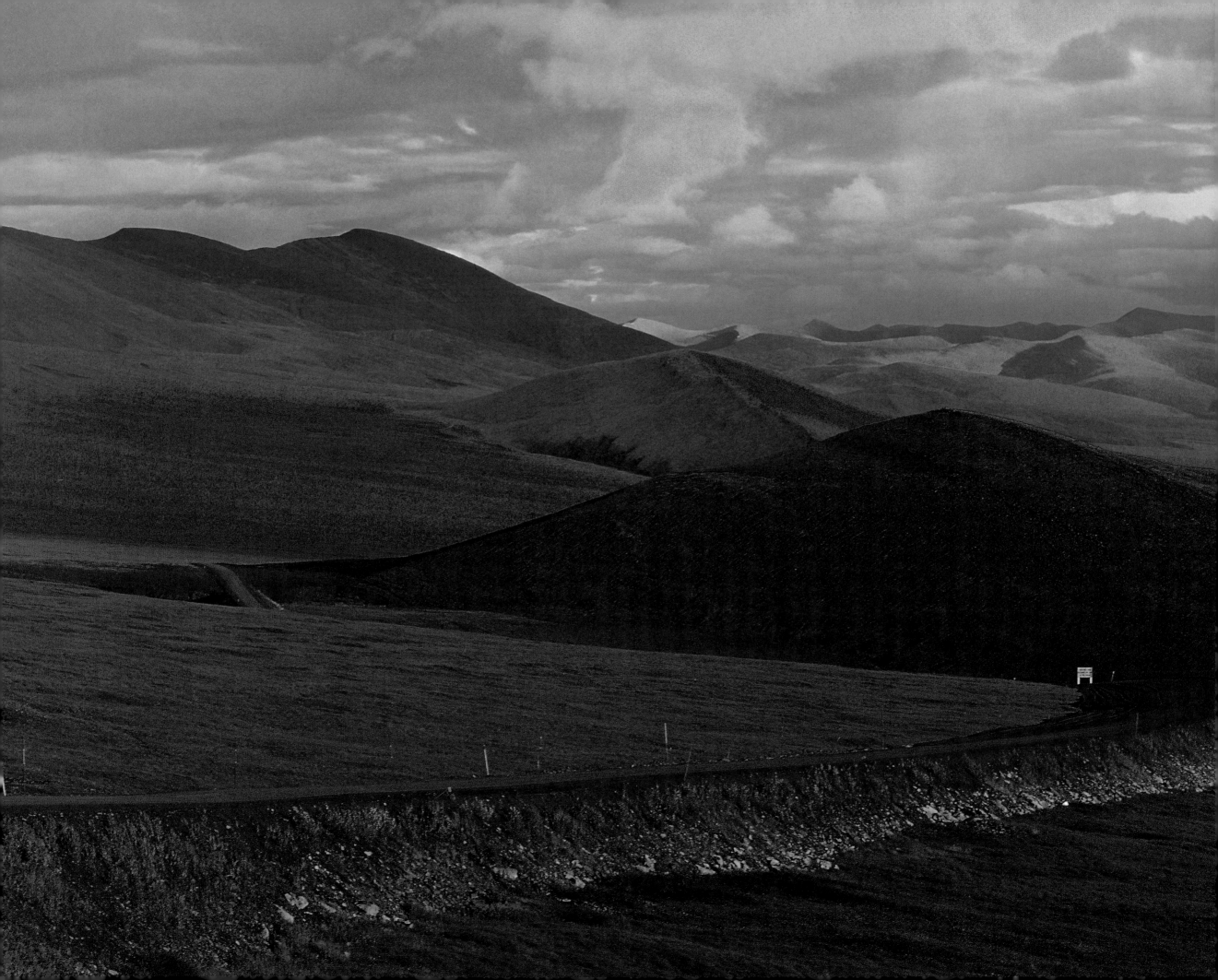

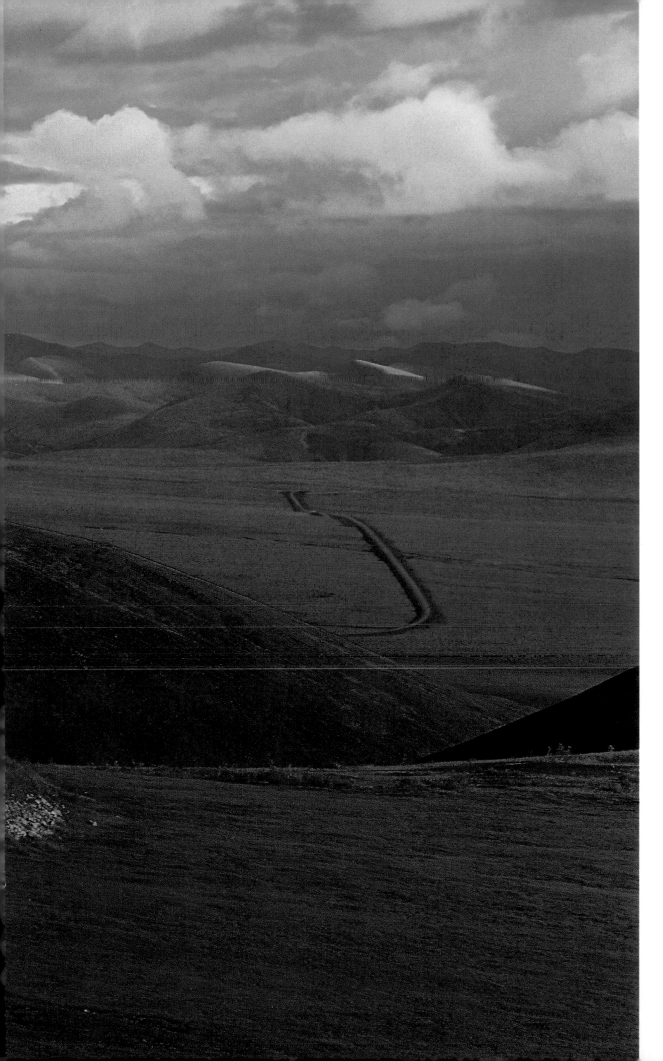

Dempster Highway, Yukon Territory
The Dempster is an adventurer's highway — a narrow line of gravel threading through a vast wilderness. Stretching 737 kilometres from the Klondike gold fields to the Mackenzie Delta of the Northwest Territories, this remote highway penetrates into the heart of Canada's northern frontier. In this photo the highway snakes through the Richardson Mountains near the Northwest Territories border. Yukon's Ogilvie Mountains are in the background.

ACKNOWLEDGEMENTS

First, I would like to thank the sponsors who helped make this book possible: DayMen Photo Marketing (Mamiya, Lowepro, Slik, Rodenstock and Metz equipment), Singh-Ray (Singh-Ray filters), Tiffen Manufacturing and Nadel Enterprises (Tiffen Filters), Carousel Photographics (film processing), Technicare (film and supplies), The Lab Works (photographic art prints), and Oshry Camera (photographic equipment). Special thanks to Lorne Hildebrant, Shirley and Paul Martens, Marty Nadel, Clive Oshry, Bob Singh, Robert Smythe, and Sandie Stern for their support and trust.

Special thanks to Pierre Guevremont for guidance, encouragement, support, and for having a really huge shoulder!

Thanks especially to family, friends, and colleagues for support and advice. The biggest debt of gratitude goes to my wife, April, for support above and beyond anything reasonable and sane. Special thanks to David Boag for his positive and important influence on my life. Finally, thanks to all the great Canadian photographers out there who continually thrill and inspire me with their imagery.

For fine art reproduction prints of any of the photographs in this book please contact The Lab Works — Edmonton at (403) 413-1850.

DayMen	Lowepro
Mamiya	TECHNICARE INC.
SLIK	The LabWorks.
SINGH-RAY Filters For Over 35 Years	CAROUSEL
TiFFEN®	RODENSTOCK
Metz	OSHRY CAMERA EXCHANGE
NADEL	

All photographs in this book were taken using Fujichrome Professional transparency film. I always use a tripod and I relied on a Slik Professional 4 tripod with an Arca Swiss B1 ball head to hold my cameras. I carry my gear in well-designed Lowepro packs; for this project I used a Super Trekker, Photo Trekker AW, Mini Trekker and Orion AW. Specific information on cameras, lenses, and filters used for each shot is given in the following list.

BRITISH COLUMBIA

Victoria
Mamiya 645 Pro, 35 mm lens,
Tiffen ND.6 grad filter.

Florencia Bay
Fuji GX617, 180 mm lens,
Cokin P173 polarizer.

Dinner Rock
Mamiya 645 Pro, 45 mm lens,
Cokin P173 polarizer.

Cathedral Grove
Fuji GX617, 90 mm lens,
Tiffen warm-tone polarizer.

Farwell Canyon
Fuji GX617, 180 mm lens,
Tiffen 812 warming filter.

Osoyoos Ecological Reserve
Mamiya 645 Pro, 45 mm lens,
Singh-Ray 2 stop hard-edge grad filter,
Tiffen 812 warming filter,
Hoya enhancer.

Yoho National Park
Mamiya 645, 55 mm lens,
Cokin P173 polarizer,
Singh-Ray 1 1/2 stop reverse grad filter.

Manning Provincial Park
Mamiya 645 Pro, 150 mm lens,
Tiffen 80B filter.

Vernon Area
Fuji GX617, 90 mm lens,
Tiffen warm-tone polarizer.

Kelowna
Mamiya 645 Pro, 55 mm lens,
Singh-Ray 2 1/2 stop reverse grad filter.

ALBERTA

Castle Mountain
Mamiya 645 Pro, 35 mm lens,
Singh-Ray 2 1/2 stop reverse grad filter,
Singh-Ray colour intensifier.

Vermilion Lake
Fuji GX617, 180 mm lens,
Tiffen warm-tone polarizer.

Peyto Lake
Mamiya 645 Pro, 35 mm lens,
Tiffen warm-tone polarizer.

Wilcox Pass
Mamiya 645 Pro, 45 mm lens,
Cokin G2 grad filter,
Singh-Ray colour intensifier.

Turner Valley Area
Canon EOS A2E, 24 mm lens,
Hoya polarizer.

Leduc Area
Canon A2E, 20 mm lens,
Singh-Ray 3 stop reverse grad,
Singh-Ray colour intensifier.

Writing-on-Stone Provincial Park
Mamiya 645 Pro, 35 mm lens,
Singh-Ray 2 1/2 stop reverse grad filter,
Singh-Ray colour intensifier.

Dry Island Buffalo Jump
Mamiya 645 Pro, 45 mm lens,
Singh-Ray 2 1/2 stop reverse grad filter.

Astotin Lake
Fuji G617, 105 mm lens,
Tiffen ND.6 grad filter.

SASKATCHEWAN

Cypress Hills
Mamiya 645, 45 mm lens,
Singh-Ray 1½ stop hard-edge grad filter,
Singh-Ray colour intensifier.

Robsart
Fuji GX617, 180 mm lens,
Cokin P173 polarizer.

Val Marie Area
Fuji GX617, 180 mm lens,
Tiffen warm-tone polarizer.

Cold Lake
Mamiya 645 Pro, 35 mm lens,
Tiffen ND.6 grad filter,
Tiffen 812 warming filter.

Qu'Appelle Valley
Mamiya 645 Pro, 45 mm lens,
Tiffen warm-tone polarizer.

Big Muddy Badlands
Zone VI field camera, 135 mm lens,
Cokin P173 polarizer.

The Great Sandhills
Mamiya 645 Pro, 45 mm lens,
Cokin P173 polarizer.

MANITOBA

Spruce Woods Provincial Park
Mamiya 645 Pro, 35 mm lens,
Singh-Ray 4 stop hard-edge grad filter,
Tiffen 812 warming filter.

Portage Bay
Fuji GX617, 180 mm lens,
Tiffen warm-tone polarizer.

Minnedosa Area
Canon A2E, 80-200 mm lens,
Tiffen warm-tone polarizer.

Holland Area
Canon A2E, 50 mm lens,
Cokin T2 grad filter.

Pisew Falls
Fuji GX617, 90 mm lens,
Cokin P173 polarizer.

Grayling Lake
Canon EOS A2E, 24 mm lens,
Cokin G2 grad filter.

Churchill
Fuji GX617, 180 mm lens,
Cokin P173 polarizer.

ONTARIO

Lake Huron
Mamiya 645 Pro, 55 mm lens,
Singh-Ray polarizer,
Singh-Ray colour intensifier.

Thousand Islands
Fuji GX617, 180 mm lens,
Tiffen warm-tone polarizer.

Barron Canyon
Mamiya 645 Pro, 35 mm lens,
Singh-Ray 3½ stop reverse grad filter,
Singh-Ray colour intensifier.

Sea Lion Rock
Mamiya 645 Pro, 35 mm lens,
Tiffen warm-tone polarizer.

Forester's Falls
Mamiya 645 Pro, 80 mm lens,
Cokin P173 polarizer.

Algonquin Provincial Park
Mamiya 645 Pro, 150 mm lens,
Tiffen 81C warming filter.

Rushing River
Mamiya 645 Pro, 35 mm lens,
Cokin P173 polarizer,
Singh-Ray 1 stop hard-edge grad filter.

George Lake
Mamiya 645 Pro, 35 mm lens,
Tiffen ND.9 grad filter,
Tiffen 812 warming filter.

Chikanishing River
Zone VI field camera, Rodenstock 210 mm lens,
Cokin P173 polarizer.

Bruce Peninsula
Zone VI field camera, 135 mm Rodenstock lens,
Cokin P173 polarizer.

QUEBEC

Gaspé Peninsula
Mamiya 645, 55 mm lens,
Tiffen warm-tone polarizer,
Tiffen ND.3 grad filter.

Percé Rock
Fuji GX617, 180 mm lens,
Tiffen warm-tone polarizer.

Cap-des-Rosiers
Mamiya 645 Pro, 150 mm lens.

La Mauricie National Park
Mamiya 645 Pro, 80 mm lens,
Tiffen warm-tone polarizer,
Singh-Ray colour intensifier.

Portage du Fort
Mamiya 645 Pro, 150 mm lens,
Tiffen warm-tone polarizer.

Eastern Townships
Mamiya 645 Pro, 150 mm lens

Diable River
Zone VI field camera, 210 mm lens.

Grande-Grave Historic Site
Mamiya 645 Pro, 150 mm lens,
Cokin P173 polarizer.

NEW BRUNSWICK

Cape Enrage

Mamiya 645 Pro, 80 mm lens,
Tiffen warm-tone polarizer,
Singh-Ray colour intensifier.

Laverty Road

Zone VI field camera, Rodenstock 210 mm lens,
Tiffen 81C filter.

Point Wolfe Bridge

Zone VI field camera, Rodenstock 135 mm lens.

Kelly's Beach

Mamiya 645 Pro, 80 mm lens,
Singh-Ray 3 stop hard-edge grad filter,
Singh-Ray colour intensifier.

Miramichi River

Mamiya 645 Pro, 150 mm lens,
Tiffen 812 warming filter.

NOVA SCOTIA

Kejimkujik National Park

Mamiya 645 Pro, 80 mm lens,
Tiffen warm-tone polarizer,
Singh-Ray colour intensifier.

Peggy's Cove

Fuji GX617, 180 mm lens,
Cokin P173 polarizer.

The Lookoff

Zone V1 field camera, 210 mm lens,
Tiffen warm-tone polarizer.

Northwest Cove Harbour

Zone V1 field camera, 210 mm lens,
Cokin P173 polarizer.

Balancing Rock

Fuji GX617, 180 mm lens,
Tiffen warm-tone polarizer.

Cape Breton Highlands

Zone IV Camera, Rodenstock 135 mm lens,
Tiffen warm-tone polarizer.

PRINCE EDWARD ISLAND

French River

Mamiya 645 Pro, 55 mm lens,
Cokin P173 polarizer.

Cape Turner

Mamiya 645 Pro, 35 mm lens,
Tiffen warm-tone polarizer,
Singh-Ray colour intensifier.

Elephant Rock

Mamiya 645 Pro, 35 mm lens,
Tiffen ND.9 neutral density filter,
Tiffen ND.6 grad filter.

Little Harbour Area

Mamiya 645 Pro, 80 mm lens,
Tiffen warm-tone polarizer,
Singh-Ray 1 stop hard-edge grad.

NEWFOUNDLAND

Trout River

Mamiya 645 Pro, 80 mm lens,
Singh-Ray colour intensifier,
Tiffen 812 warming filter

Quidi Vidi Village

Fuji GX617, 180 mm lens,
Tiffen warm-tone polarizer.

Cape Spear

Fuji GX617, 180 mm lens,
Tiffen warm-tone polarizer.

Northwest River

Mamiya 645 Pro, 35 mm lens,
Cokin P173 polarizer.

St. John's Harbour

Mamiya 645 Pro, 35 mm lens,
Tiffen warm-tone polarizer.

Codroy Valley

Zone VI field camera, Rodenstock 210 mm lens,
Tiffen warm-tone polarizer.

NORTHWEST TERRITORIES

Nahanni Butte

 Mamiya 645 Pro, 150 mm lens,

 Tiffen ND.6 grad filter,

 Tiffen 812 warming filter.

Lady Evelyn Falls

 Fuji GX617, 90 mm lens,

 Tiffen warm-tone polarizer.

Alexandra Falls

 Mamiya 645 Pro, 35 mm lens,

 Singh-Ray 2 stop reverse grad filter,

 Singh-Ray colour intensifier,

 Tiffen 812 warming filter.

Kakisa River

 Mamiya 645 Pro, 80 mm lens,

 Singh-Ray blue grad filter.

YUKON TERRITORY

Top of the World Highway

 Mamiya 645 Pro, 35 mm lens,

 Singh-Ray 2 stop reverse grad,

 Hoya didymium filter.

Whitehorse

 Fuji GX617, 180 mm lens.

Eagle Plains

 Mamiya 645 Pro, 35 mm lens,

 Cokin P173 polarizer,

 Singh-Ray 1 1/2 stop hard-edge grad.

Kathleen River

 Mamiya 645 Pro, 55 mm lens,

 Singh-Ray 2 stop reverse grad,

 Singh-Ray colour intensifier.

Dempster Highway

 Mamiya 645 Pro, 150 mm lens,

 Cokin P173 polarizer.